FEEDING
CREATIVITY

MARY
McCARTNEY

FEEDING CREATIVITY

A Cookbook for Friends and Family

MARY McCARTNEY

TASCHEN

Dedicated to my husband + kids
my chief tasters - thanks for your
love + support. And Mum + Dad for
your original inspiration. X Mary

Cook, Meet, Picture, Eat

The idea just popped into my mind one day. I often collaborate with Peter Blake, taking photographs of his sitters for him to paint from. Spending time at his art studio, I grew to love the compact kitchen Peter has there. I am, by nature, a feeder, so the next time I visited, I made him something to eat and took a portrait of him to mark the occasion. Work stops, food is heated up and shared, and the talk takes on a different dimension as we lunch together. In these moments, great memories are created.

It struck me soon afterwards how much my two great loves, photography and food, have started to merge. I have hosted three series of my cooking show *Mary McCartney Serves It Up!* and Peter became the first of many wonderful sitters on the journey that became *Feeding Creativity.* I decided to take food to creative people I visited and see where the journey took me. The book not only neatly combines the two disciplines I know something about, but also provides a platform to show how delicious and easy meat-free cooking can be. So, an idea was born. This wasn't going to be a project that was ever really nailed down in terms of a schedule. I took my opportunities when they came along.

There is an organised chaos to this book, which I love. Artists tend to be quite spontaneous individuals and opportunities presented themselves that I needed to embrace, like having two hours to bake a cake and take it across town to Jeff Koons's stu-

dio in New York City, cooking a tart for David Hockney with a hangover from hell or getting stuck in the mud taking a veggie burger to Emily Eavis at the Pyramid Stage at Glastonbury. It made every journey an adventure, unpredictable and authentic. Each project put me on the spot. I had to react quickly to openings and invites, thinking of what I could make that would be delicious and appropriate for each creative. I had to think about how I would get the shot I wanted with a ticking clock and without a supporting crew, just me and my camera. In the end I realised that I actually thrive in chaos.

My approach to food photography generally may not be as spontaneous as that of my portrait photography, but in working on this project I learnt to enjoy the process on the food side of things too. There were, of course, some challenges, such as shooting the actor Martin Freeman on the hottest day of the year and watching the ice cream melt through the (clouded up) lens. But there were many triumphs, recipes that I will use forever and a long line of inspirational people who agreed to indulge me without judgement or an agenda. I am forever indebted to you all.

My mother, Linda, was a pioneer for animal rights and vegetarianism, at a time when it was not fashionable and when there were very few choices. She did the hard yards, which inspired us to carry the torch forward. Meat-Free Monday promotes the idea that having at least one plant-based day each week is an accessible and easy way to do something good for the planet, animals and our health. As an ambassador for MFM, I started writing recipes more methodically. My cookbooks and cooking show were my way of sharing new inspirational recipes with anyone who was interested. For this book, I have focused on creating each recipe as plant-based to show how quick, easy, delicious and accessible it can be. It's a way of eating that I lean towards more and more. If you are someone who is looking to reduce meat consumption, you can start gradually. Once you try it, I am sure you will find you really enjoy it. I hope to entice you to fall in love with this way of eating.

This book is about sharing the recipes I love to create. *Feeding Creativity* also debunks the myths that plant-based cooking takes longer, uses more ingredients and is more complicated. You are not missing out on anything by eating this way; you are just enjoying great-tasting food that is more environmentally conscious. The journey this book has taken me on has reminded me time and time again of the value of eating together.

BREAKFAST/BRUNCH

SHEET PAN PANCAKES **Cameron Diaz 12**
DELUXE HASH BROWN **Sheku Kanneh-Mason 16**
POACHED PLUMS TOASTED VANILLA PORRIDGE **Ruthie Rogers 20**
SKYWALKER RANCH BARS **George Lucas 26**
OVERNIGHT CHIA POT **Brian Clarke 30**
FEEL-GOOD SMOOTHIE **Stella McCartney, Gigi and Bella Hadid 34**
MUSHROOM, POLENTA, CAVOLO NERO **Stanley Tucci 48**

STARTERS/SIDES

GLOBE ARTICHOKES WITH TARRAGON DIJON DRESSING **HAIM 44**
HARISSA BBQ PULLED JACKFRUIT **Celeste 48**
CHILLI SWEETCORN FRITTERS **Olivia Harrison 52**
CRISPY COATED MUSHROOMS WITH GREEN DIP **Merlin and Cosmo Sheldrake 56**
BLOODY MARY DIP WITH SKEWERS **Kathleen Kennedy and Lisa Eisner 60**
BEET AND CARROT BLINI BITES **Yoav Levanon 64**
BAKED CRISPY CAULI SWEET AND SOUR **Milla Jovovich and Ever Anderson 68**
ROASTED BUTTERBEANS AND CHERRY TOMATOES **Anoushka Shankar 72**

BAKED TEMPURA FRIES **Jess Glynne 76**
SELECTION OF SIDES (BROCCOLINI WITH ROMESCO SAUCE, HARISSA
CARROTS, CHARRED CABBAGE WITH CITRUS TAHINI) **Sumayya Vally 80**

SOUPS/SANDWICHES/SALADS

REVIVING CHILLI, LEMON, GINGER SOUP **Michelle Yeoh 88**
LEEK AND SWEET POTATO SOUP **Cindy Sherman 92**
CREAM OF TOMATO SOUP **Cate Blanchett 96**
ROASTED TOASTED SALAD **Nile Rodgers 100**
PLANT CAESAR SALAD **Jay Brown 104**
CHICKPEA "TUNA" SALAD SANDWICH **Elvis Costello 108**
PBLT SANDWICH **Gilbert & George 112**

MAINS

SMOKED TOFU PAD THAI **Simone Ashley 120**
BLACK LENTIL SWEET POTATO COCONUT CURRY **Peter Blake 124**
CREAMY GREEN PASTA **Dad and Ringo 130**
PARTY PIE WITH SCOTCH BONNET HOT SAUCE **Edward Enninful 134**
MODERN SHEPHERD'S PIE **Chrissie Hynde and Johnny Marr 138**
SMOKEY BLACK-EYED BEAN STEW **Beth Ditto 142**
LOADED CORN TORTILLA **Jake Chapman 146**
SMOKEY DOGS **Woody Harrelson 150**
ALE STEW WITH HERB DUMPLINGS **Ted Green and Jill Butler 154**
LOADED DOUBLE BEAN BURGERS **Emily Eavis 158**
STICKY CASHEW TOFU AND GINGER RICE **Theresa Lola 164**
SESAME TOFU AND TERIYAKI NOODLES **Marc Quinn 168**
MUSHROOM STEAK, BEURRE-LESS BLANC AND FRIES **Jamie Dornan 172**
SPEEDY VEGGIE BOLOGNESE **David Oyelowo and Family 176**
RED ONION, PEA AND SPINACH TART **David Hockney 180**

BAKING/DESSERTS

ICED SPICED BANANA CAKE **Rose Wylie 188**
JEWELLED CHOCOLATE BARK **John Williams 194**
RAINBOW SPRINKLES CAKE **Jeff Koons 198**
STICKY BLACK RICE AND MANGO **Tracey Emin 202**
GRILLED PINEAPPLE, RUM SAUCE AND ICE CREAM **Martin Freeman 208**
BANOFFEE CHEESECAKE **Francesca Hayward 212**
TOWERING BERRY TRIFLE **David and Catherine Bailey 216**
NO COOK CHOCOLATE RASPBERRY TART **Steve Buscemi 220**
PEANUT, PRETZEL, CHOCOLATE COOKIES **George Condo 224**
FROZEN COCONUT KEY LIME PIE **Samantha Morton 230**
CHERRY CLAFOUTIS **Daniel Silver 234**
MAPLE VODKA PEACHES **Camilla Fayed 240**
PECAN BROWNIES **Sharleen Spiteri 246**
CHOCOLATE ORANGEY COOKIES **Drew Barrymore 250**
GLAZED BAKED DOUGHNUTS **Mark Rylance 254**
SHORTCUT APPLE TART **Judi Dench 258**
CITRUS SYRUP POLENTA CAKE **Ed Ruscha 262**

CAMERON DIAZ

Breakfast, Brunch

SHEET PAN PANCAKES

Home, Los Angeles

Cameron really appreciates food. On the occasions we get to meet up, food and drink usually play a big part. When she and her sister-in-law Nicole Richie were guests on my cooking show, I made them brunch and Cameron supplied her Avaline Rosé, from organic vineyards. Nicole was liberal in her pouring, and it went down a little too easily. We were having such a laugh that for a moment I forgot the cameras were even there.

I was in LA with my sister Stella and our family, so we planned a brunch at Cameron's place — all of us, the more the merrier. We have a mutual love of family gatherings; I had the perfect recipe for such an occasion. Heading out to her place I grabbed all the ingredients for my Sheet Pan Pancakes: the batter, berries and maple syrup. As a fellow Virgo, I knew that Cameron was a perfectionist and her kitchen was going to be organised and well-equipped. I was right; it even gave Stanley Tucci's kitchen a run for its money!

These pancakes were ridiculously quick to prepare, with no need to stand by the cooker flipping and flipping each one individually. Rather, I poured the batter into the sheet pan and popped them straight into the oven. Then Cameron, Stella and I had a great chance to catch up, with Cameron's brilliant sense of humour brightening up our day. We got so lost in conversation that I burnt the first batch! Second time around Cameron did the honours, getting the pancakes out, slicing and stacking, ready for the clan to get tucked in. The oozy blueberries popping with flavour, a hint of banana and cinnamon, finished off with a drizzle of maple syrup. Always a winner.

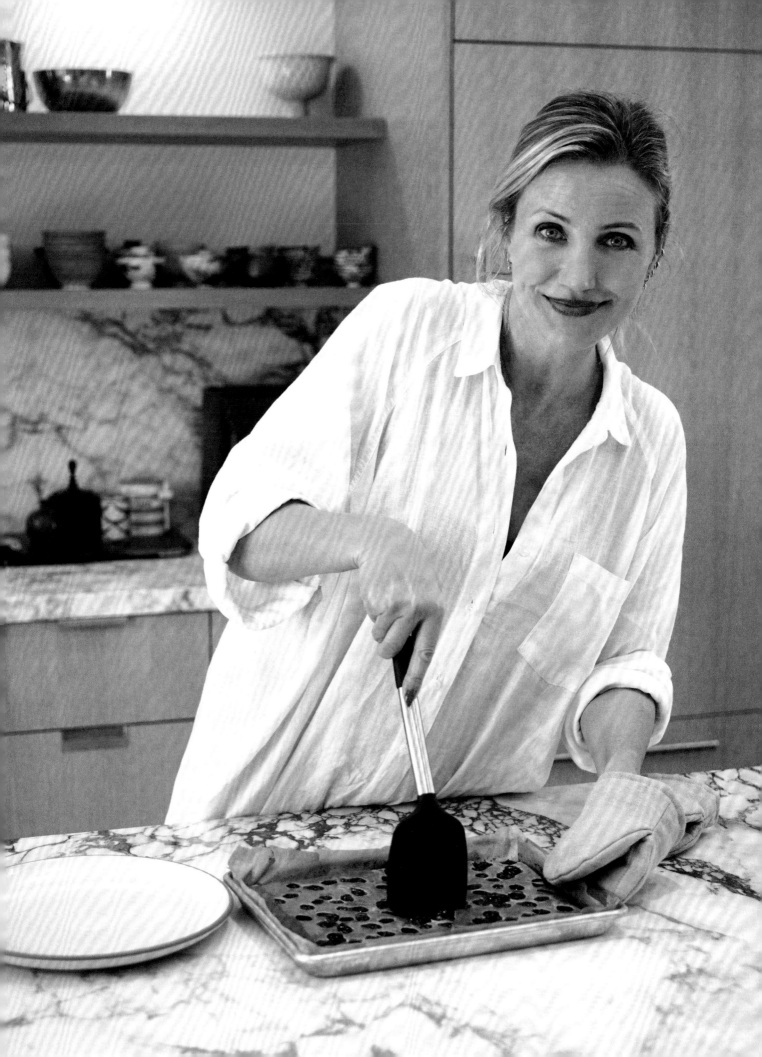

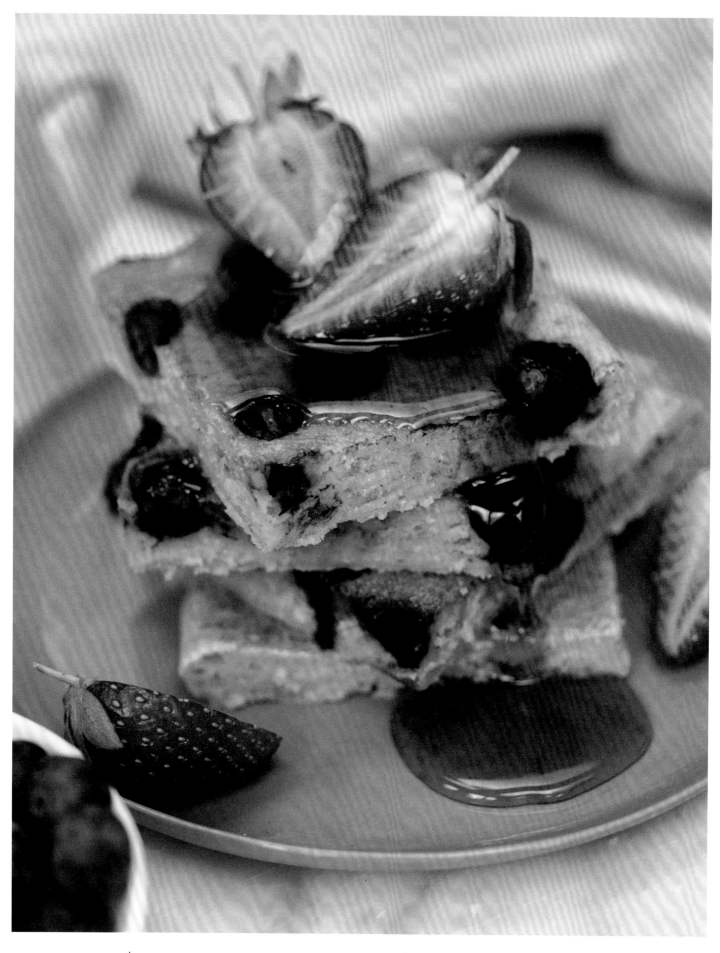

Whisk together the pancake batter, pour into the
sheet pan, sprinkle with blueberries – then get it into
the oven to do the cooking.

14

SHEET PAN PANCAKES

Ingredients

Olive oil, for greasing the baking sheet

Batter
2 medium-sized ripe bananas, peeled
750 ml (3 cups plus 2 tablespoons) unsweetened
 plant-based milk
3 tablespoons apple cider vinegar
2 tablespoons olive oil
2 tablespoons vanilla extract
360 g (3 cups) plain (all-purpose) flour
4 teaspoons baking powder
1 teaspoon sea salt
1 tablespoon ground cinnamon

Topping
150 g (5 oz) fresh blueberries
2 tablespoons coconut sugar (or soft brown sugar)

To serve
Maple syrup
Handful of fresh berries (I use strawberries)
Vegan whipped spray cream (optional)

Method
Preheat the oven to 200°C/400°F.

Line a 30 × 40 cm (12 × 16 in.) baking sheet with lightly oiled parchment paper to prevent the pancake from sticking to the tray as it cooks.

Batter
Put the ripe bananas in a medium mixing bowl and mash well using a fork. Stir in the milk, vinegar, olive oil and vanilla extract.

In a separate larger mixing bowl, combine the flour, baking powder, sea salt and cinnamon. Form a well in the middle of the dry ingredients, and then, mixing constantly (to ensure a smooth batter), gradually pour the wet ingredients into the dry mixture. Whisk together well.

Pour the pancake batter into the prepared baking sheet and smooth evenly to the edges.

Topping
Scatter the blueberries over the batter and sprinkle the sugar evenly over the top. Bake for 30 minutes until golden brown and springy to the touch. Leave to rest for a couple of minutes for ease of cutting.

To serve
Cut into 12 rectangles and plate 3 pieces per person, drizzle with maple syrup, place berries on the side and add a swirl of cream (if using).

SHEKU KANNEH-MASON

Breakfast, Brunch

DELUXE HASH BROWN

Home, London

I first came across Sheku when I was researching the 90-year history of Abbey Road Studios for my documentary. The renowned composer Edward Elgar opened the studios in 1931. His cello concerto, hailed by many as the finest classical composition of the 20th century, was brought to life, for me, by the Jacqueline du Pré 1965 recording made at the studios. So who better to interview, to bring the story full circle, than Sheku, the gifted cellist whose powerful Abbey Road recording of the same concerto had the same impactful effect on me?

We met at Abbey Road, in Studio 1, a space so large it can comfortably accommodate a large symphony orchestra. When I handed Sheku the original recording schedule for the Jacqueline du Pré sessions, I could see he was visibly moved. As a child he had often heard her performance in his parents' car, and it was a huge influence on his wish to play the cello himself. Sheku was soft-spoken and reflective when answering my questions. He had brought his cello with him, so, before we parted company, I asked if he would mind playing a part of the Elgar concerto. He agreed, and those familiar notes made me want to smile and cry at the same time. His playing was so passionate, sensitive and real.

I had made Sheku my Deluxe Hash Brown, something nourishing and layered with flavours. We met at his home, and ate together in his living room. In addition to the usual living room furniture, there were his cello, cello cases and, above the mantelpiece, images of those who had inspired him—Bob Marley, Tupac and Millie Jackson. He really appreciated the home-cooked food. When we were finished, I left Sheku to prepare for his upcoming concert, including his own Bach arrangements. Such a brilliant, creative and gentle soul. A rising musical superstar—watch this space.

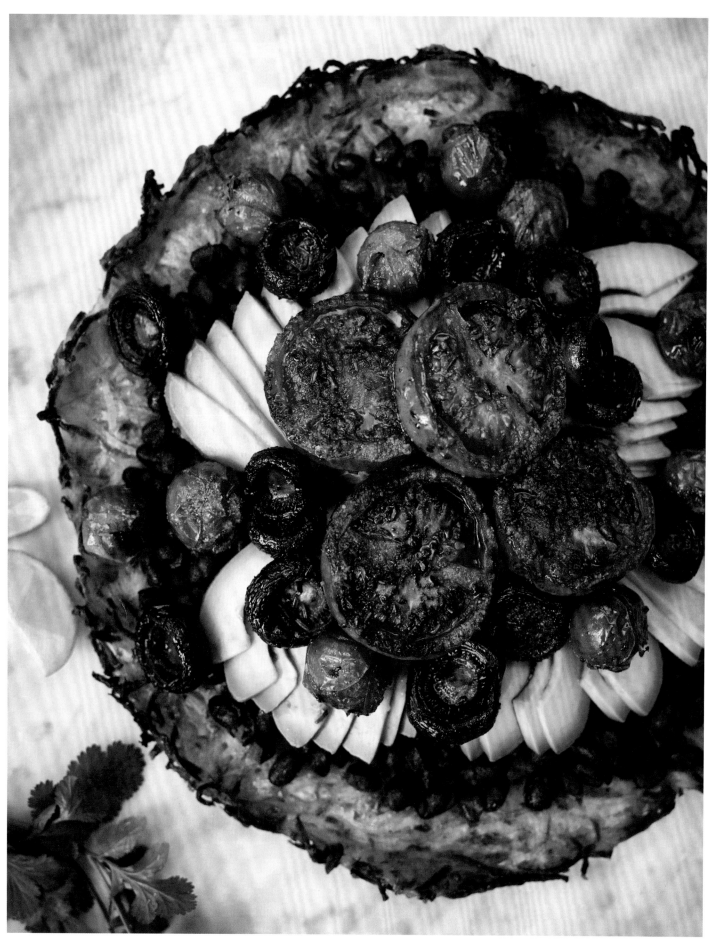

18 Crisp hash brown base topped with layers of protein rich black beans, juicy tomatoes, mushrooms, avocado with a scatter of spring onions and coriander.

DELUXE HASH BROWN

Ingredients

Hash Brown
1kg (2.2lb) waxy potatoes, scrubbed clean
3 tablespoons olive oil
1 tablespoon sea salt

Roasted Mushrooms and Tomatoes
2 large ripe tomatoes, cut in half
200g (7oz) button (closed cup) mushrooms,
 cleaned and stalks trimmed
2 tablespoons olive oil or vegetable oil
2 tablespoons soy sauce (or tamari for gluten-free)
1 tablespoon Worcestershire sauce (vegan)
1 teaspoon garlic powder
1 tablespoon fresh thyme leaves, finely chopped,
 or 1 teaspoon dried thyme
½ tablespoon fresh rosemary, finely chopped,
 or 1 teaspoon dried mixed herbs

Cumin Spiced Beans
1 tablespoon olive oil
1 × 400g (14oz) can of black beans, drained
 and rinsed
½ teaspoon ground cumin

To serve
1 ripe avocado, cut in half, stone removed,
 flesh scooped out of skin
Juice of ½ a lime
Pinch of sea salt
2 spring onions (scallions), green and white parts
 thinly sliced (optional)
Handful of parsley or coriander (cilantro), chopped

Method

Hash Brown
Grate the potatoes or use a food processor with a grater blade. Place the grated potato into a colander and rinse under cold water to wash away the starch. Shake dry and lay onto a clean kitchen towel and roll up tight to squeeze out the excess water (to ensure they crisp up when cooking).

Heat 3 tablespoons of oil in a 30cm (12in.) large skillet or frying pan on a medium-high heat. Scatter the grated potato evenly onto the base of the pan and sprinkle over the sea salt. Use a spatula to push the potato firmly and evenly down into the base of the pan. Leave the potatoes to cook undisturbed for 10–15 minutes or until brown and crispy on the bottom.

Roasted Mushrooms and Tomatoes
Preheat the grill (broiler) to medium-high. Place the tomato halves and mushrooms on a baking tray with the cut side facing up. Drizzle over the olive oil, soy sauce and Worcestershire sauce. Sprinkle over the garlic powder and chopped herbs and place under the grill. Cook for 8–12 minutes until the vegetables release their juice.

Cumin Spiced Beans
In the meantime, heat 1 tablespoon of olive oil in a small saucepan over medium heat. Add the drained and rinsed black beans, sprinkle over the cumin and stir-fry for 2–3 minutes.

Remove the cooked mushrooms and tomatoes from under the grill and place them on the bottom shelf of the oven (to stop them from overcooking but to keep them warm until the hash brown is ready).

Now place the skillet under the grill to brown the top of the hash brown for about 5 minutes until golden and crispy on top.

Once the hash brown is cooked, remove from the grill (remember the handle will be hot, so use an oven glove!) and remove the tomatoes and mushrooms from the oven.

To assemble
Slide the hash brown onto a chopping board. Layer on the black beans and sliced avocado, seasoned with lime and sea salt, then add the mushrooms and tomatoes, sliced spring onions and parsley or coriander.

19

RUTHIE ROGERS

Breakfast, Brunch

POACHED PLUMS TOASTED VANILLA PORRIDGE

Home, London

This morning I was taking breakfast to Ruthie Rogers, the co-founder and owner of London's iconic River Cafe restaurant. I have been eating at her place for so long, but now it was my turn to feed her. She is such an accomplished chef, so I must admit I was a little out of my comfort zone. Best to keep it simple then. Ruthie greeted me with a hug, warm and welcoming as ever, the sun streaming through the windows of her double-height kitchen. We had a quick espresso together, and then, as I started preparing breakfast, Ruthie set the table ready for me to photograph the food. Her preference was spoon on the side, so it wouldn't distract from the recipe.

It was a joy to be cooking in Ruthie's kitchen, with her signature steel worktops, professional pans and the pop of colour from her fluorescent-handled knives. As the deep red plums poached, I toasted the almonds and pumpkin seeds, and made the vanilla porridge, marvelling at what a beautiful-looking bowl of breakfast it was. I was surprised when Ruthie admitted she didn't usually eat porridge, but I needn't have worried, as her bowl was soon wiped clean. As she is always cooking for others, it felt good to be cooking for her for a change, to allow her to relax. And, as I usually see her in the hustle and bustle of the River Cafe, it was a pleasure to chat and catch up in the calm of her beautiful home.

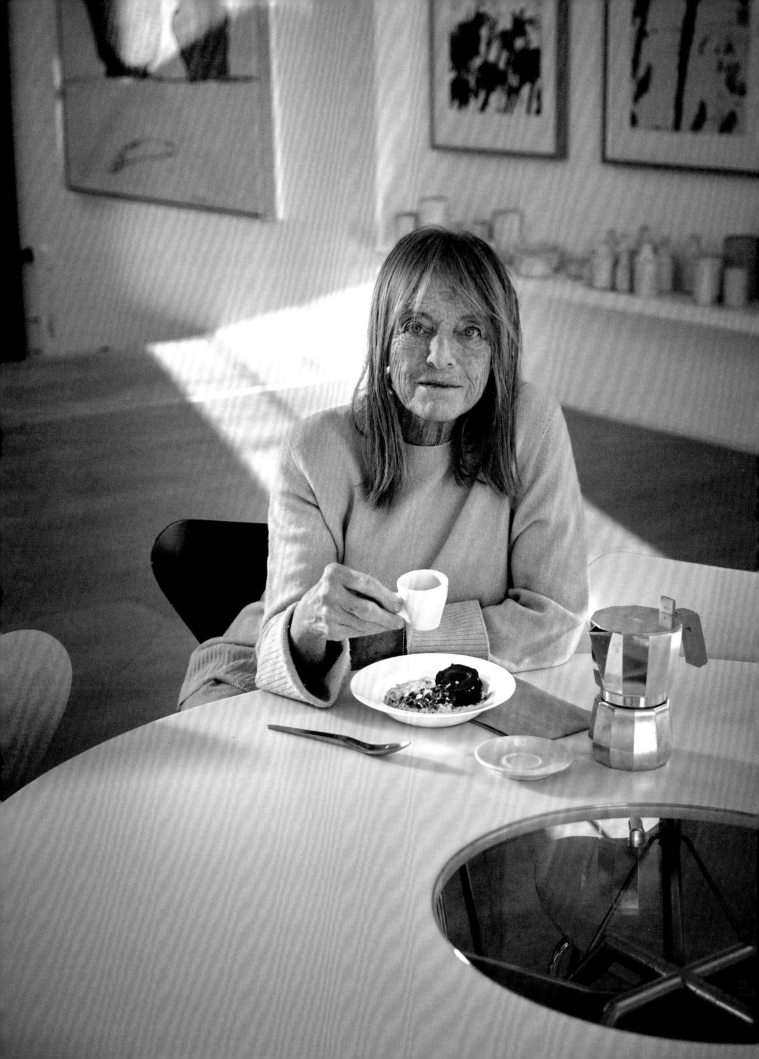

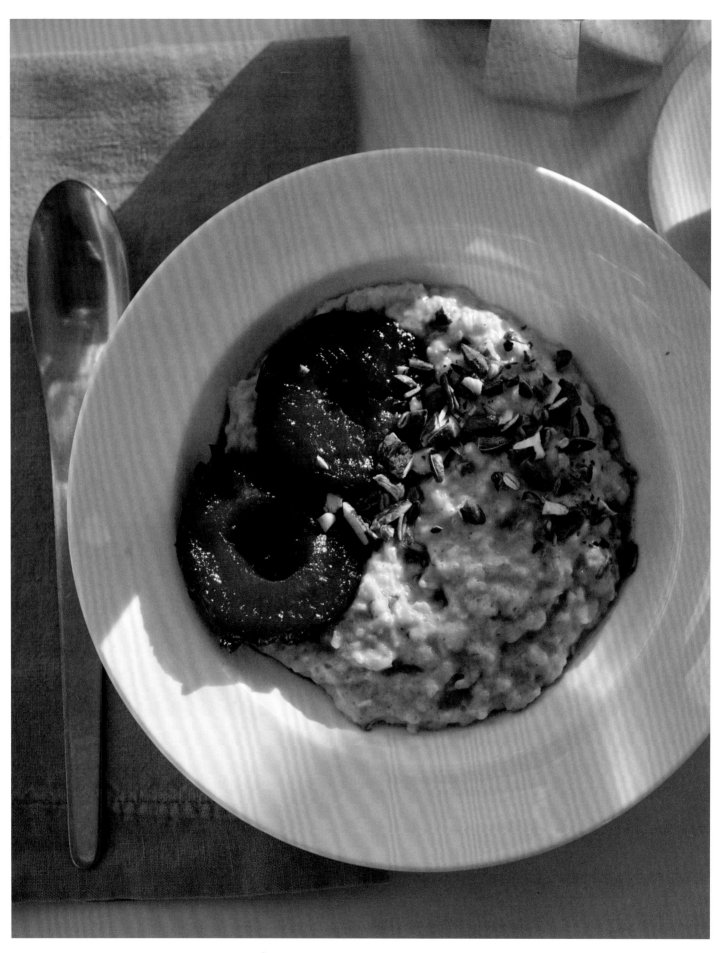

Sweet poached plums and vanilla-flavoured creamy porridge, topped with toasted almonds and pumpkin seeds. Ready to fuel your day!

POACHED PLUMS TOASTED VANILLA PORRIDGE

Ingredients

Toasted Topping
2 tablespoons almonds, roughly chopped
2 tablespoons pumpkin seeds, roughly chopped

Poached Plums
Juice of 1–2 oranges
2 ripe red plums, halved and stones removed
1 tablespoon maple syrup

Vanilla Porridge
85g (1 cup) porridge (rolled) oats
 (gluten-free, optional)
480g (2 cups) unsweetened plant-based milk
 (I use cashew)
1 tablespoon vanilla extract
½ teaspoon sea salt

To serve
Maple syrup, to drizzle

Method

Toasted Topping
Toast the chopped almonds and pumpkin seeds in a small frying pan over medium heat for about 4 minutes until they start to brown, shaking the pan so they don't burn. Transfer to a bowl and wipe the pan clean.

Poached Plums
Using the same pan, warm the orange juice (you want enough orange juice to cover the bottom of the pan, 1cm (⅓in.) deep). Place the plums in the orange juice, cut side up, and bring to a gentle simmer. Drizzle the maple syrup into the well of each plum and cook for 3 minutes. Turn the plums over and simmer gently, poaching for another 3–4 minutes until they are just cooked through but still holding their shape.

Vanilla Porridge
Place the oats and milk in a small/medium saucepan. Stir in the vanilla extract and the sea salt. Simmer gently on a medium heat for about 5 minutes, stirring often, until the porridge is thick and creamy (check the packet for cooking time). Stir in half of the toasted nut and seed mix, reserving the other half for serving.

To serve
Divide the porridge between two breakfast bowls. Lay the plums on top, sprinkle over the remaining toasted mix and add a little drizzle of maple syrup to finish.

GEORGE LUCAS

Breakfast, Brunch

SKYWALKER RANCH BARS

Skywalker Ranch, California

I was in California to interview George Lucas about the 90-year history of Abbey Road Studios, which was where he and the legendary composer John Williams had recorded the scores for the *Star Wars* and *Indiana Jones* movies. The morning of, the prospect of directing one of the greatest filmmakers of all-time hit me as a daunting prospect. I was staying in a nearby hotel but managed to persuade the staff to let me use the kitchen to make George a quick batch of my granola bars. I then sped towards his house at Skywalker Ranch, north of San Francisco, where we would be filming that day. When *Star Wars* was made back in the 1970s, there were no special effects houses in existence, so George Lucas started his own. The rest is history.

Skywalker Ranch is very high-tech. In contrast, we sat in his pool house, which is a wonderfully nostalgic nod to the 1950s, with a Wurlitzer jukebox, floral fabric cosy armchair, flagstone chimney breast and fireplace. All very relaxed, and George made me feel welcome. He was in a chipper mood, and in between bites, our conversation flitted between anecdotes about John Williams ("Johnny" to him) — he said they chose to record in London at Abbey Road because it had the space they required and the best orchestras, which kept them coming back, saying, *"It's about the people"* — and how he had just binge-watched Peter Jackson's epic documentary series *The Beatles: Get Back*. But today he seemed most excited about his latest passion project, the Lucas Museum of Narrative Art in Los Angeles, dedicated to all forms of visual storytelling, from painting, sculpture and photography to cinema, advertising and video installations. As a photographer and filmmaker I found it fascinating. George walked me through his project, characteristically enthralling, impressive and effusive. I needn't have been nervous after all. Instead, I left feeling inspired.

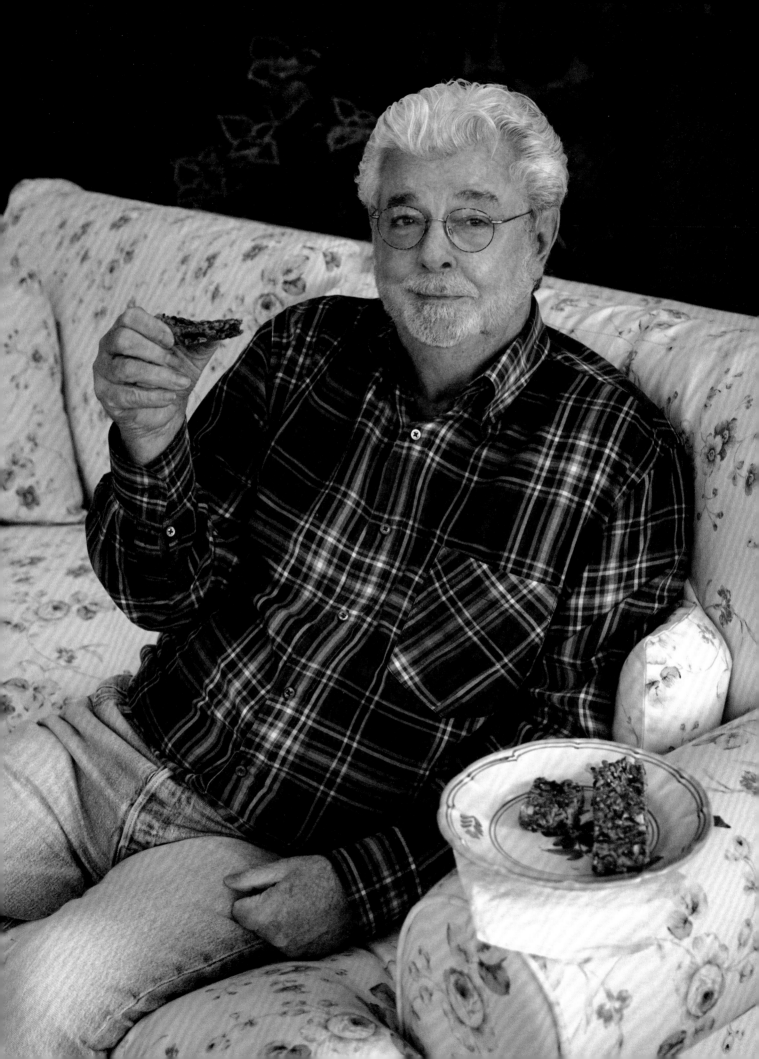

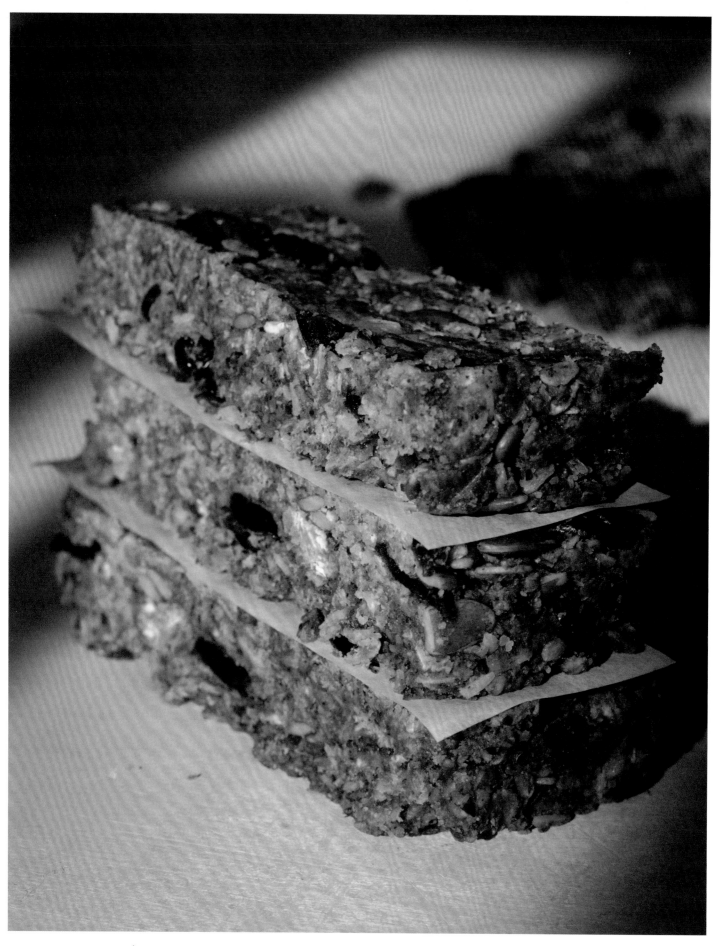

No bake and speedy to make. For any time, anywhere.
Packed with energy boosting ingredients and the flavours
of almond, cinnamon, and cranberry.

28

SKYWALKER RANCH BARS

Ingredients

80 g (⅓ cup) almond butter
4 tablespoons maple syrup
4 tablespoons freshly squeezed orange juice
130 g (1½ cups) porridge (rolled) oats
(gluten-free optional)
3 tablespoons milled flaxseeds
½ teaspoon ground cinnamon
Zest of ½ an orange
3 tablespoons pumpkin seeds
3 tablespoons dried cranberries

Method

Line a 20 × 20cm (8 × 8 in.) square baking tin with parchment paper.

Measure the almond butter, maple syrup and orange juice into a medium saucepan. Place over a medium-low heat and stir well to combine and form a thick, smooth paste, then remove from the heat.

Stir in the oats, flaxseeds, cinnamon, orange zest, pumpkin seeds and cranberries and mix firmly until it forms a stiff dough, ensuring all the oats are well coated. You can use clean hands to bring the mixture together if you like.

Tip the mixture into the lined tin and press it down to form an even layer, using clean hands or a metal spoon (the oats will stick to a wooden spoon).

Place in the fridge to chill for about 1 hour or until ready to eat.

To serve
Once cool, cut into 12 pieces by cutting 3 slices down one side and 2 across the other.

BRIAN CLARKE

Breakfast, Brunch

OVERNIGHT CHIA POT

Home, London

Brian Clarke has been in my life for as long as I can remember, a close friend of my parents and now a close friend to me. Brian creates the most incredible large-scale stained glass artworks—their colour and design exude pure joy. I love his creativity and the way he talks about art. He is a total inspiration.

I brought him breakfast on a sunny morning in May and found him in his garden courtyard perusing art books. I left him reading outside as I went to the kitchen to add the fruit and nut topping to the coconut chia seed pudding I had made. There was an array of artworks in progress. Intricate prototype stained glass pieces in the hallway, bright paper cut-out collages of flowers and nature, and exquisite watercolours of red poppies. The poppy series is particularly personal to me, as Brian would reminisce about the day my moth-er decided to scatter her jar of poppy seeds (from her herb rack, I might add!) as her experiment to see if they would grow flowers. To everyone's surprise, including Brian's, they did. Now, he can't think of a poppy with-out remembering her, so his poppy paintings are qui-etly dedicated to her.

We moved inside and I handed him his breakfast pot, which he peered at inquisitively, particularly the chia seeds. In his wonderful Oldham accent, and with a brilliant sense of humour, he enquired, *"What's this frog spawn stuff?"* Poking it with his spoon, he en-gaged cautiously, as it wasn't something he had eaten before. One taste, and that beautiful, beaming grin came over his face, as he exclaimed he found it fresh and clean, and would be happy to eat it every morning. I gave him the jars and the recipe, pleased I had a new convert.

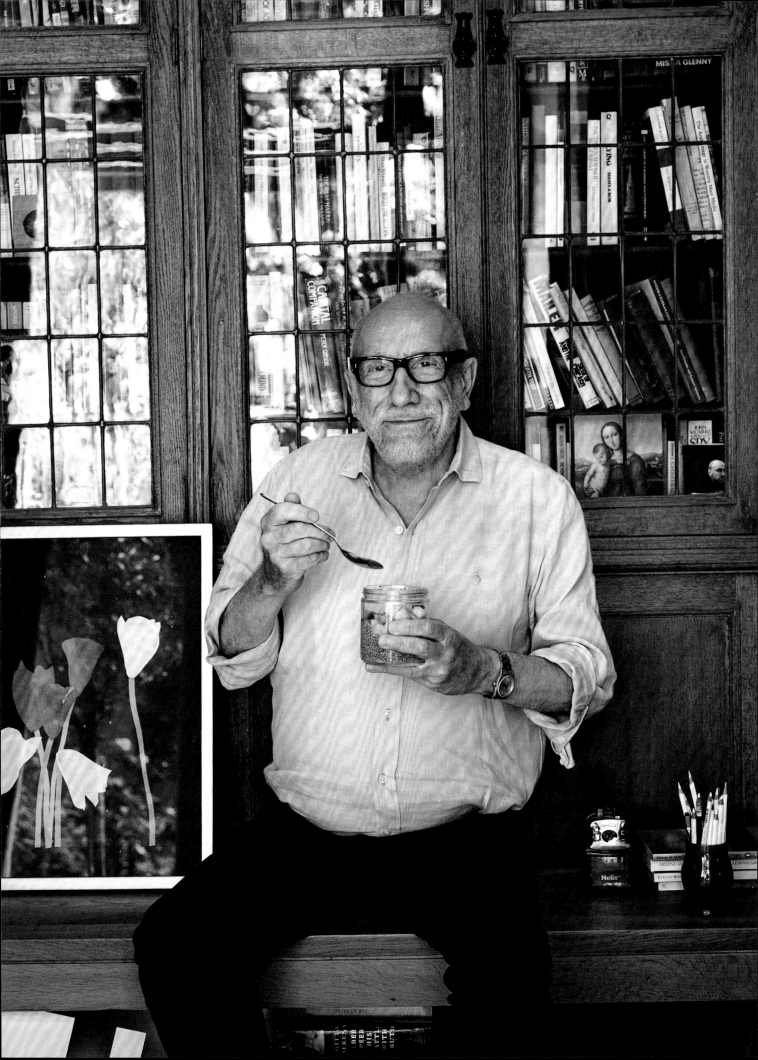

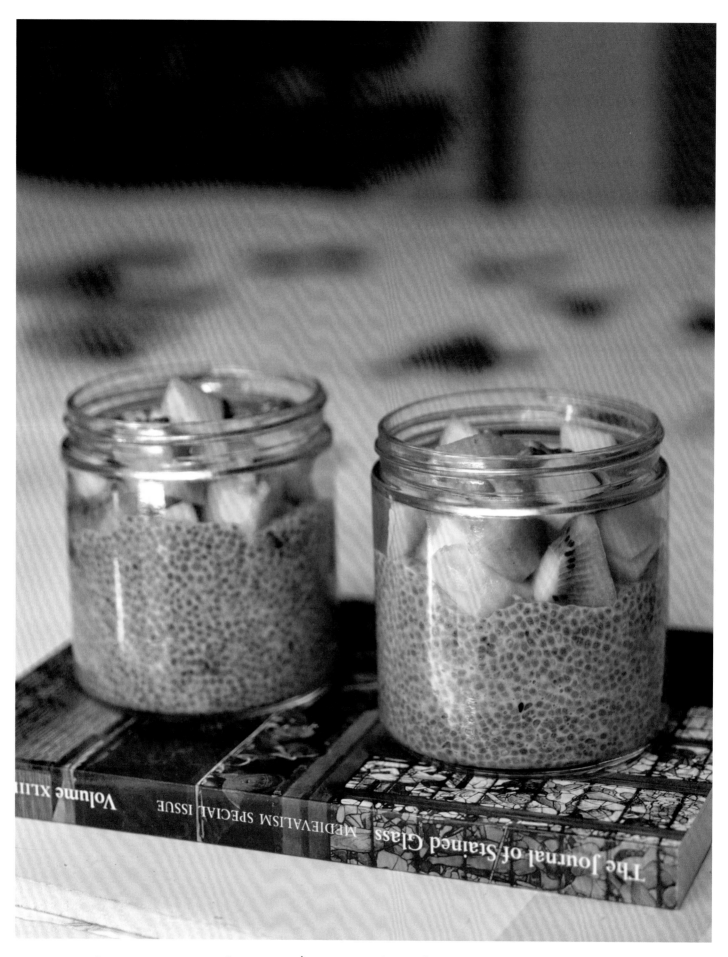

Convenient and versatile. Simply mix the pudding ingredients together and pop into the fridge overnight. By the morning it will have transformed into a superfood pudding.

OVERNIGHT CHIA POT

Ingredients

3 tablespoons chia seeds
200 ml (7 fl. oz) coconut milk drink (carton, not can)
1 tablespoon maple syrup
1 teaspoon vanilla extract
1 tablespoon pumpkin seeds

To serve

Chopped fruit of your choice (e.g. kiwi, mango, pear,
 strawberries, blueberries)
4 walnuts broken into small pieces (optional)

Method

You will need a 350 ml (12 fl. oz) container with a lid.

Spoon the chia seeds into the jar and mix in the coconut milk. Add the maple syrup, vanilla extract and pumpkin seeds and stir well. Put on the lid and leave to chill in the fridge. Stir with a fork after an hour or so to ensure the chia seeds and coconut milk have combined well for a smooth pudding. Chill overnight or for up to 3 days.

When ready to eat, chop up the fresh fruit and lay it on top of the chia pudding (it should have a nice jelly pudding consistency by the morning). Top with some chopped walnuts, if using.

STELLA McCARTNEY, GIGI AND BELLA HADID

Breakfast, Brunch

FEEL-GOOD SMOOTHIE

Centre Pompidou, Paris

My little sister, Stella, and I are best friends. We are just two years apart in age, and have grown up side by side, keeping each other entertained along the way. She is one of the funniest people around. I understand how high-pressure her fashion shows can be for her, so as her big sister, I feel protective towards her. Whenever I can, I tag along with Stella to give her some love and moral support. So on the morning of her show, we left the hotel at 7 am to travel together to the venue.

One of my earliest childhood memories is of Stella and me hiding out in our mum's wardrobe, trying on her 1970s gold platform boots and high heels. For as long as I can remember, Stella was always interested in fashion. She too inherited the family drive for animal welfare and has spearheaded cruelty-free initia-

tives and kinder ways to run a fashion business. I'm super proud of her.

To brighten up her morning I made her this fruit smoothie, something she could carry around with her and sip as she checked the clothes and the models backstage and watched the show run-through to check the catwalk and the music. Something portable to nourish her. Wandering with smoothie in hand, this lovely, spontaneous moment happened where us four sisters gravitated together for my photo. In a playful mood, Stella said: "Let's do a picture for my sister Mary." Bella and Gigi Hadid were up for it. Funny to think a few minutes later they were walking down the catwalk in the Pompidou, and I was in the front row, watching the whole spectacle unfold.

34

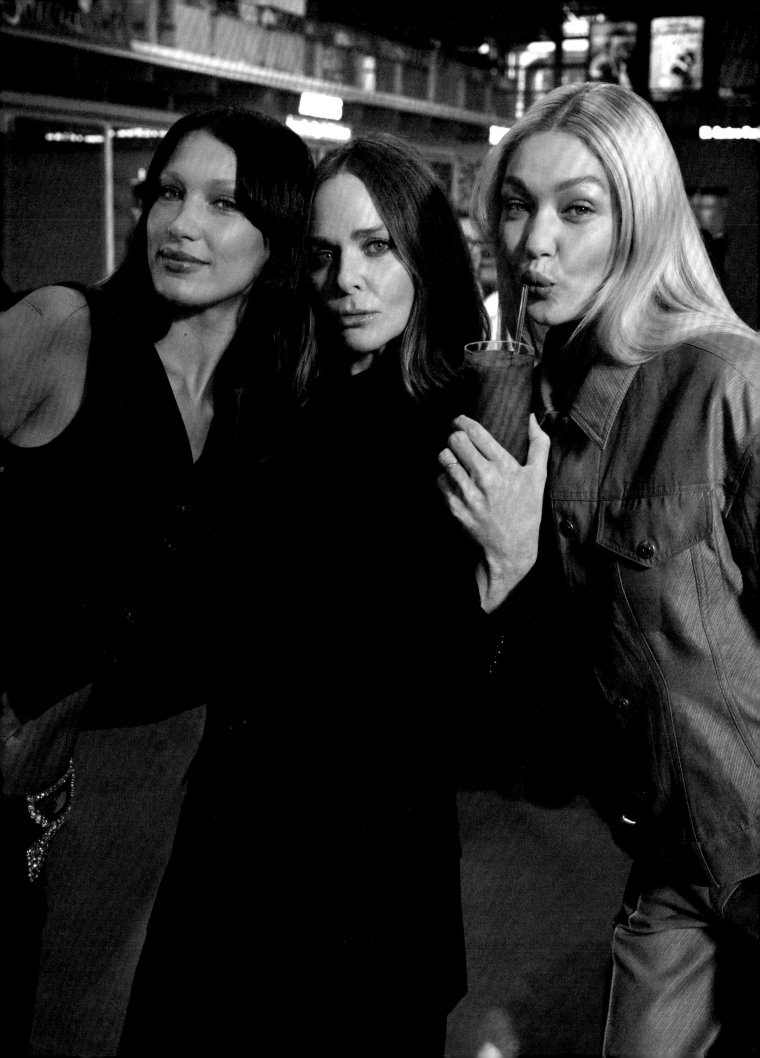

A vibrant start to the day within a few short minutes!
Accessible all year round, as frozen berries hold their nutrients
and keep this smoothie nice and chilled.

FEEL-GOOD SMOOTHIE

Ingredients

100 g (3½ oz) frozen mixed berries
1 ripe banana, peeled
1 tablespoon milled hemp seeds
1 tablespoon milled flaxseeds
1 tablespoon sesame seeds
1 tablespoon pumpkin seeds
240 ml (1 cup) unsweetened plant-based milk

Method

Add all the ingredients into a blender and blitz for about 30 seconds, until smooth. Alternatively, blend in a jug with a handheld stick blender.

To serve
Pour into a glass to serve.

STANLEY TUCCI

Breakfast, Brunch

MUSHROOM, POLENTA, CAVOLO NERO

Home, London

My mind boggled about what to make for Stanley Tucci when he agreed to be in this book. He is known for his deep love of Italian gastronomy, and his award-winning TV show *Searching for Italy* is a love letter to Italian food. In short, Stanley loves food and is something of an expert. I wanted to impress him with something simple and comforting. We planned to meet at 11 am at his home—brunch time. I was still overthinking it, so I rummaged through my kitchen cupboards for inspiration, devising a recipe in my mind as I went along. I had the ingredients for polenta infused with fresh herbs, served with earthy, meaty-textured mushrooms and cavolo nero, all lifted with fresh lemon. Decision made.

It was a sunny morning in London as I headed over to his home with my bag of ingredients and my camera. When he opened the door, I could see his sense of

relief that I hadn't turned up with a whole film crew to document the occasion. He opened a beautiful bottle of chilled Gavi, and we set about cooking together. I looked around his kitchen for a saucepan and frying pan, and Stanley, of course, had all the best equipment. I made the herby polenta, while he got on with the sautéed mushrooms. We made a good team in the kitchen, gradually working our way through the wine.

Stanley was the perfect brunch companion. We became pals a few years ago when I took portraits of him for British *Vogue*. He has become that type of friend who, though I may not see him for months, it only takes a moment to be reunited. The best way to describe Stanley is as a raconteur. He always has the best stories and tells them so wonderfully, like you've been invited into the best secrets of all time. I left full of polenta and a new set of delicious anecdotes.

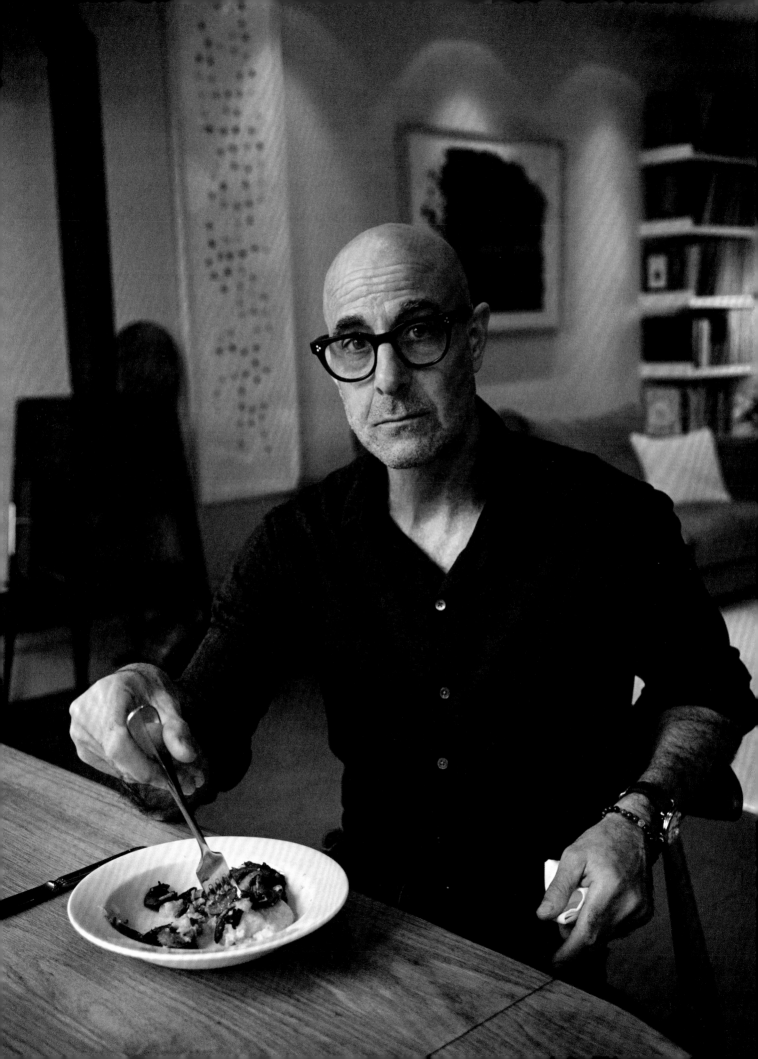

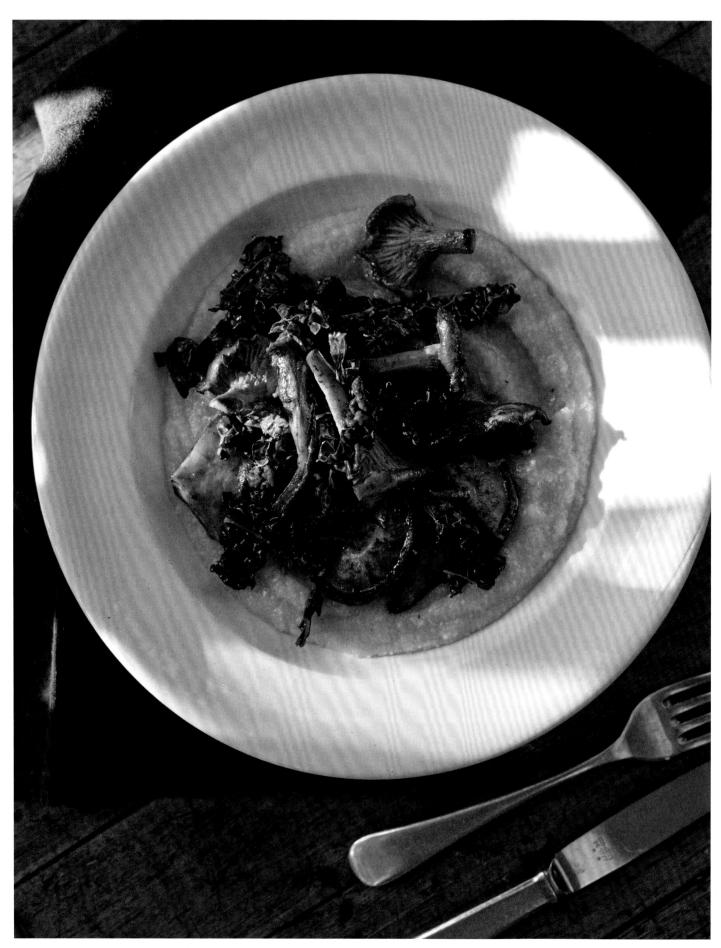

Pure comfort in a bowl: Creamy golden polenta topped with the
earthy tones of rice, mushrooms and cavolo nero. Lifted with a
touch of fresh thyme, balsamic and lemon zest.

MUSHROOM, POLENTA, CAVOLO NERO

Ingredients

Polenta
750 ml (3 cups plus 2 tablespoons) vegetable stock
1 bay leaf
1 tablespoon fresh thyme leaves, chopped
125g (¾ cup) polenta (not quick cook)
2 tablespoons B_{12} nutritional yeast flakes
2 tablespoons extra virgin olive oil
Freshly ground black pepper
Sea salt, to taste (optional—the stock may be
 salty enough)

Sautéed Vegetables
3 leaves cavolo nero or kale
1 tablespoon olive oil
2 garlic cloves, finely chopped
300g (10½oz) mixed mushrooms, brushed clean
 of any dirt and sliced (I use chanterelle, cremini
 and oyster mushrooms)
1 tablespoon thyme leaves
½ tablespoon balsamic vinegar
1 teaspoon Worcestershire sauce (vegan)
Zest of ½ lemon, plus more to serve

Method

Polenta
Heat the vegetable stock in a medium saucepan and
bring to a gentle simmer, add the bay leaf and thyme and
then stir in the polenta. Turn the heat down a little and stir
often, until it forms a porridge-like consistency, check-
ing the polenta packaging for recommended cooking
time. Once thickened, fish out the bay leaf and discard.
Then stir in the yeast flakes and olive oil for extra gloss
and flavour, and season to taste with salt and pepper.

Sautéed Vegetables
While the polenta is cooking, cut the woody spine
away from the cavolo nero. Blanch in boiling water
for 2 minutes, strain and slice thinly.

Heat the olive oil and garlic in a medium frying pan.
Add the sliced mushrooms and thyme and stir-fry for
1–2 minutes. Add the balsamic vinegar and Worces-
tershire sauce, and fry until the liquid released from
the mushrooms has nearly evaporated. Add the cavo-
lo nero to the pan and fry for 1 minute. Finally, stir in
the lemon zest.

To serve
Spoon the polenta onto the serving plates, and top
with the sautéed vegetables. Grate over a little more
lemon zest to finish.

STARTERS

SIDES

HAIM

Starters, Sides

GLOBE ARTICHOKES WITH TARRAGON DIJON DRESSING

Home, Los Angeles

I hadn't met the HAIM sisters before, so I was alarmed when I pressed their doorbell and felt an unusual breeze. On further inspection I realised I had somehow managed to get a huge, embarrassing rip down the back of my all-in-one, so my greeting to Alana (keyboard/vocals/guitar) consisted of "Hi, got any safety pins, please?", whilst simultaneously shuffling in so she didn't see my butt hanging out! Sisters Danielle (vocals/drums/guitar) and Este (bass/guitar/vocals) leapt to the rescue and my dignity was saved.

We found an immediate connection, as I am very close with my sisters too. Everyone says the HAIM sisters are brilliant company, and it was true. Effervescent, sharp and funny, their dynamism seemed to be more powerful as a collective. Este lit up when I revealed it was artichokes for lunch. It transpires she has a yearning to have an artichoke farm one day, with Monterey County, north of LA, being the self-proclaimed 'artichoke capital of the world'. But I sensed she had much more to achieve first. We ate on their sun-dappled deck, our chatter peppered with appreciation for the artichokes and my distinctive dressing. Despite their wonderful hospitality, Alana confessed to having such a fear of giving guests food poisoning that she calls them the next day to check they're OK. As I left, after a wonderful afternoon in the Californian sun, we planned to meet again when HAIM were next playing in London.

44

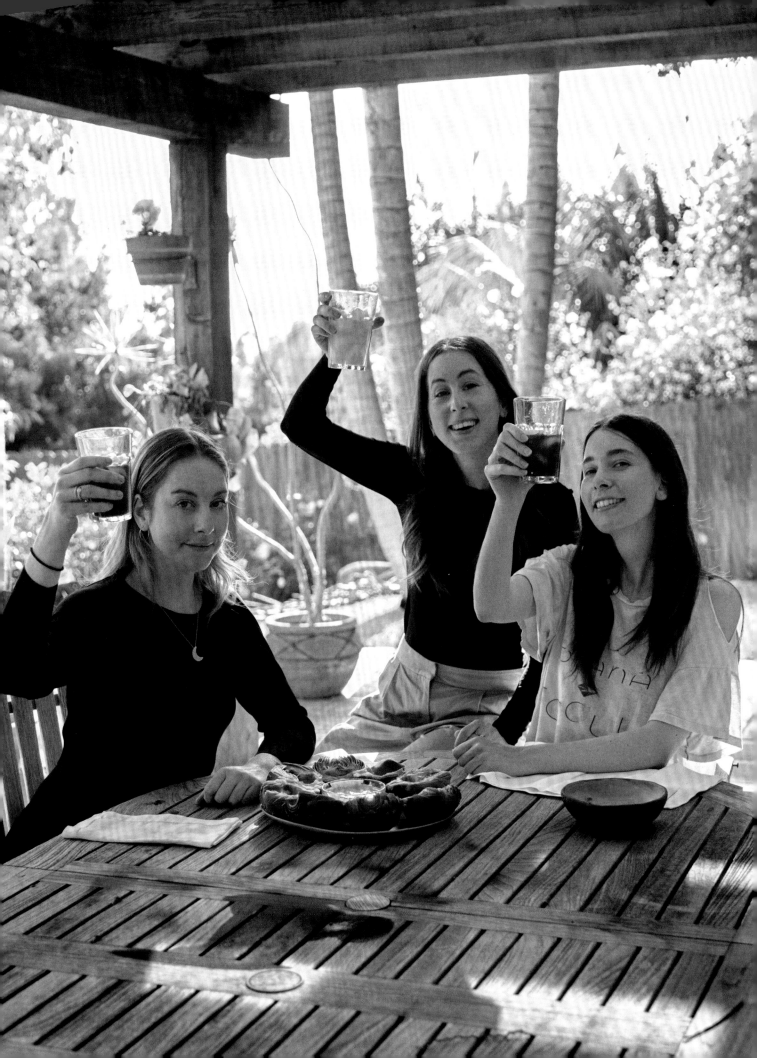

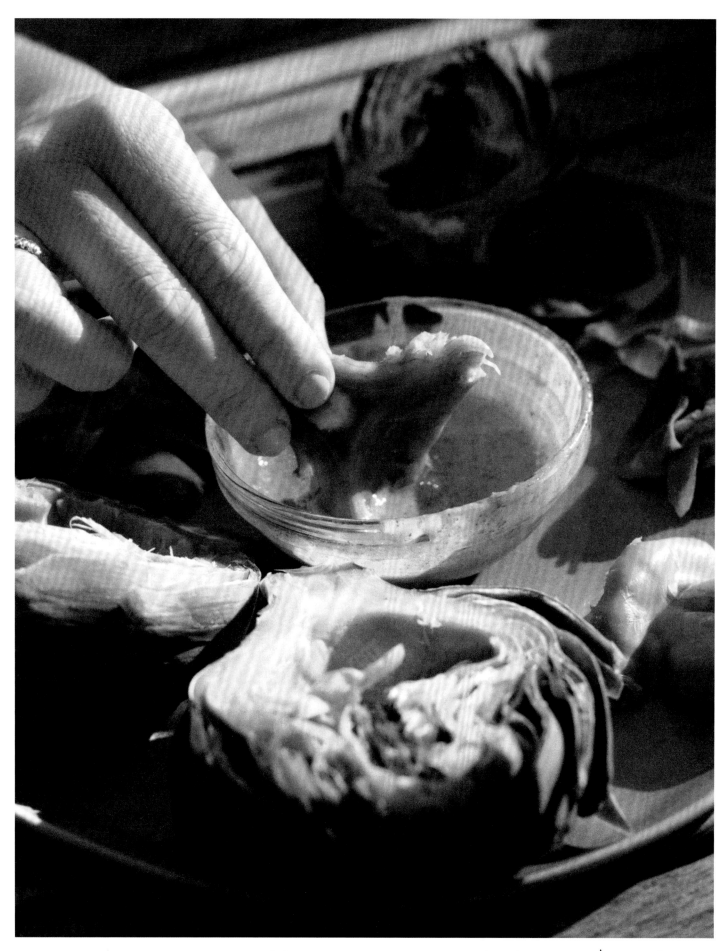

Majestic poached globe artichokes, perfectly designed by nature for dipping in this tangy tarragon and Dijon mustard dressing. Perfect sharing food!

GLOBE ARTICHOKES WITH TARRAGON DIJON DRESSING

Ingredients

Artichokes
4 globe artichokes (about 400 g/14 oz each)
Pinch of sea salt
½ lemon, cut into wedges

Dressing
2 tablespoons Dijon mustard
1 tablespoon freshly squeezed lemon juice
4 tablespoons white wine vinegar
3 tablespoons tarragon leaves
1 teaspoon maple syrup
Pinch of sea salt
120 ml (½ cup) extra virgin olive oil

Method

Artichokes
Cut the stem of the artichoke off, leaving 1 cm (½ in.) at the base of the globe. Peel away any little tough leaves to neaten around the stalk end. Cut 1 cm (½ in.) off the pointy end of the leaves using a bread knife to level out the top.

Bring a large saucepan of water to the boil and add a big pinch of sea salt. Submerge the artichokes in the boiling water and add the lemon wedges to the saucepan to stop the artichokes from going brown when cooking.

Simmer for 30–40 minutes until cooked through. Pick off a leaf to test; it should come off very easily.

Dressing
To make the dressing put the mustard, lemon juice, vinegar, tarragon, maple syrup and a pinch of sea salt into a jug. Blitz using a handheld stick blender while gradually pouring in the olive oil so the dressing can thicken.

Remove the artichokes from the water and drain well. Once they are not too hot to handle, cut them in half; the knife should go through smoothly. If not, return to the pan for a little longer. Using a teaspoon, scrape away the hairy spiky layer in the centre and discard, but do not cut away the "heart," as this is the best bit to eat at the end once all the leaves are gone.

To serve
Decant the dressing into a small dip bowl and place it on a large serving platter with the halved artichokes arranged around it.

CELESTE

Starters, Sides

HARISSA BBQ PULLED JACKFRUIT

My Studio Kitchen, London

I met Celeste for the first time when I took her portrait in London. I love her music, her incredible voice and her knockout individual style. When she arrived on set, I was struck by how she quietly observed everything that was going on around her, and I could tell that the best plan would be not to rush her, instead allowing her time to become comfortable in front of the camera, open up and get more into the process of collaborating. She looked deep into my lens and I got the shot. I found her mesmerising—she struck me as someone who is very calm and grounded, but with the stature and voice of a true diva!

We stayed in touch. She spoke so eloquently when I interviewed her for my documentary, answering each question from the heart. I used her performance of "Hear My Voice", filmed in Studio 2 at Abbey Road, for the end sequence to pull on the heartstrings of my audience in the finale.

Then I invited her to be a guest on my cooking show. Although not something she would usually do, she reminded me she liked to throw herself into new experiences, and she trusted me. I loved cooking for her. Once I had made my Harissa BBQ Pulled Jackfruit, we built our tacos, overstuffed—really delicious and very messy. We giggled as we attempted, and failed, to eat them with some kind of civility, trying not to drop too much, whilst I quizzed her about what it was like attending the Oscars when she was nominated. As she left, we were already planning our next moment.

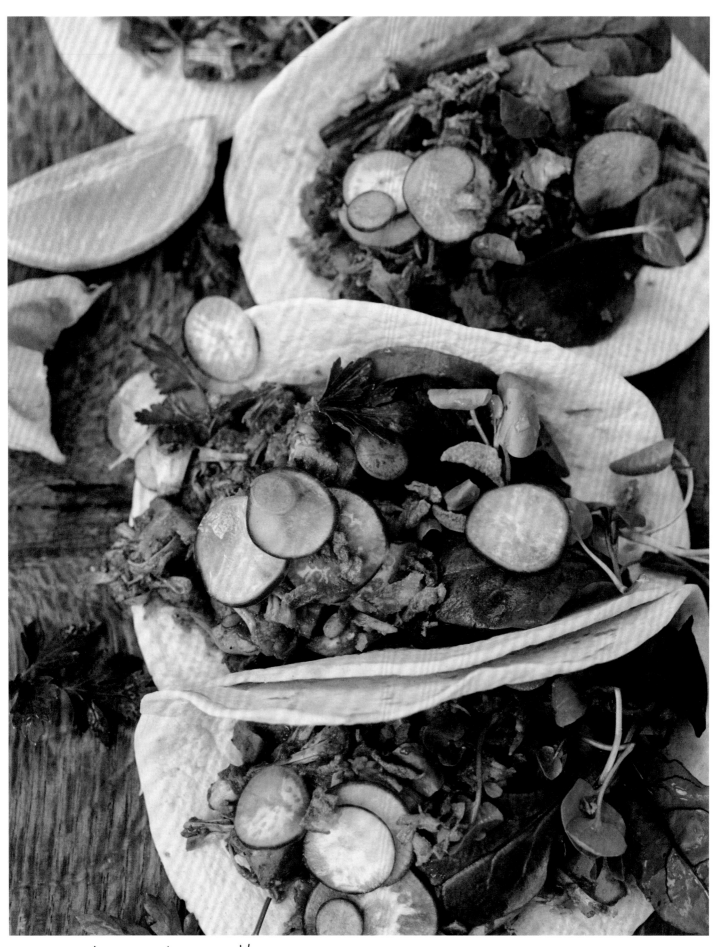

A succulent filling. Enjoy the heat of this harissa no cook
BBQ sauce paired with the jackfruit. As they cook together
50 it breaks down to a fleshy texture similar to pulled
pork or chicken.

HARRISSA BBQ PULLED JACKFRUIT

Ingredients

Quick-Pickled Radish
2 radishes, thinly sliced
120 ml (½ cup) apple cider vinegar
Pinch of sea salt

Harissa BBQ Sauce
60 ml (¼ cup) tomato ketchup
2 tablespoons vinegar, such as apple cider
1 tablespoon extra virgin olive oil
1 teaspoon ground cumin
1 teaspoon garlic powder
1 teaspoon harissa paste
Pinch of sea salt
Pinch of freshly ground black pepper

Jackfruit
1 tablespoon olive oil
1 × 400 g (14 oz) can of jackfruit chunks, drained

To serve
Flatbreads or soft corn tortillas, warmed
Handful of mixed salad leaves
Crispy onions (store-bought)
Parsley leaves
Lemon wedges
Plant-based feta (optional)

Method

Quick-Pickled Radish
Put the sliced radishes into a bowl, cover with the vinegar and add the salt. Leave them to pickle while you make the rest.

Harissa BBQ Sauce
Add the ketchup, vinegar, olive oil, cumin, garlic powder, harissa paste, salt and pepper to a bowl and whisk with a fork to combine well.

Jackfruit
Heat the oil in a frying pan over a medium heat. Add the jackfruit chunks and cook for 5–10 minutes. As the fruit softens, use a wooden spoon to push and break down the chunks into smaller shredded stands. Stir in the harissa BBQ sauce and toss to coat. Cook for 1–2 minutes, until sticky and well absorbed into the jackfruit.

To serve
Divide the jackfruit mixture between the flatbreads/ tortillas, then layer on the salad leaves, pickled radishes, crispy onions, parsley and feta (if using). Give them a little squeeze of lemon and roll them up into wraps.

OLIVIA HARRISON

Starters, Sides

CHILLI SWEETCORN FRITTERS

Home, Los Angeles

Cooking for Olivia is like cooking for family, and we have become even closer since my mum passed away 25 years ago. I feel like we have each other's backs. Olivia is forever young at heart and always curious about the world. It's infectious! It was springtime and Olivia happened to be in LA when I was, so of course we were going to meet up. I hadn't been to her place in LA before, so I was keen to check it out. Olivia was in town doing press for her new poetry book, *Came the Lightening: Twenty Poems for George*, her beautifully written love story. I arrived before her to get the food ready for her return, so I had time to rummage around the kitchen, opening every cupboard to find the things I needed to make my dish.

I knew exactly what to feed her to make her happy, Chilli Sweetcorn Fritters with Sweet Chilli Dipping Sauce. I know she loves this recipe! It felt even more fitting sharing this with her here, as she was born in Los Angeles and has Mexican heritage, and I know sweetcorn is high on her list of favourite ingredients. Reunited, we headed outside into her garden paradise. True to its Californian location, it's a celebration of mature cacti and succulents—a desert oasis. Wherever she is, Olivia is so connected to nature and is an expert horticulturist. She confided in me that she had been craving these fritters. She was a joy to feed and so appreciative, which made it all worthwhile.

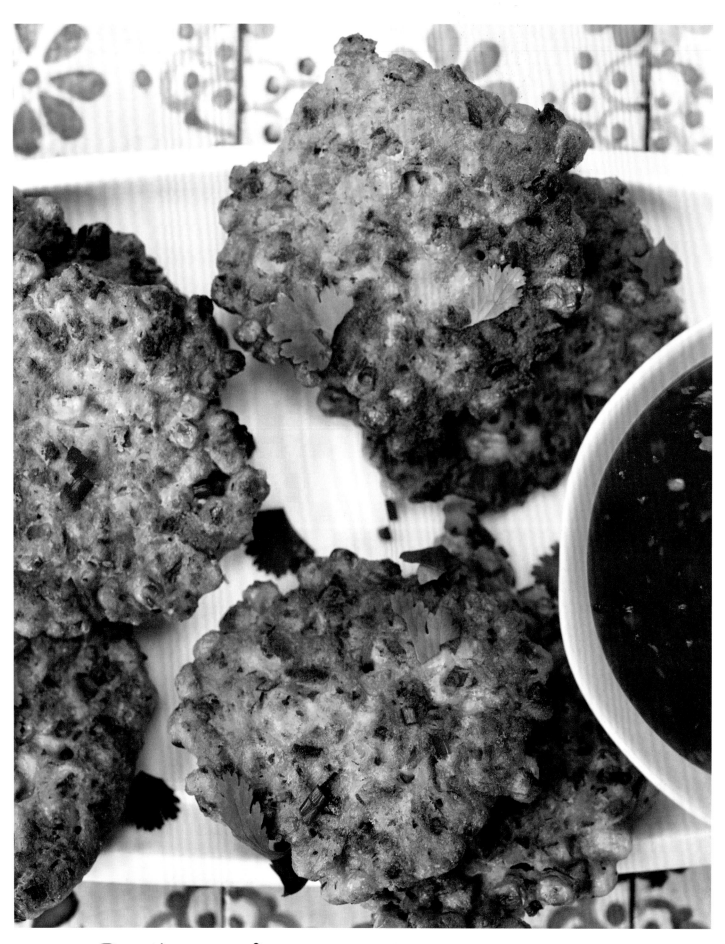

Bursting with flavour, these fritters celebrate the taste of
Summer. Make ahead and reheat at your convenience. Use
54 frozen or tinned sweetcorn to make all year round. Perfect
packed lunch addition, or picnics.

CHILLI SWEETCORN FRITTERS

Ingredients

300 g (2 cups) sweetcorn (frozen and thawed,
 fresh from the cob, or canned and drained)
1 medium garlic clove, finely chopped
1 red chilli, deseeded and finely chopped
1 small red onion, finely chopped
1 tablespoon B_{12} nutritional yeast flakes
3 tablespoons coriander (cilantro) or parsley,
 finely chopped
120 g (1 cup) plain (all-purpose) flour,
 or gluten-free flour
1 teaspoon baking powder
100 ml (scant ½ cup) unsweetened plant-based
 milk (I use cashew)
½ tablespoon soy sauce (or tamari for gluten-free)
1 tablespoon freshly squeezed lemon juice
½ teaspoon sea salt
Freshly ground black pepper
3–4 tablespoons vegetable or olive oil, for frying

To serve
Sweet chilli sauce (store-bought), warmed

[*]Makes 16 fritters, each about 7 cm (3 in.) in diameter

Method

In a medium bowl, mix together the sweetcorn, garlic, chilli, red onion, B_{12} nutritional yeast flakes and herbs. Stir in the flour and baking powder, then gradually pour in the milk and soy sauce, mixing to combine all the ingredients well. Season with lemon juice, salt and pepper.

Heat 1 tablespoon of the oil in a large sauté or frying pan over a medium-high heat. To check the heat, drop in a test teaspoon of batter; if it's hot enough you will hear a sizzle.

Spoon in a heaped tablespoon of the mixture for each fritter, leaving a little space between each one so they don't stick together. Gently pat each fritter down with the back of the spoon so it flattens slightly and is easy to cook on both sides. Fry for about 2 minutes, until golden brown, then flip over to brown the other side for a further 2 minutes, until golden.

Cook the fritters in batches, using a tablespoon of oil for each batch, until all the mixture is finished.

To serve
Plate up the fritters with warmed sweet chilli sauce in a dipping bowl.

MERLIN AND COSMO SHELDRAKE

Starters, Sides

CRISPY COATED MUSHROOMS WITH GREEN DIP

Home, Gloucestershire

I was excited to meet the Sheldrake brothers. They explore the world of our delicate ecosystems and how we coexist. Merlin is a renowned ecologist and microbiologist, and I love his book *Entangled Life: How Fungi Make Our Worlds, Change Our Minds and Shape Our Future*, which opened up a whole new fungal world for me. And his brother, Cosmo, is a musician, composer and ecological sound artist who created the album *WakeUp Calls*, a love poem to birdsong. I find their collective enthusiasm for nature totally infectious.

On my arrival we headed straight to the kitchen, the heart of the home. I had saved one of my most popular (and quite appropriate) recipes for them: Crispy Coated Mushrooms with Green Dip. Whilst the mushrooms were heating in the AGA, I spotted an illustration of the brothers on a bottle. On closer inspection I

discovered it was their fermented hot sauce. Turns out they have been brewing and fermenting together for years. The science behind it blows my mind. To think that this little bottle of hot sauce houses large populations of microbes that form complex ecological systems—both fascinating and delicious!

With the dips and the mushrooms plated up, we sat outside on a bench by the pond to eat, chat and enjoy the extraordinary view over the valley. We bonded over our deep love of and appreciation for the natural world. All too soon it was time for me to head home. Back at the station, sitting on a bench waiting for the train, I resisted the temptation to check my phone. Instead, looking up at the late afternoon's summer sky, I was transfixed by the big fluffy clouds as they drifted by, daydreaming and holding onto this calm feeling before speeding back to the bustle of city life again.

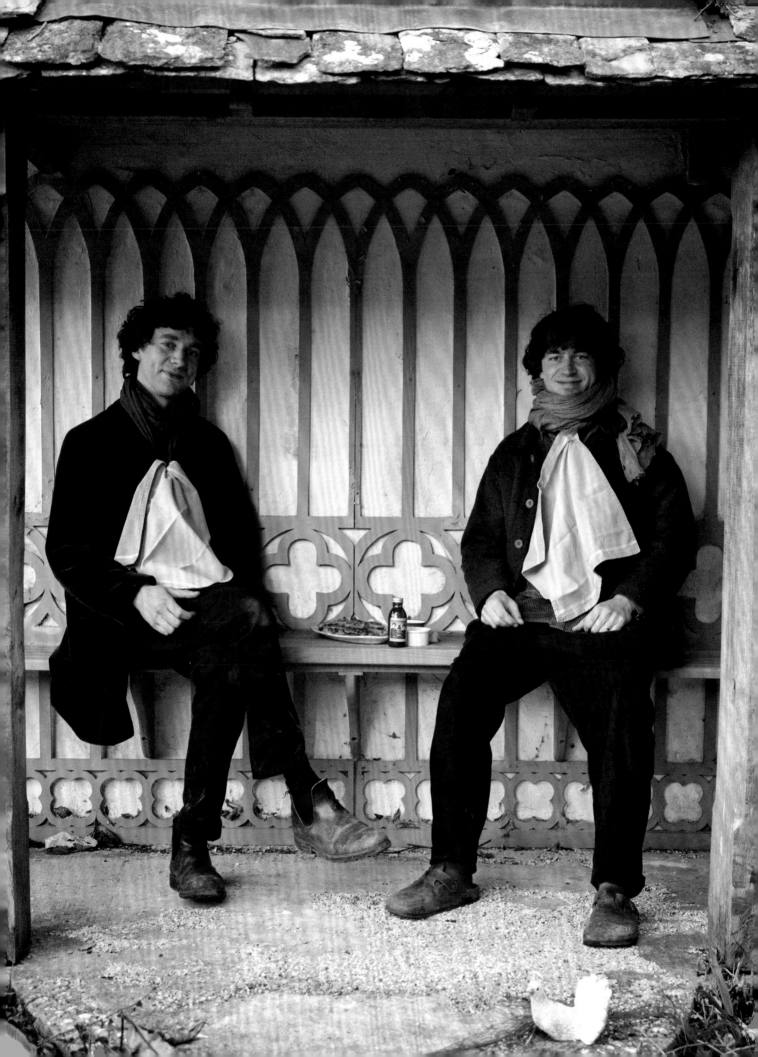

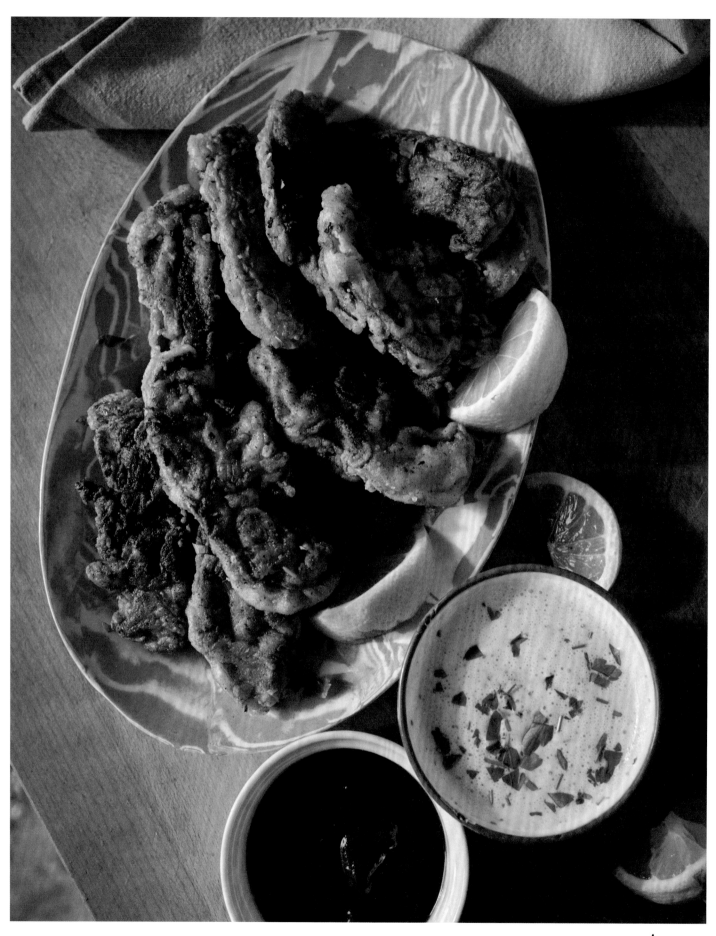

So easy — this is the ultimate mushroom deliciousness!
Crisp on the outside and succulent on the inside and perfect
58 to dunk into this citrus fresh dip. A big hit at any
gathering!

CRISPY COATED MUSHROOMS WITH GREEN DIP

Ingredients

Green Dip
120 ml (½ cup) unsweetened plant-based yogurt
(I favour coconut)
1 tablespoon freshly squeezed lemon juice
1 garlic clove, crushed
20 g (½ oz) fresh parsley leaves
Pinch of sea salt

Crispy Mushrooms
4 large portobello mushrooms
2 tablespoons Worcestershire sauce (vegan)
100 g (1 cup) cornflour (starch)
120 g (1 cup) plain (all-purpose) flour
(gluten-free optional)
4 tablespoons savoury seasoning
(I use Cajun seasoning, or "chicken" seasoning
spice mix, vegan)
120 ml (½ cup) unsweetened plain plant-based yogurt
(I favour coconut)
120 ml (½ cup) ice-cold sparkling water
Vegetable oil, for frying

Method

Green Dip
Blitz all the dip ingredients together in a jug with a handheld immersion stick blender until they turn a vibrant green colour, about 15 seconds. Pour into a serving bowl or airtight container and keep chilled in the fridge until ready.

Crispy Mushrooms
Slice the mushrooms across into about 1 cm (½ in.) thick strips. Drizzle over the Worcestershire sauce and toss to coat evenly.

Mix the dry ingredients (flour, cornflour and savoury seasoning) together in a medium bowl.

In a separate medium-sized bowl, mix together the wet ingredients (plain yogurt and sparkling water) until smooth.

Now to triple-coat the mushrooms: first, dip them in the flour mix, then coat in the yogurt mixture and then back into the flour mix once again so they are evenly coated. Repeat until all the mushrooms are coated and arrange them on a plate ready for frying.

Pour approximately 8 cm (3 in.) of the vegetable oil into a large wok or saucepan and bring up to heat (check the oil is hot enough by dipping the handle of a wooden spoon in—if it is ready to start frying, lots of little bubbles should form around the handle). Cook the mushrooms in small batches so the pan is not overcrowded; fry for 3 minutes on each side until golden brown and crispy.

Carefully remove each mushroom from the pan using tongs and lay them on a kitchen paper-lined baking tray to soak up any excess oil.

To serve
Arrange the crispy mushrooms on a serving platter and serve with the green dip in a small bowl.

KATHLEEN KENNEDY AND LISA EISNER

Starters, Sides

BLOODY MARY DIP WITH SKEWERS

Home, Los Angeles

I got to know Kathleen in London, when she was producing *Star Wars*, and first met her at Pinewood Studios, where I took her portrait for *Vogue* magazine. She cut an impressive figure on set and made it a memorable day for me. We stayed in touch, meeting up for lunch or dinner when she's back in London. She is married to Frank Marshall, another legendary film producer, and they both made it down to Provence last year for my photographic exhibition, *Moment of Affection*, at Château La Coste. The two of them are a pleasure to spend time with and are a treasure trove of great stories and experiences.

I was in their hometown of Los Angeles and was invited to dinner at their beautiful home. Their close friends Lisa and Eric Eisner were invited too. Lisa is a jewellery designer and a keen horticulturist. Her garden in LA is simply breathtaking and she just has an effortless style about her. Eric is an attorney and former music executive with great charm and humour. What a lineup! I brought my Bloody Mary Dip with Focaccia Skewers to have with pre-dinner drinks. They were my guinea pigs for turning the well-known cocktail into a dip. We sat around their bar chatting and drinking our aperitifs. The recipe was a triumph— I should have made more. After a delicious dinner we disappeared into the darkness of their screening room for a sneak preview of the trailer for the latest Indiana Jones movie, which Kathleen produced. With a bag of popcorn from their vintage popping machine, it was the perfect way to end the evening.

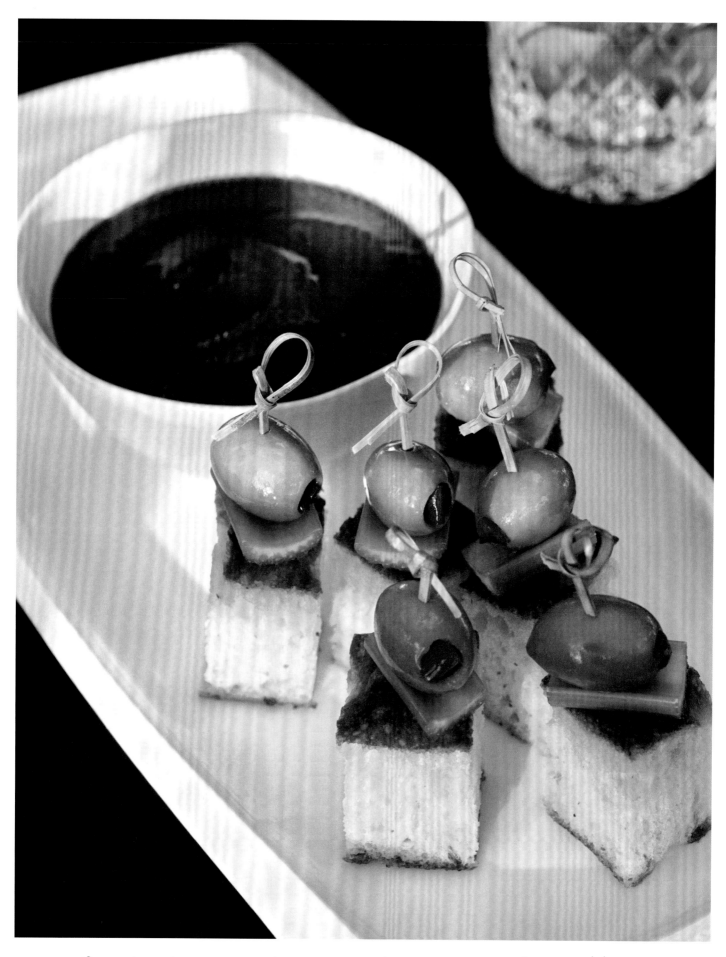

My twist using all of the flavours of a classic bloody Mary
cocktail, and turning it into a delectable dip, served with
soft focaccia bites, crisp celery and a little salty olive.

62

BLOODY MARY DIP WITH SKEWERS

Ingredients

Bloody Mary Dip
400 g (14 oz) tomato passata (strained tomatoes)
1 tablespoon tomato paste
1 tablespoon balsamic vinegar
1 tablespoon Worcestershire sauce (vegan)
½ teaspoon celery salt
½ teaspoon Tabasco sauce, or more to taste
2 tablespoons extra virgin olive oil
60 ml (2 oz) vodka (optional)
Freshly ground black pepper to taste

Focaccia skewers
200 g (7 oz) focaccia loaf, cut into bite-sized
 pieces, about 2 cm (1 in.) cubes
3 medium celery sticks, strings peeled away
 and cut into 2 cm (1 in.) pieces
20 small pimento-stuffed green olives
20 cocktail skewers

Method

Bloody Mary Dip
Put all the dip ingredients, except for the olive oil, into a saucepan over a medium heat and bring to a gentle simmer for 5 minutes. Set aside to cool slightly, then stir in the extra virgin olive oil. It can be served warm or at room temperature.

Focaccia skewers
Meanwhile, thread a small olive, a piece of celery and a cube of focaccia onto each cocktail skewer.

To serve
Pour the dip into a bowl and arrange the focaccia skewers on a serving plate.

YOAV LEVANON

Starters, Sides

BEET
AND CARROT
BLINI BITES

St Martin-in-the-Fields, London

I met Yoav backstage at one of Stella's fashion shows in Paris. He caught my eye, as he was on his own, quietly observing, taking everything in. I wondered who he was, thinking, from his striking features, maybe a model or somehow involved in fashion. I asked my sister, and she waxed lyrical about him, explaining he was a 19-year-old pianist who had taken the classical music world by storm. And she had invited him to her show after she had seen him perform. I was drawn to Yoav, seeing how curious he was about this alien world of fashion in which he found himself, and it was fascinating to see a world that I knew well through his eyes. It seemed that all new experiences fired and inspired him, and that this would be reflected in his music somehow.

He invited me to his concert at St Martin-in-the-Fields, a church in London. Touchingly, he knew that this was where we had held my mother's memorial service, and that he'd totally understand if it were too emotional for me to come. But that was more reason to hear him play there. In return for the invitation, I would bring him something to eat after his performance. At the piano, Yoav had an aura around him, and his playing was mesmeric, extraordinary for an artist so young. I got lost in the moment, in this very emotive of locations. I met him onstage after the concert, to present him with the Beet and Carrot Blinis I had made for him. He took one bite, and he was instantly hooked, saying, *"one of the most delicious and addictive things I've ever eaten"*. Now that's exactly the reaction I appreciate.

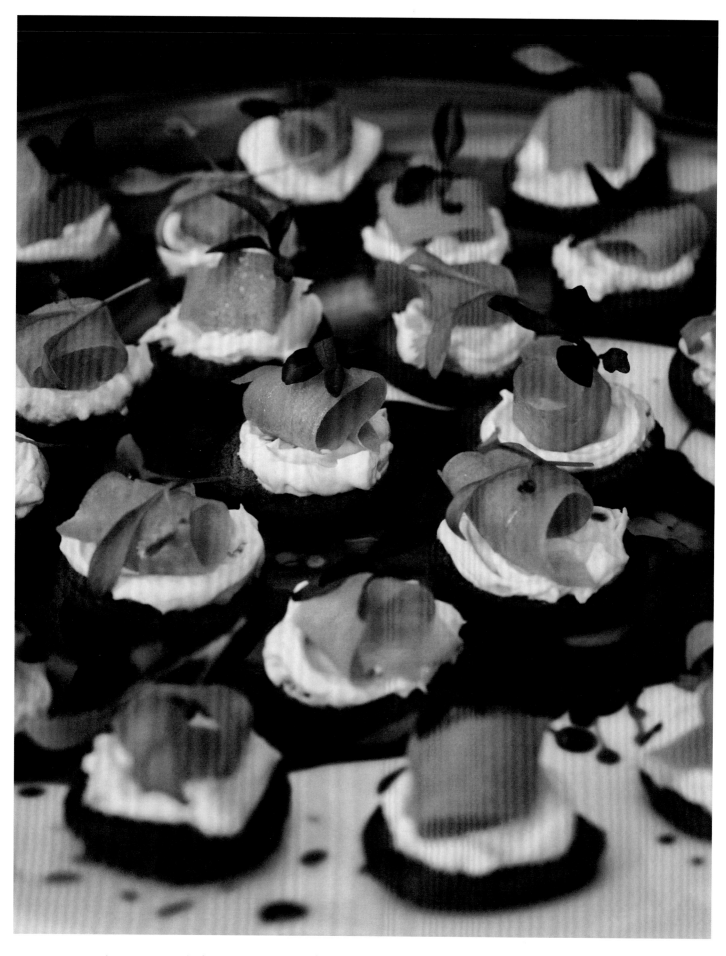

Bite sized buckwheat blinis topped with cream cheese, refreshing
pickled carrot ribbons and micro herbs. A beauty to behold and
bursting with flavour.

66

BEET AND CARROT BLINI BITES

Ingredients

Pickled Carrot Ribbons
1 medium carrot, peeled
1 tablespoon toasted sesame oil
1 tablespoon mirin
1 tablespoon brown rice vinegar
½ teaspoon agave syrup
¼ teaspoon sea salt

Beet Blinis
40 g (⅓ cup) buckwheat flour
1 tablespoon plain (all-purpose) flour
1 tablespoon beetroot powder (optional)
1 teaspoon baking powder
Pinch of sea salt
120 ml (½ cup) unsweetened plant-based milk
1 tablespoon olive oil or vegetable oil,
 plus a little more for frying

To serve
150 g (5 oz) plant-based cream cheese
 (I use flavoured with chives)
Micro herbs or chives, to decorate

Method

Pickled Carrot Ribbons
Shave the carrot into ribbons using a vegetable peeler —each blini will have one carrot ribbon on top. Place in a heat-proof bowl and cover with boiling water for 15 seconds. Drain and then place on a clean tea towel or kitchen roll to dry off any excess water.

Mix the sesame oil, mirin, brown rice vinegar, agave syrup and salt in a medium bowl. Add the carrot ribbons and toss well to coat in the marinade. Set to one side to pickle and absorb the flavours for at least 30 minutes.

Beet Blinis
Sieve both flours, beetroot powder, if using, and baking powder into a medium bowl, and add a pinch of sea salt. Make a well in the middle of the dry ingredients and then pour in the milk and 1 tablespoon of oil. Whisk until the mixture forms a smooth batter with a heavy, creamy consistency. If the mixture is a little thick, add a ½ tablespoon of milk.

Place a medium/large frying pan over a medium heat and add a little cooking oil. (Test if the pan is hot enough by using a drop of batter; it should sizzle slightly.) Drop teaspoonfuls of batter into the hot pan, flattening slightly into even circles with the back of the spoon. As soon as bubbles appear on the top of the blini, flip it over and cook for a minute or two longer. Remove from the pan and place on a cooling rack. Fry in batches until all of the batter has gone.

To serve
Once the blinis are cool, spoon half a teaspoon of cream cheese on top of each one. Roll a carrot ribbon around your little finger to shape it, and place it on top of the cream cheese. Garnish with micro herbs or chopped chives and serve on a large plate or platter.

MILLA JOVOVICH AND EVER ANDERSON

Starters, Sides

BAKED CRISPY CAULI SWEET AND SOUR

Home, Los Angeles

Milla is a force of nature: striking, passionate and nurturing, and always inspired by art, friends and family. A few years ago, we were working together on a photoshoot in Belgium, and on the way back to our hotel we took a detour to go to a special toy shop so she could pick out the perfect gift for her then 3-year-old daughter, Ever. Today I am cooking for them both. Ever is now 15 years old, and a bright, budding actress in her own right.

Milla has just moved to a house at the very top of the hills above LA. A wonderful concrete-and-glass brutalist family home, with a 360-degree panoramic view. I was immediately drawn to the mural that she and her girls had created together. This home had a real sense of their creativity and personalities. I had made these crispy, sticky cauliflower bites, as they appeal to all ages, give or take a bit of spice. Milla and Ever munched away, and they licked the plate clean. I was amused to see their little rescue dog, Vinny, wander over to check out what he was missing. What a perfect lunchtime. Simply hanging and sharing food. That's what it's all about.

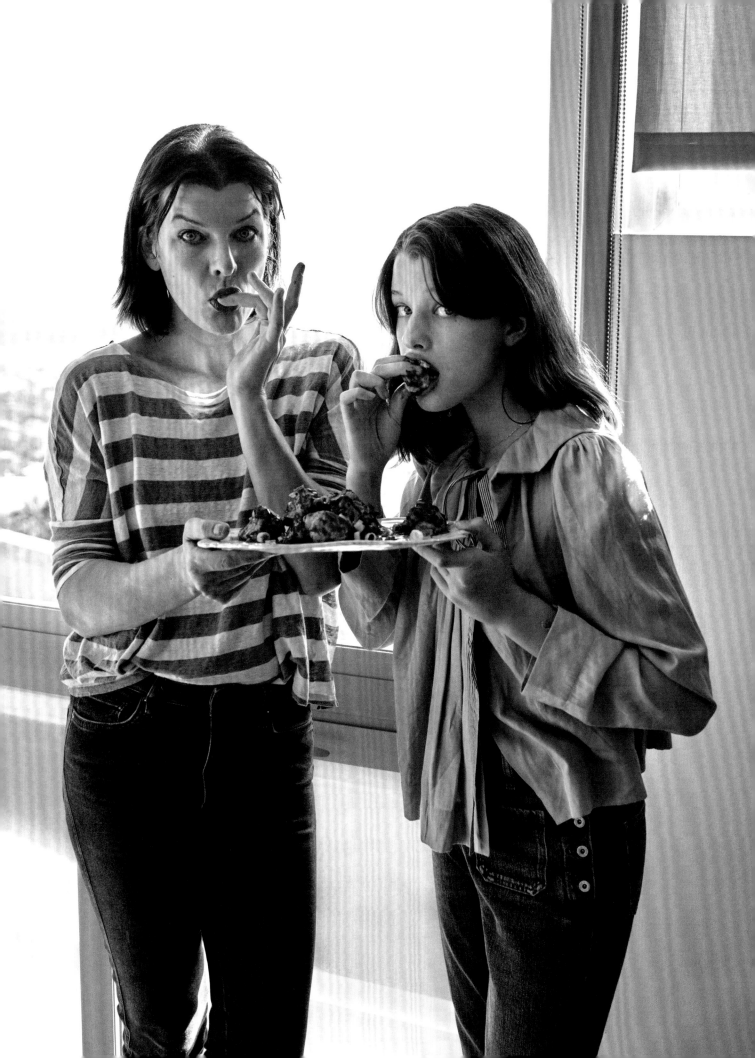

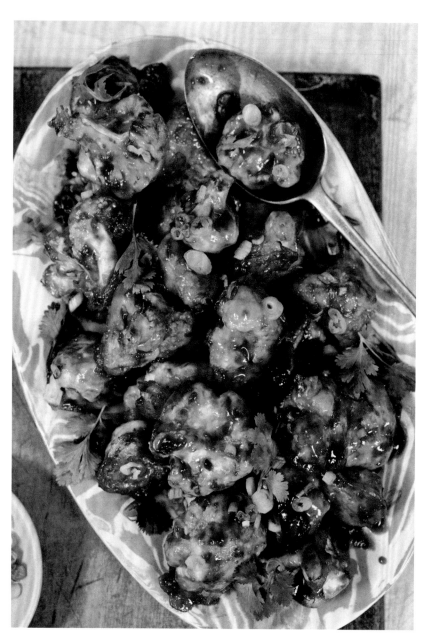

Batter coated cauliflower florets, baked and then tossed in an aromatic sweet and sour sticky sauce. Finished with a sprinkle of fresh chopped spring onions and coriander. Irresistibly moreish!

BAKED CRISPY CAULI SWEET AND SOUR

Ingredients

1 cauliflower (about 450 g/1 lb),
 cut into bite-sized florets
Vegetable oil, for greasing

Batter
120 g (1 cup) plain (all-purpose) flour
25 g (¼ cup) cornflour (starch)
1 teaspoon baking powder
1 teaspoon ground ginger
1 teaspoon garlic powder
Pinch of sea salt
240 ml (1 cup) chilled sparkling water

Sweet and Sour Sauce
1 tablespoon toasted sesame oil
2 garlic cloves, finely chopped
2 tablespoons soy sauce
2 tablespoons cider vinegar
 (or rice/white wine vinegar)
3 tablespoons soft brown sugar
2 tablespoons tomato ketchup
1–2 tablespoons sriracha, to taste

To serve
2 spring onions (scallions), thinly sliced
2 tablespoons fresh coriander (cilantro),
 finely chopped

Method

Preheat the oven to 230°C/450°F. Line two large baking trays with parchment paper and grease liberally with about 2 tablespoons of oil.

Batter
In a large mixing bowl, stir together the flour, cornflour, baking powder, ground ginger, garlic powder and salt. Make a well in the middle and stir in the sparkling water, whisking with a fork to form a smooth batter. Add the bite-sized cauliflower florets and gently toss to coat them evenly in the batter.

Place the battered florets on the baking trays, allowing space between each one to help them crisp up in the oven (if they are too close, they will steam rather than go crispy).

Cook for 10–15 minutes until crispy and golden brown, turning over once halfway through.

Sweet and Sour Sauce
While the cauliflower is in the oven, place all the sauce ingredients in a small saucepan. Using a wooden spoon, mix well and bring to a gentle bubbling simmer. Cook for about 10 minutes, stirring often, until the sauce becomes a glossy consistency and coats the back of the wooden spoon.

Remove the cauliflower from the oven and transfer to a large bowl. Drizzle over the sweet and sour sauce, add most of the spring onions and coriander, leaving some behind for garnish, and gently toss the mixture to coat each floret with the sauce.

To serve
Transfer to a serving plate and finish off by sprinkling over the remaining spring onions and coriander or parsley.

ANOUSHKA SHANKAR

Starters, Sides

ROASTED BUTTERBEANS AND CHERRY TOMATOES

Home, London

Cooking for Anoushka at her home felt like the perfect way to catch up with her. She is an incredibly talented composer and musician, being taught under the tutelage of her father, the legendary Ravi Shankar. Through his close association with the Beatles and his relationship with George Harrison, she has always felt like extended family to me.

Ahead of time I asked her what she would like to eat. She replied, *"Honestly, whatever is easy and suits you. But please, no Indian food!"* This made me smile, I wouldn't have attempted to serve her Indian food, as she is used to a very high standard. We talked a lot about motherhood, both having boys, and exchanged stories and advice. She found me a baking tray and I laid rosemary sprigs, butterbeans, garlic and cherry tomatoes on the base, then drizzled liberally with olive oil and Worcestershire sauce and seasoning, then into the oven for 20 minutes — almost feels too easy! It smelled incredible as it cooked.

Plates in hand, we headed upstairs to her music room, the home of her upright piano and sitar. She played for me, and I was transported — such ease and elegance, we both drifted off for a moment into a daydream. I felt like I got the better end of the deal in that moment. We headed back to the kitchen and used the fresh focaccia bread to wipe around and soak up the juices at the bottom of the baking dish. It was so tasty; one could argue it's the best bit.

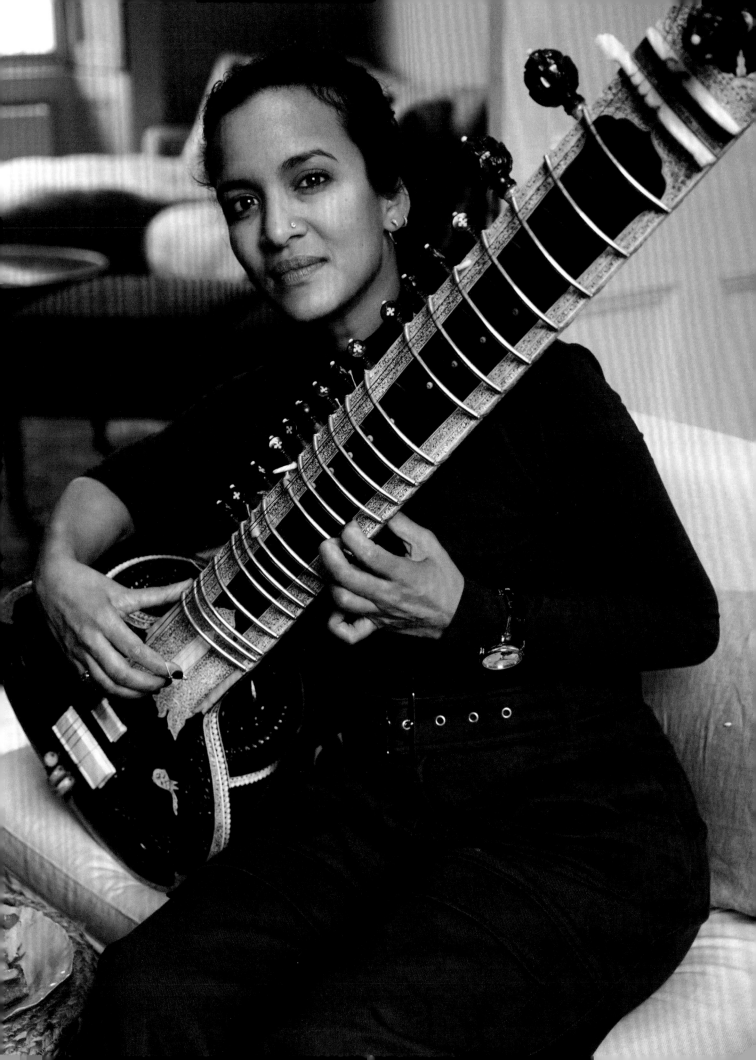

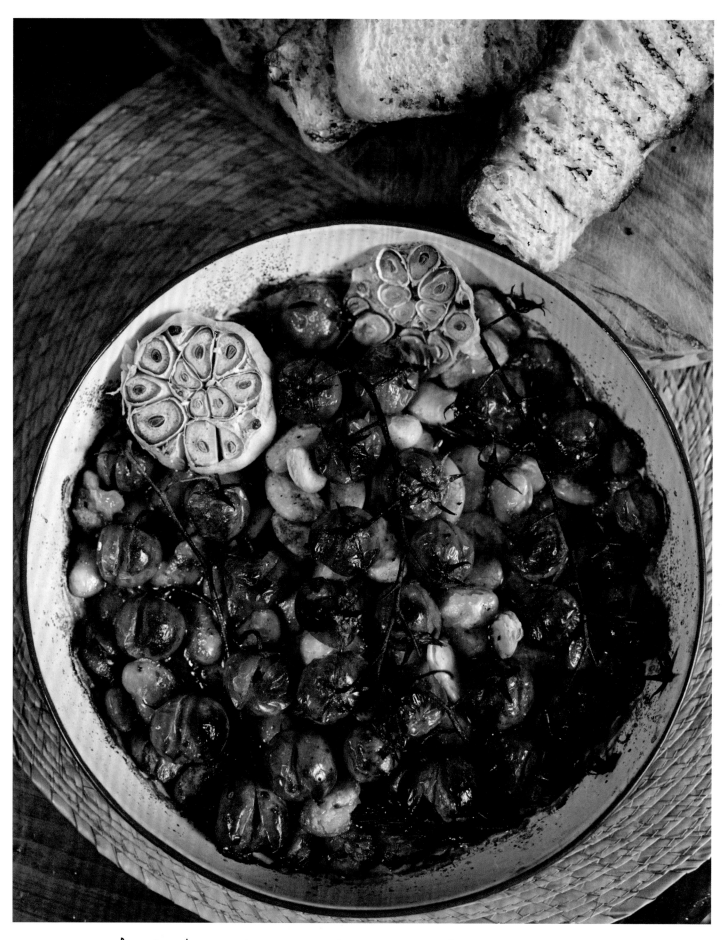

As simple as it sounds: Just assemble the ingredients and let the oven do the work. Celebrating the flavours of the humble butter bean and juicy tomatoes. Mopped up with fresh bread.

74

ROASTED BUTTERBEANS AND CHERRY TOMATOES

Ingredients

4 sprigs of fresh rosemary
225 g (8 oz) cherry tomatoes,
 preferably on the vine
1 × 400 g (14 oz) can of butterbeans,
 drained (drained weight 235 g/8 oz)
1 tablespoon Worcestershire sauce (vegan)
2 garlic bulbs
3 tablespoons extra virgin olive oil
Sea salt and freshly ground black pepper to taste

To serve
Fresh or lightly toasted bread
 (I like focaccia or ciabatta)

Method

Preheat oven to 180°C/350°F.

Arrange the rosemary sprigs onto the base of a baking dish (about 25 cm/10 in.). Add the drained butterbeans to the dish and place the cherry tomatoes on their vines on top. Pierce the tomato skins with a sharp knife so they don't pop while cooking in the oven.

Drizzle the olive oil and Worcestershire sauce over the butterbeans and tomatoes, and season with a pinch of sea salt and black pepper.

Cut the tops off the garlic bulbs to expose the top of the cloves, and place them on one side of the baking dish. Bake for 20–25 minutes.

To serve
Serve the roasted butterbeans and tomatoes in the baking dish. Squeeze the cooked garlic cloves to release the cooked centre. Spread the soft roasted garlic cloves onto the fresh bread (toasted if you prefer).

75

JESS GLYNNE

Starters, Sides

BAKED TEMPURA FRIES

My Photo Studio, London

Jess Glynne had just signed to EMI Records, and I asked to take her portrait to accompany the announcement. A new chapter of her life with new music on the way! She came over to my studio for the shoot. We know each other socially, having first met when she played Glastonbury, which is such a joyful place. It was there that she introduced me to her family, and I took the opportunity to do a mini photo session with them all. She's great, and we always manage to have a good moment when we bump into each other. But this was our first professional collaboration, and we were both in work mode. I was getting the photographic set ready whilst Jess was in hair and make-up and getting those fabulous nails done. She looked radiant.

I could see from her expression that I had chosen the wrong music playlist, being too frantic for her mood, so I switched it to something more mellow. I always think about setting the right atmosphere in the studio, as it relaxes my sitter and gets much better results. It had been a while since Jess had done promotion, and this was the beginning of a very busy period for her. She soon got into the swing of it and, by the end, she was enjoying herself. At the end of our session, we devoured the Baked Tempura Fries and made plans to meet soon at our local pub for a proper catch-up. It was great to see the fruits of our labour in the music press a few weeks later. It turned out we both did a good job!

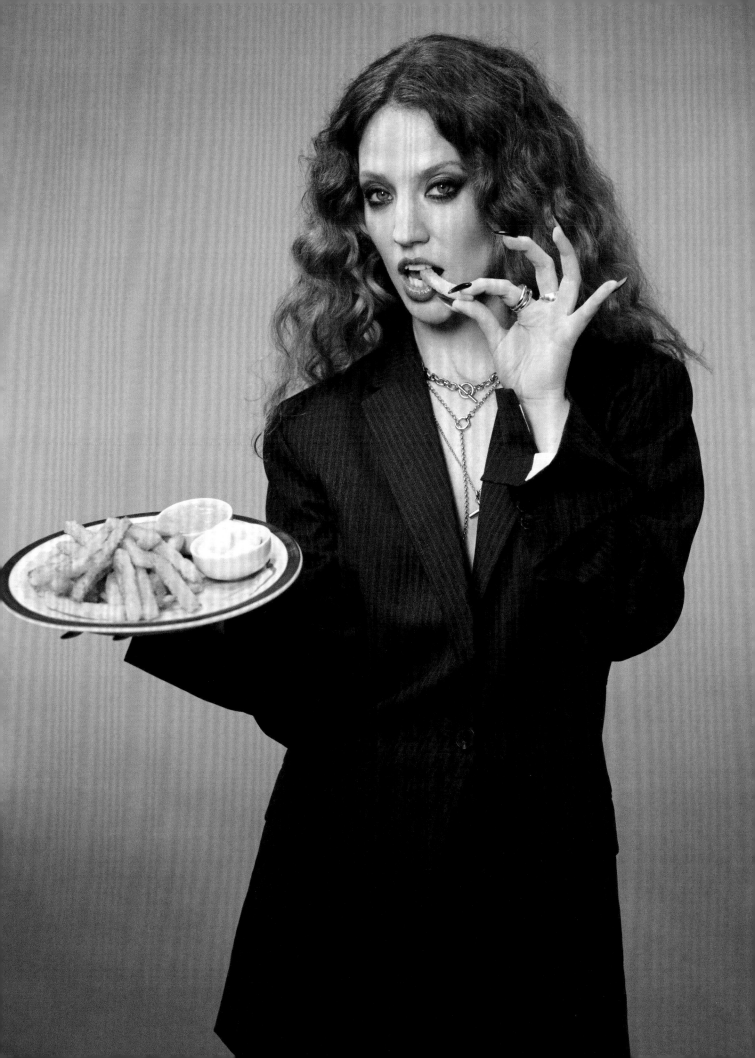

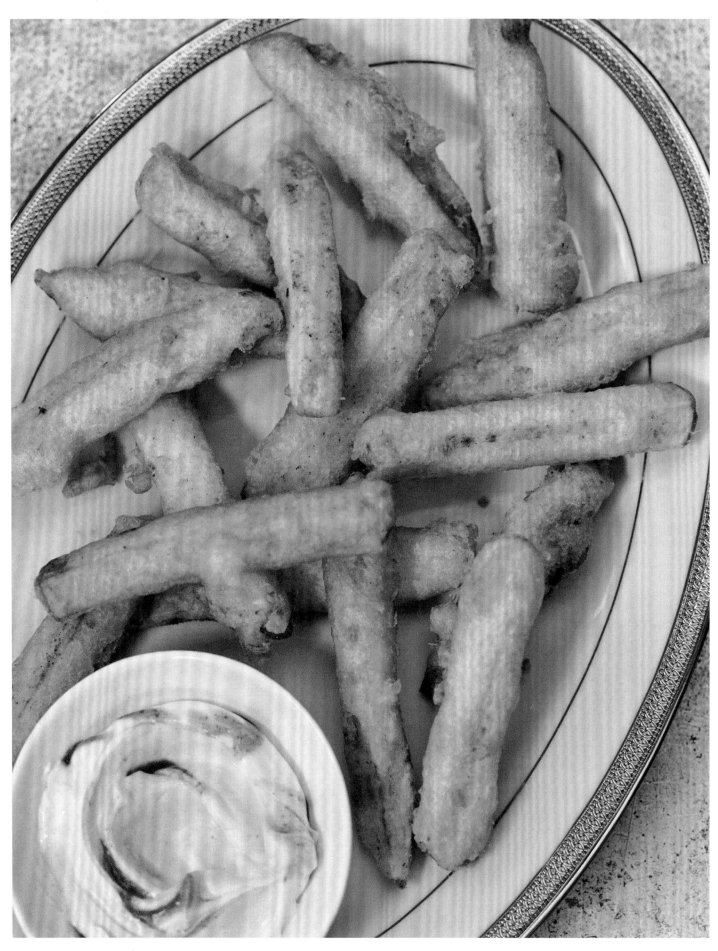

Hand cut potato par boiled and lightly coated in an easy tempura batter - baked in the oven. Crispy on the outside and fluffy on the inside. What's not to like ?!

BAKED TEMPURA FRIES

Ingredients

4 tablespoons vegetable cooking oil
600 g (1.3 lbs) potatoes, such as Maris Piper
 or russet, cut into batons
60 g (½ cup) plain (all-purpose) flour, for dusting

Tempura Batter
100 g (1 cup) cornflour (starch)
120 g (1 cup) plain (all-purpose) flour
1 teaspoon baking powder
1 teaspoon sea salt
1 teaspoon paprika (optional for flavour)
1–2 teaspoons garlic powder (optional for flavour)
215 ml (7 fl. oz) ice-cold sparkling water

To serve
2 tablespoons mayonnaise, vegan
1 tablespoon sriracha, or other hot sauce

Method

Preheat the oven to 200°C/400°F. Line two large baking trays with parchment paper and drizzle 2 tablespoons of oil over each one.

Place the potato batons in a large pan of cold water and bring to the boil. As soon as the water is boiling, drain the potatoes and leave them to steam in a colander over the hot pan to dry off thoroughly.

Meanwhile, make the tempura batter by mixing together the cornflour, flour, baking powder, salt, paprika and garlic powder. Slowly pour in the sparkling water and whisk until well combined.

Lightly dust the steamed potatoes with the extra flour. Then dip each of the potatoes into the tempura batter, shake off any excess, and then transfer to the greased baking trays, allowing space between the fries so they can crisp up. You may need to add a splash more sparkling water to the batter to loosen it, as it thickens up over time. Bake the fries for 20–25 minutes, turning over halfway through.

To serve
Mix the mayonnaise and sriracha together in a small dip bowl and serve with the freshly baked fries.

SUMAYYA VALLY

Starters, Sides

SELECTION OF SIDES

Home, London

Sumayya grew up with a deep sense of community and is a rising star in the world of architecture. Intuitive, South African and Muslim, she is someone who learns from the cultures and traditions that she's grown up observing from within. These experiences range from those of her formative years in the small town where she grew up, to the times visiting her grandmother in Johannesburg, which gave her a love for cities and city planning.

Through her practice, Counterspace, Sumayya was the youngest architect ever to have been invited to design the annual Serpentine Pavilion in London. For the design itself, she was inspired by mosques, markets and meeting places in London: a celebration of people coming together. I first met her at a lunch that the Ser-pentine Gallery was holding for its friends. She was interesting, observant, reflective. She had been travelling a lot lately, as she had undertaken the role of artistic director of the first-ever Islamic Arts Biennale in Saudi Arabia, so I brought her a selection of very nourishing and colourful dishes. It was a sunny Monday in May as I made my way across town to see her at her flat near the Natural History Museum in South Kensington. When she opened the door to me, I was struck again by her very individual style. I plated up the food, and we placed it at the centre of the table to eat and share. She sketched in her notebook as we ate, and we talked about our mutual love of London, especially the wealth of museums.

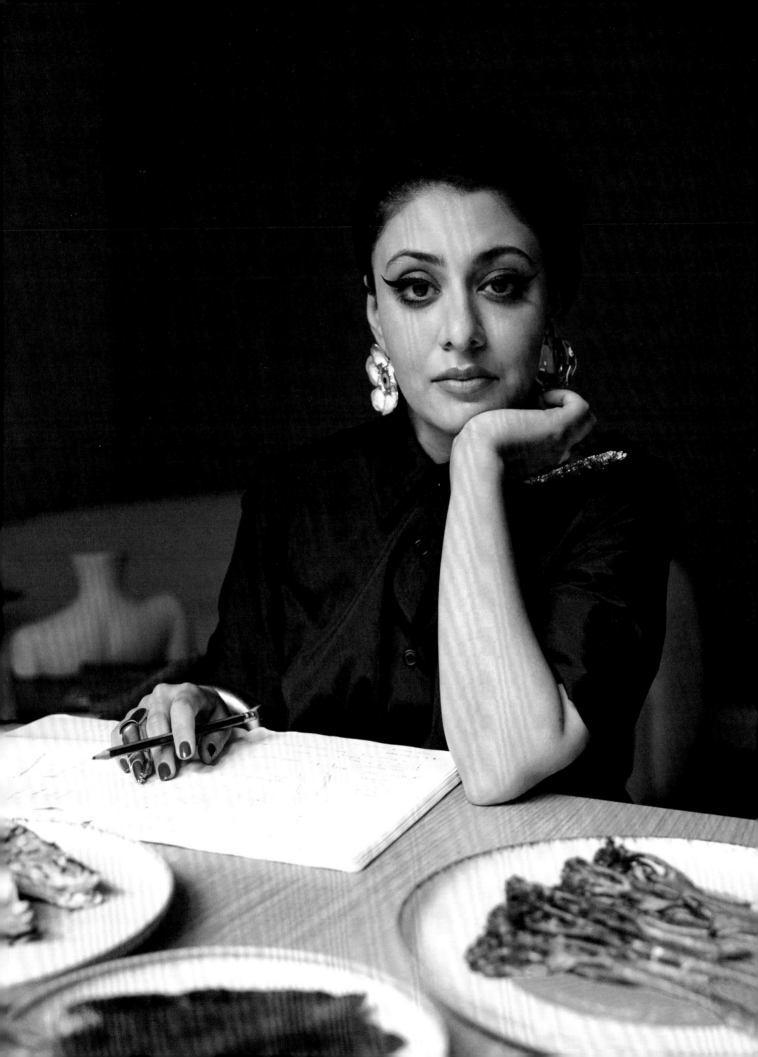

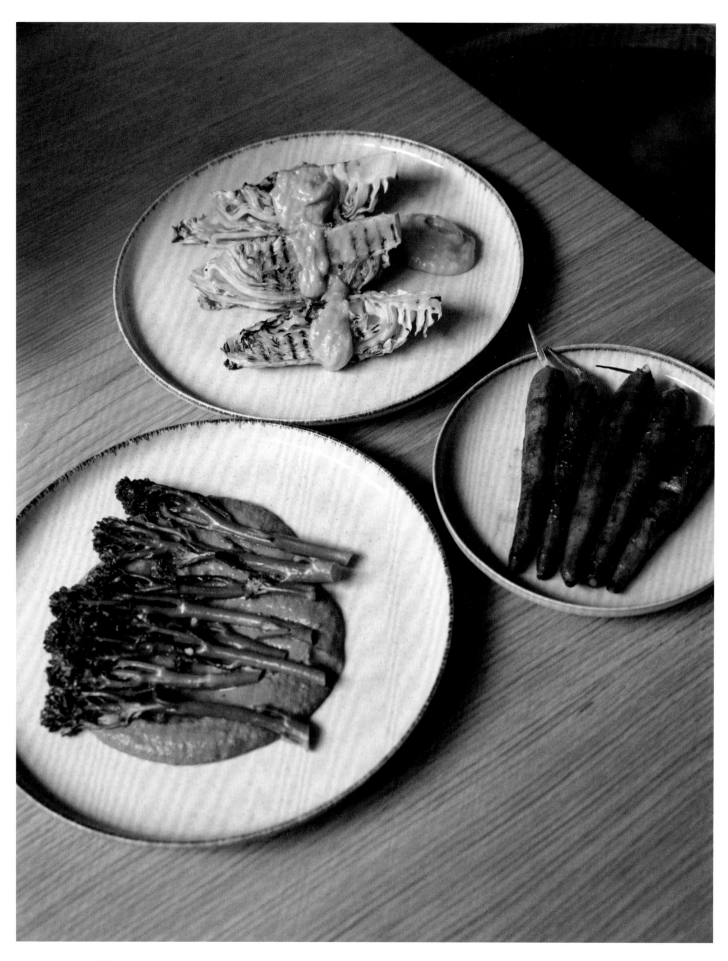

A celebration of side dishes. Choose one to accompany

your meal, or make all three together!

BROCCOLINI WITH ROMESCO SAUCE

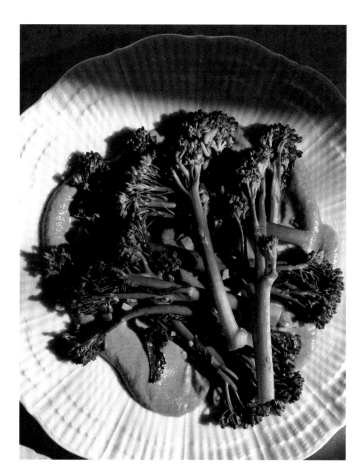

Ingredients

Broccoli/Broccolini
200 g (7 oz) tender stem broccoli (broccolini)
½ teaspoon olive oil
1 medium garlic clove
½ teaspoon sea salt

Romesco Sauce
75 g (½ cup) blanched or toasted almonds
300 g (10½ oz) jarred roasted red peppers, drained
1 garlic clove
1 teaspoon white wine or apple cider vinegar
1 teaspoon sea salt, or to taste

Method

Broccoli/Broccolini
Rinse the broccoli in water (no need to pat dry as the water will help it steam), then place a frying pan over a medium-high heat, and stir-fry the broccoli in the oil with the garlic and a pinch of salt until tender, which will take about 6–7 minutes.

Romesco Sauce
While the broccoli cooks, make the sauce. Blitz the almonds, roasted red peppers, garlic, vinegar and sea salt in a blender for 20–30 seconds, until smooth.

To serve
Pour the Romesco Sauce onto the base of a plate and arrange the stir-fried broccoli on top. The Romesco Sauce saves well in an airtight container in the fridge. Really tasty spooned onto a veggie burger too.

HARISSA CARROTS

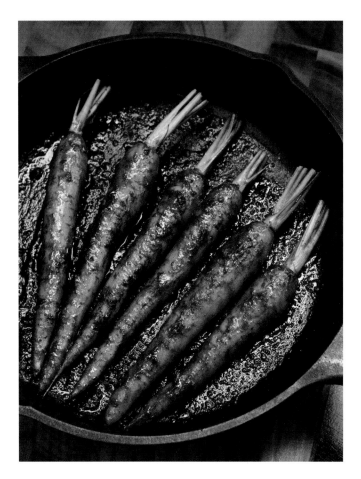

Ingredients

Carrots
6 medium heritage carrots, scrubbed clean
1 teaspoon harissa paste
½ teaspoon maple syrup
Pinch of sea salt

Marinade
1 tablespoon extra virgin olive oil
1 tablespoon harissa paste
1 tablespoon maple syrup

To serve
A little squeeze of fresh lemon juice (optional)

Method

Carrots
Place a medium lidded frying pan or saucepan on a medium-high heat. Cover the base of the pan with ½ cm (¼ in.) of water, and using a wooden spoon, stir in 1 teaspoon of harissa paste, ½ teaspoon of maple syrup and a pinch of sea salt.

Lay the carrots in the pan and cover with the lid so they steam. Bring to a gentle simmer. Shake the pan to coat the carrots with the flavours.

Cook for 6–8 minutes, shaking the pan often to cook all sides of the carrots. Test with a fork; the carrots are ready when they are tender and fall off the fork but still have a bite to them.

Marinade
In a small bowl mix together 1 tablespoon olive oil, 1 tablespoon of harissa paste and 1 tablespoon of maple syrup. Brush the mixture liberally over the cooked carrots to glaze.

Serve with a little squeeze of fresh lemon (optional).

CHARRED CABBAGE WITH CITRUS TAHINI

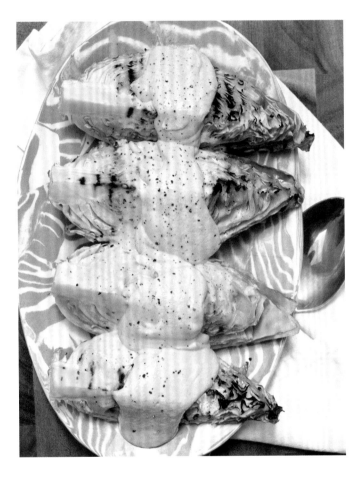

Ingredients

Cabbage
1 head pointy cabbage or savoy cabbage
1 tablespoon olive oil
Pinch of sea salt
Pinch of freshly ground black pepper

Citrus Dressing
120 ml (½ cup) tahini
4 tablespoons freshly squeezed lime juice
Pinch of sea salt
8 tablespoons boiling water

To serve (optional)
Freshly ground black pepper

Method

Cabbage
Preheat a griddle or frying pan over medium-high heat.

Slice the cabbage in half through the root, then cut in half again to make four quarters. Drizzle over the olive oil and season with sea salt and pepper.

Place the cabbage onto the pan and cook for around 2 minutes on each side until charred on all three sides.

Citrus Dressing
While the cabbage is cooking, make the dressing by mixing together the tahini, lime juice and salt in a small bowl with a fork. Stir in 8 tablespoons of boiling water to thin out the dressing (you may not need all the water), so it's just pourable.

To serve
Arrange the charred cabbage on a serving plate and spoon the dressing on top, followed by a crack of freshly ground black pepper.

SOUPS

SANDWICHES

SALADS

MICHELLE YEOH

Soups, Sandwiches, Salads

REVIVING CHILLI, LEMON, GINGER SOUP

Mandarin Oriental, Hyde Park, London

Oscar winner Michelle Yeoh first came onto my radar over 20 years ago, when I was transfixed by her performance in *Crouching Tiger, Hidden Dragon*. She is such a powerful actor, her body and facial expressions conveying so much before you even hear her say a line of dialogue. We met some years later for a photograph session, wandering around together in Paris and then again in London. My first impressions were confirmed: she has a powerful presence, knows her mind and is not one to be pigeonholed. I really admire her.

Ahead of time, I had requested a list of her favourite ingredients. I decided to use them all, trying them out in a soup that turned out to be vibrant and punchy — the perfect representation of Michelle herself. We arranged to meet at London's Mandarin Oriental, where she always stays when visiting London. We sat at a table in her suite, and I gave her the lemon to squeeze into her bowl of soup as a finishing touch to really bring it alive. I could see from her expression that, after taking her first sip, she was pleasantly surprised. Not just a mushroom soup, it had so much more power hiding in the broth, with that kick of ginger and chilli heat too. Michelle said she would love the recipe, saying the soup would be perfect energy food for her to eat on a film set. This was the highest accolade for me, so I immediately scribbled it onto a notepad for her.

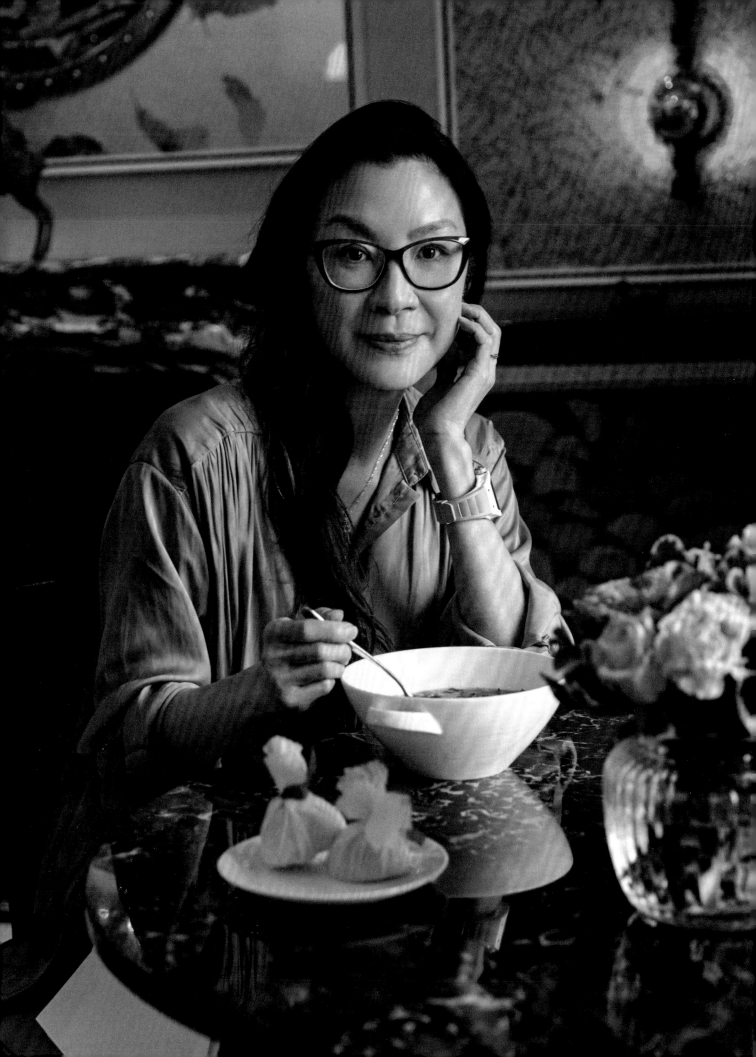

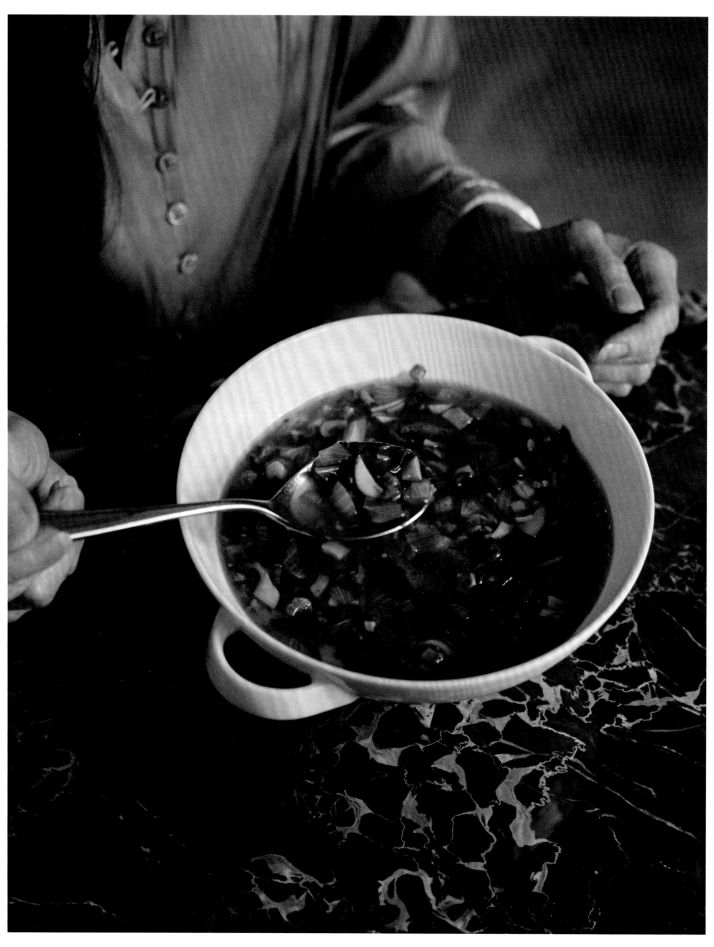

A brilliantly invigorating soup. Tender chopped mushrooms and
delicate baby spinach in a ginger, chilli and lemon broth —
that really packs a punch.

90

REVIVING CHILLI, LEMON, GINGER SOUP

Ingredients

1 tablespoon olive oil
200 g (7 oz) shallots, finely chopped
200 g (7 oz) chestnut (cremini) mushrooms,
 cleaned and finely chopped
1 tablespoon soy sauce (or tamari for gluten-free)
¼ teaspoon chilli flakes
5 cm (2 in.) ginger, peeled and finely chopped
950 ml (4 cups) vegetable stock
100 g (3½ oz) baby spinach, washed
Sea salt to taste, although the vegetable
 stock may be salty enough

To serve
Juice of ½ lemon

Method

In a medium/large saucepan over a medium heat, add the oil and shallots and sauté for 5 minutes. Stir in the mushrooms, soy sauce or tamari, chilli flakes and ginger. Sauté for a further 5 minutes.

Stir in the vegetable stock, bring to a gentle simmer, and cook for 10 minutes. Turn off the heat and stir in the baby spinach.

To serve
Divide between soup bowls and add a squeeze of lemon.

CINDY SHERMAN

Soups, Sandwiches, Salads

LEEK AND SWEET POTATO SOUP

Home, the Hamptons

My mum was American, and we visited family in the Hamptons in Long Island every summer, pretty much from the time I was born. Cindy Sherman has a place in Springs, a part of the island known for its creative residents—Jackson Pollock, Lee Krasner and Willem and Elaine de Kooning all lived in Springs. One reason for this may be the incredible light.

One day I received a message from Cindy inviting me, my husband and kids for a casual lunch. My husband and I were star-struck to meet her. I accepted immediately, in case she changed her mind. I took my Leek and Sweet Potato Soup as a contribution towards the lunch. She welcomed us warmly; at first, I found it so bizarre seeing her in real life, when I was so used to her carefully constructed image through her self-portraits.

We set up lunch outside, sitting at the long, white picnic table, with a big umbrella to shade us. It felt surprisingly surreal as I photographed Cindy sitting at the table and watched her ladling my soup into bowls. I had built her up in my mind as more aloof, but she was so warm and friendly. She has been such a big influence on me. She challenges herself in her artwork, creating her own characters. I love to imagine her in her studio, styling herself and doing her own hair and make-up, and constructing her own identity.

After lunch, Cindy asked the kids if they wanted to head with her down to the bottom of the garden to meet her beautiful blue and green pet macaw. They were eager to see him. He hopped onto her shoulder, and she gave us a guided tour with Mister Frieda on board.

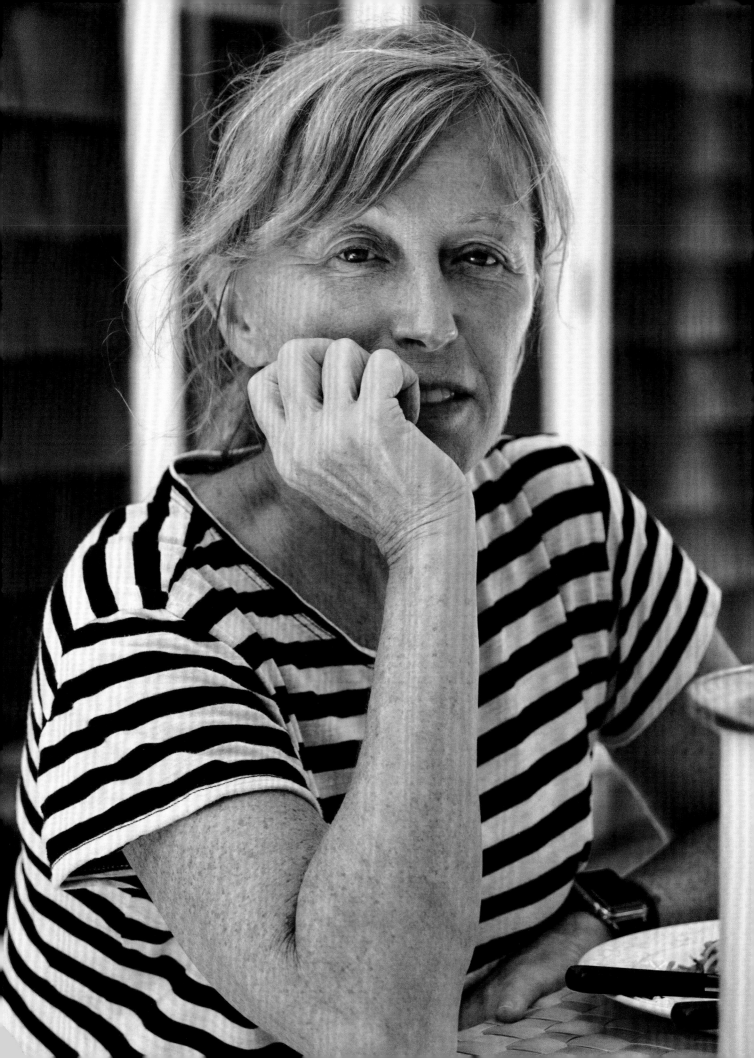

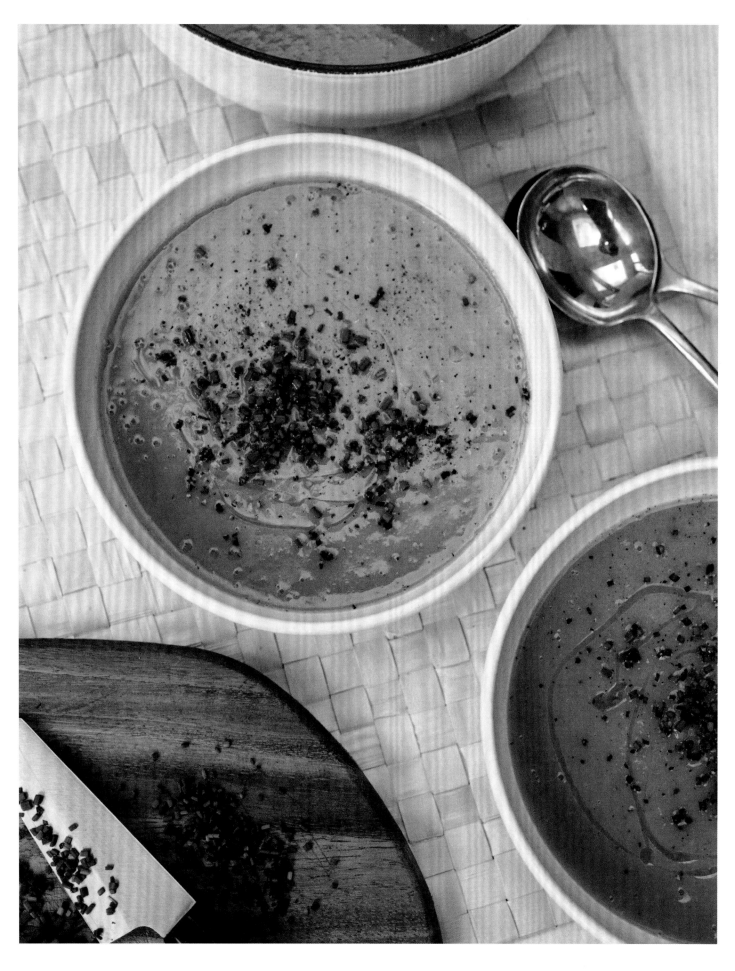

A twist on the soup we all know and love. This time packed
with antioxidant rich sweet potato.

LEEK AND SWEET POTATO SOUP

Ingredients

2 tablespoons olive oil
3 medium leeks, cleaned and chopped
3 medium garlic cloves, peeled and chopped
1 medium onion, chopped
2 medium sweet potatoes (about 300 g/10 ½ oz),
 peeled and chopped
1 teaspoon ground cumin
1 sprig fresh rosemary (or 1 teaspoon dried
 mixed herbs)
1 × 400 g (14 oz) can of white beans, drained
 (I use cannellini or butterbeans)
800 ml (3 ½ cups) vegetable stock
Sea salt and black pepper to taste

To serve (optional)
Vegan crème fraîche (soured cream)
Chives, finely chopped
Freshly ground black pepper

Method

Heat the oil in a medium/large saucepan over a medium heat, and add in the leeks, garlic, onion, sweet potatoes, cumin, herbs and beans. Fry for a couple of minutes on a sizzling heat.

Stir in the vegetable stock, bring to a gentle simmer and cook for 15 minutes or until the sweet potatoes are soft. Remove the rosemary sprig, if using, and discard.

Using a stick blender, blitz until smooth. Or, if you prefer it not to be blended, cut all the vegetables very small when preparing them. Taste and season with sea salt and pepper if necessary.

To serve
Serve the soup in a bowl with a spoonful of vegan crème fraîche on top, if using, and garnish with chopped chives and black pepper.

CATE BLANCHETT

Soups, Sandwiches, Salads

CREAM OF TOMATO SOUP

On Set, London

Cate was in London filming the last scenes of a production that had been months in the making, so to give her some much-needed sustenance I took her some of my homemade Cream of Tomato Soup—food for the soul, veggie Jewish penicillin. It's inspired by the recipe my mum used to make for me; my favourite comfort food. It was winter and already getting dark when I was shown into her dressing room. Grabbing a moment together while she had a break between takes, she was, as always, a delight and eager to check out what I'd brought.

I suddenly had a mild panic attack as I realised maybe it wasn't the cleverest thing to bring this leading lady bright red soup with its spill-on-costume potential. I very carefully poured her a bowl with a doorstop slice of toasted sourdough for dunking. She enjoyed the unexpected little kick of my secret ingredient, chilli jam. Cate dined at her hair and make-up dressing table. With her script and her horn-rimmed reading glasses waiting for attention, I sneaked a look at her handwritten notes and ideas scribbled on top. With Cate nourished and revived, my job here was done. Not a drop of soup was spilled!

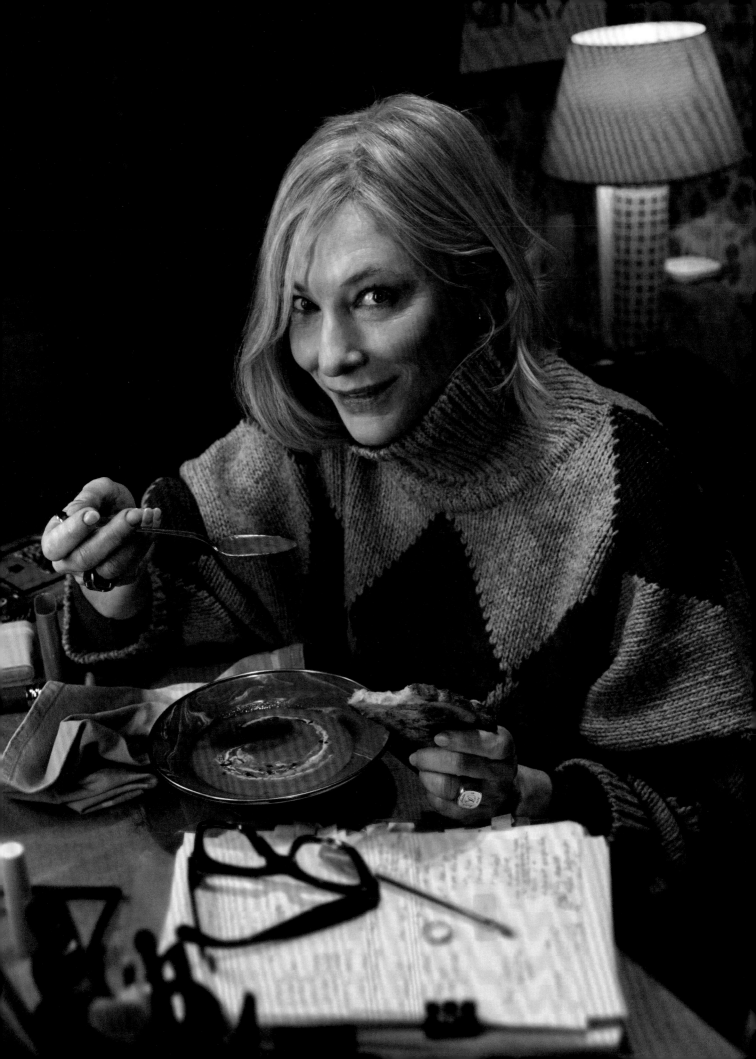

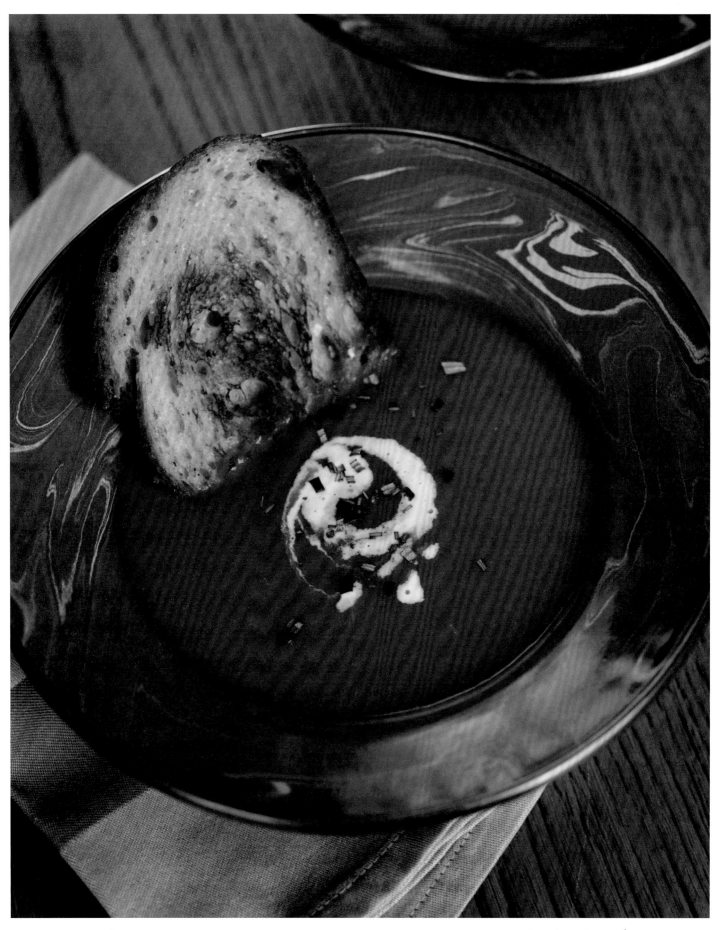

Inspired by my mother this is pure comfort food. Can be made all year round, using skinned fresh tomatoes when in season, or jarred whole tomatoes in the colder months. A soup that makes me happy.

98

CREAM OF TOMATO SOUP

Ingredients

2 tablespoons olive oil
1 stick celery, chopped
1 medium onion, chopped
550 g (20 oz) fresh plum tomatoes, skinned
 (or the equivalent in canned or jarred
 whole tomatoes)
300 ml (10 fl. oz) vegetable stock
2 tablespoons tomato paste
1 tablespoon chilli jam or sweet chilli sauce
2 sprigs of fresh rosemary
240 ml (1 cup) unsweetened plant-based cream
Freshly ground black pepper and sea salt to taste

To serve

A drizzle of unsweetened plant-based cream
Toast (optional)

Method

Add the olive oil to a large saucepan over a medium heat and sauté the celery and onion for 2–3 minutes, until they start to soften.

If using fresh tomatoes

To skin the tomatoes, score the end of the tomatoes gently with a knife. Place them in a large saucepan, and pour boiling water over them until they are submerged. Leave the tomatoes to blanch in the boiling water for 3–4 minutes. Pour away the boiling water and run cold water over the tomatoes. Once they are cool enough to handle, peel away the skin (it should come off very easily).

If using jarred whole tomatoes

Drain the tomatoes through a sieve over a bowl (retaining the liquid to make the vegetable stock quantity). Add boiling water to the retained tomato liquid to make the amount up to 300 ml (10 fl. oz), along with a vegetable stock cube or 1 tablespoon of low sodium bouillon powder.

Roughly chop the tomatoes and add them to the saucepan with the celery and onion. Stir in the tomato paste, chilli jam and rosemary sprigs. Then pour in the vegetable stock, bring to a gently bubbling simmer and cook for 10–15 minutes.

Remove the rosemary sprigs and discard them. Use a handheld immersion stick blender to blitz the soup until smooth. Finally, stir in the plant-based cream and season with sea salt and black pepper to taste.

To serve

Serve the soup garnished with a swirl of cream, and toast or a sandwich on the side.

NILE RODGERS

Soups, Sandwiches, Salads

ROASTED
TOASTED SALAD

Abbey Road Studios, London

I grew up around the corner from Abbey Road Studios, so it's a historic place close to my heart. Today, I was bringing lunch to the multi-talented, multi-hyphenate legend Nile Rodgers. As he shares my love for the studios, it was the perfect meeting place.

I prepped the autumn-inspired Roasted Toasted Salad, full of depth, colour and texture, at home. I live nearby, so I took the opportunity to stroll over to the studios, soaking up the sunlight on the way. A self-confessed workaholic, Nile never stops writing, creating, recording—and I found him in a writing room, looking fabulous, wearing full colour and pattern, as well as his trademark beret and contagious smile, with his

famous Hitmaker Stratocaster by his side, as always.

I said I would meet him in the café downstairs. I've spent a lot of time in that café over the years, so I knew the staff would lend me a plate and some cutlery. The recording studios have no windows, to avoid distractions while making music, so we chose a table in the café near the windows, where we could enjoy the sunlight streaming in. Nile savoured every bite, and it was lovely to have that time with him. Time to get back to work, we said our goodbyes, and I enjoyed just watching him cross the café, briefly stopping to say hello to everyone on his way. Abbey Road Studios has a warm community feel, a home away from home.

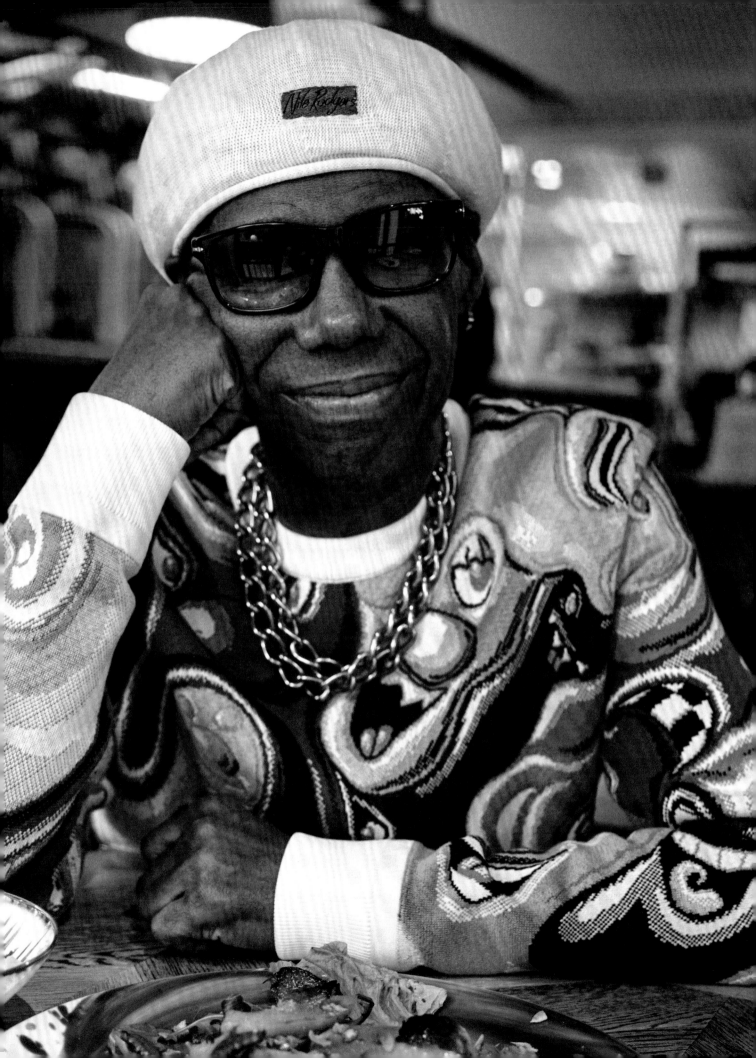

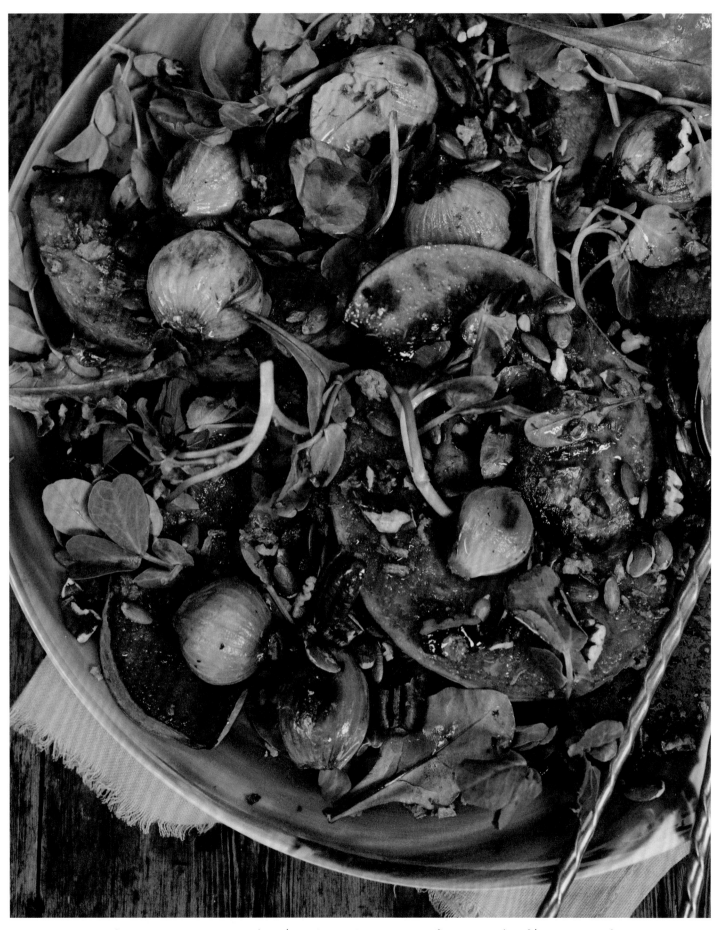

A centrepiece salad celebrating the Autumnal flavours of roasted pumpkin and shallots, on a bed of fresh green leaves and topped with toasted pecans, pumpkin seeds and shop bought crunchy fried onions. United with a mustard vinaigrette dressing.

ROASTED TOASTED SALAD

Ingredients

Roasted Vegetables
1 small pumpkin or butternut squash
 (about 600g/1⅓ lb), peeled and deseeded
12 round shallots (about 200g/7oz),
 peeled and kept whole
2 tablespoons balsamic vinegar
2 tablespoons olive oil
Sea salt and freshly ground black pepper to taste

Toasted Toppings
50g (⅓ cup) pecans, roughly chopped
2 tablespoons pumpkin seeds

Dressing
4 tablespoons extra virgin olive oil
1 tablespoon of freshly squeezed lemon juice
4 teaspoons red or white wine vinegar
2 teaspoons wholegrain or Dijon mustard
Small pinch of sea salt

To serve
150g (5oz) mixed salad leaves
 (I use rocket/arugula, watercress
 and baby spinach)
2 tablespoons crispy fried onions
 (store-bought)

Method

Preheat the oven to 180°C/350°F.

Roasted Vegetables
Slice the peeled butternut squash into 1cm (½in.) thick pieces. Arrange the butternut squash and peeled shallots onto a baking tray and drizzle with balsamic vinegar and olive oil. Toss to coat, then sprinkle over a pinch of sea salt and black pepper. Roast for 35 minutes, checking halfway through to give them a mix around.

Toasted Toppings
While the vegetables are cooking, in a small frying pan over medium heat (no need to add oil), toast the pecans and pumpkin seeds for 1–2 minutes, until they start to lightly brown. Remove from heat.

Dressing
Put all the dressing ingredients in a jug and whisk with a fork, or place in a jar with a lid and shake well until combined.

To serve
Lay the bed of salad leaves on a serving board or large plate. Arrange the roasted shallots and squash evenly on top and drizzle over the dressing. Then finally, for the crunchy additions, sprinkle over the toasted pecans, pumpkin seeds and crispy onions.

JAY BROWN

Soups, Sandwiches, Salads

PLANT
CAESAR SALAD

Home, Los Angeles

I remember first meeting Jay in 2013, after a Rihanna concert at the Shepherd's Bush Empire during her world tour. I met him again, a few years later, when at the BRITs, busy setting up my official backstage portrait studio. He took the time to come and say hello and check in with me, which really made an impression. I found out not only was Jay Rihanna's manager, but also the co-founder of Roc Nation, and literally the busiest person I know. I often wonder how he still manages to be so easy-going.

My husband and I got to know Jay better when he was spending a lot more time in London when Rihanna was based here. He's a family man, and his wife and kids would come to spend part of their summer in my hometown, where we all became pals.

When I was in LA, Jay's hometown, I saw him at a party, and I told him about *Feeding Creativity* and invited him to participate. I didn't think for a moment he would say yes, knowing how busy he is, but Jay being Jay, he made the time. I popped over to see him, with my husband, to try out my new recipe: Plant Caesar Salad with torn sourdough croutons. I was particularly proud of this one, especially that dressing! Each time I dunked a crouton in, it surprised me just how darn good it was! When we got there, Jay was home alone. I put the salad together and we took it outside to eat. Jay talked us through his upcoming projects, which was enough to make us both feel positively lazy. He has an effortless charm and humility. And he devoured the salad; a result in my books.

A hearty fresh salad — torn sourdough croutons, sliced avocado, crisp lettuce and balsamic coated plant "chicken" fillet. All tossed in a mooth watering creamy Caesar dressing.

PLANT CAESAR SALAD

Ingredients

Croutons
1 large loaf of sourdough bread
2 tablespoons extra virgin olive oil
2 tablespoons fresh oregano leaves,
 chopped or dried
Sea salt and freshly ground black pepper to taste

Vegan "Chicken" Fillets
4 plant-protein "chicken" fillets
1 tablespoon olive oil
4 teaspoons balsamic vinegar

Caesar Dressing
60 g (¼ cup) mayonnaise (vegan)
1 tablespoon capers
1 tablespoon maple syrup
1 tablespoon Dijon mustard
1 tablespoon extra virgin olive oil
1 tablespoon soy sauce
2 teaspoons B_{12} nutritional yeast flakes
2 teaspoons white wine vinegar
 (or apple cider vinegar)
2 garlic cloves
1 tablespoon freshly squeezed lemon juice

To serve
2 heads romaine lettuce, roughly chopped
2 ripe avocados, halved and sliced
Freshly ground black pepper

Method

Preheat the oven to 200°C/400°F.

Croutons
Cut the sourdough loaf in half and pull out the interior soft bread, breaking it into large bite-sized pieces. (You can use the leftover crust to make a toasted open-faced sandwich or breadcrumbs.)

Place the torn sourdough pieces on a baking sheet and drizzle over the oil. Sprinkle with the oregano, sea salt and pepper and toss to coat. Place in the oven to cook for 10 minutes, until golden and crisp.

Plant-Protein "Chicken" Fillets
While the croutons are baking, fry the "chicken" fillets in the olive oil in a large non-stick frying pan over a medium heat until they are cooked through (refer to the side of the pack for exact instructions). When they are almost ready, drizzle 1 teaspoon of balsamic vinegar on top of each one to glaze and cook for 2 minutes. Remove from the pan and slice into pieces, around 2 cm (¾ in.) thick.

Caesar Dressing
Add the mayonnaise, capers, maple syrup, mustard, olive oil, soy sauce, B_{12} nutritional yeast flakes, vinegar, garlic and lemon juice to a jug or glass and blitz with a handheld stick blender for about 30 seconds, until the dressing is smooth and creamy (or blitz in a blender).

To serve
Add the lettuce and sliced avocado to a large bowl. Add in half of the croutons and around half of the dressing and toss to coat. Then, top with the remaining croutons and the vegan "chicken" slices. Drizzle over the remaining dressing and finish with some freshly cracked black pepper to taste.

ELVIS COSTELLO

Soups, Sandwiches, Salads

CHICKPEA "TUNA" SALAD SANDWICH

Electric Lady Studios, New York

Checking in with Elvis, I found out he was recording with T Bone Burnett and Christopher Guest at Electric Lady Studios in Greenwich Village, Manhattan's oldest working (and thriving) recording studio. Elvis told me he had written an imaginary radio show, *The Coward Brothers*, about feuding musical siblings. He took a little persuading, as the studio is a private space to concentrate and create, but I promised not to distract him, and we decided on a short catch-up when they were planning to take a break in the session, during which I'd bring him my Chickpea "Tuna" Salad Sandwich to try out. This seemed all the more fitting when he replied that the title of his new album would be *Doorstop Sarnie*, a northern English nickname we both use for a thick sandwich.

I felt nostalgic as my husband and I walked into Electric Lady Studios, as I imagined my mum (Linda Eastman back then) coming there in the '60s to sit in on recording sessions with Jimi Hendrix and taking photos for him (they collaborated often). Elvis knew and loved Mum too. The studio had a rock-and-roll atmosphere and low, warm lighting. We found a chill-out space just off the recording studio with a comfortable long green sofa and music poster collage wallpaper. Both Elvis and my husband are big Liverpool FC fans, so that was the first point for discussion. I was more concerned about what Elvis thought of the sarnie. Good news—all that was left were crumbs. Caught up and break over, we sent Elvis back into the studio.

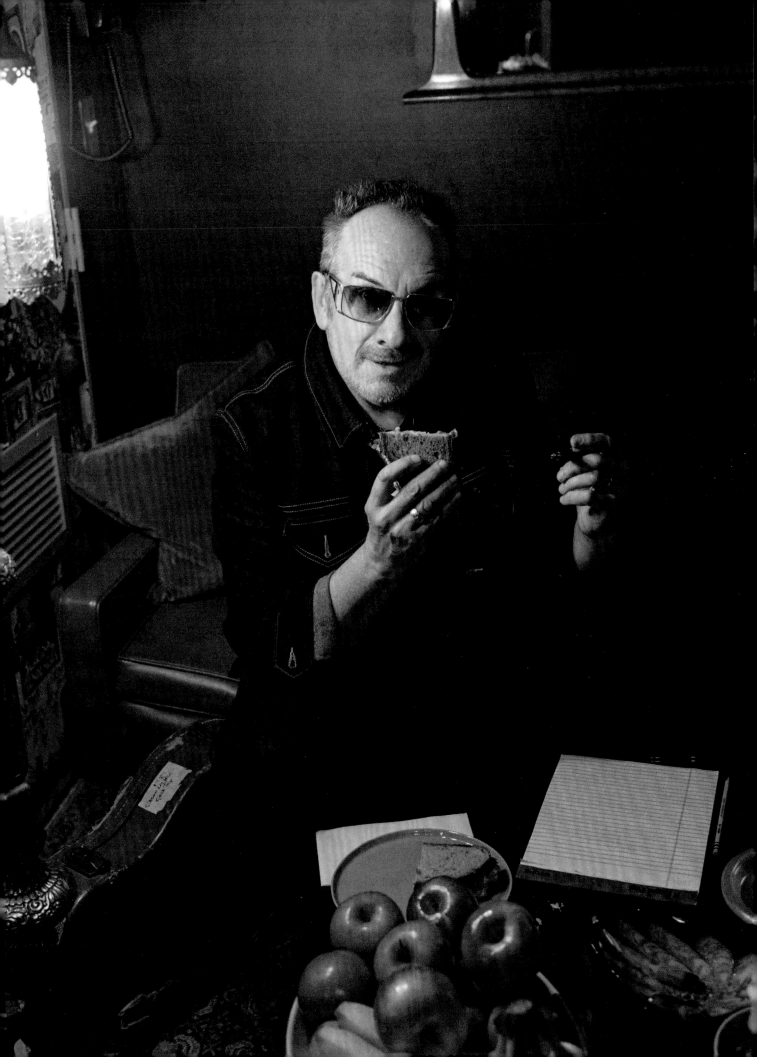

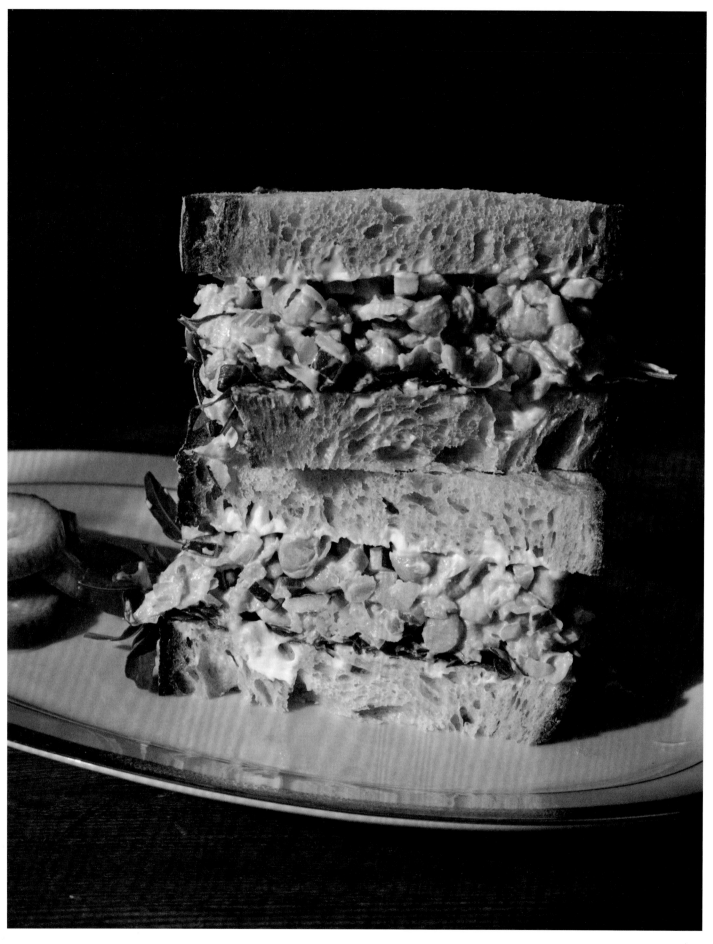

A very satisfying protein rich filling, made within minutes. The perfect sandwich filler. Also great spooned onto a baked potato or salad.

CHICKPEA "TUNA" SALAD SANDWICH

Ingredients

1 × 400 g (14 oz) can of chickpeas, drained
 and rinsed (you can retain the liquid as
 it is aquafaba, a vegan egg substitute*)
3 tablespoons mayonnaise (vegan)
1 tablespoon capers, roughly chopped
1 tablespoon pickled cucumber relish (or similar)
1 stick celery, strings peeled away
 and finely chopped
1 small red onion, finely chopped
Juice of ½ a lemon
Sea salt and freshly ground black pepper to taste

To serve
4 slices of sandwich bread of your choice
Mayonnaise (vegan) (optional)
Whole-grain mustard (optional)
Handful of rocket (arugula)

*Retained aquafaba can be used in my Sesame
Tofu and Teriyaki Noodles recipe, page 171

Method

Chickpea "Tuna" Salad
Put the chickpeas in a medium mixing bowl and press with a potato masher until they are all crushed but there's still some texture. Stir in the mayonnaise, capers, cucumber relish, celery and red onion. Squeeze in the lemon juice and give it all a good mix. Season with sea salt and pepper. It's that easy!

To assemble
Spread a thin layer of mayonnaise on one slice of bread and a thin layer of mustard on another slice. Add the rocket on top of the mayonnaise. Spoon the chickpea "tuna" filling on top, then put on the lid and cut it in half. Repeat for the second sandwich.

GILBERT
& GEORGE

Soups, Sandwiches, Salads

PBLT SANDWICH

Artists' Studio, London

Gilbert & George do not have a kitchen at their East London home, as they never eat in. Like clockwork, they go to the café around the corner for a lunchtime sandwich, and, in the evening, to the local Turkish place. They eat the same thing every day. Gilbert said to me, *"Life is too short to read menus"*. With this in mind, I decided to take them a café-style sandwich with a twist, something they have never tried before, a Plant-protein Bacon, Lettuce and Tomato Sandwich. I could see they were curious, as they took the sandwiches to their courtyard table to eat. Gilbert was less sure about the sandwich, but George prompted him to give it a try. With George making encouraging comments and noises, Gilbert had a bite, and he was curious enough to carry on eating. He seemed to like it.

We discussed how my mother had taken their portraits years before. George asked, *"How is your mother?"* and I had to explain she passed away a long time ago. I loved watching the way they moved and posed together; a living art form. They were excited to tell me they were putting the finishing touches on their new foundation, The Gilbert & George Centre, which would showcase their creations. We walked around the corner down Brick Lane to the new space for a private tour. Housed in a former brewery, it had a real warmth to it, with wooden floors and white walls suspended in front of the original brickwork. In one gallery, several men were busy hanging large artworks to launch the exhibition. Amused, George said, *"Great to see lots of men screwing in a room"*. Unfazed, the gallery hang continued.

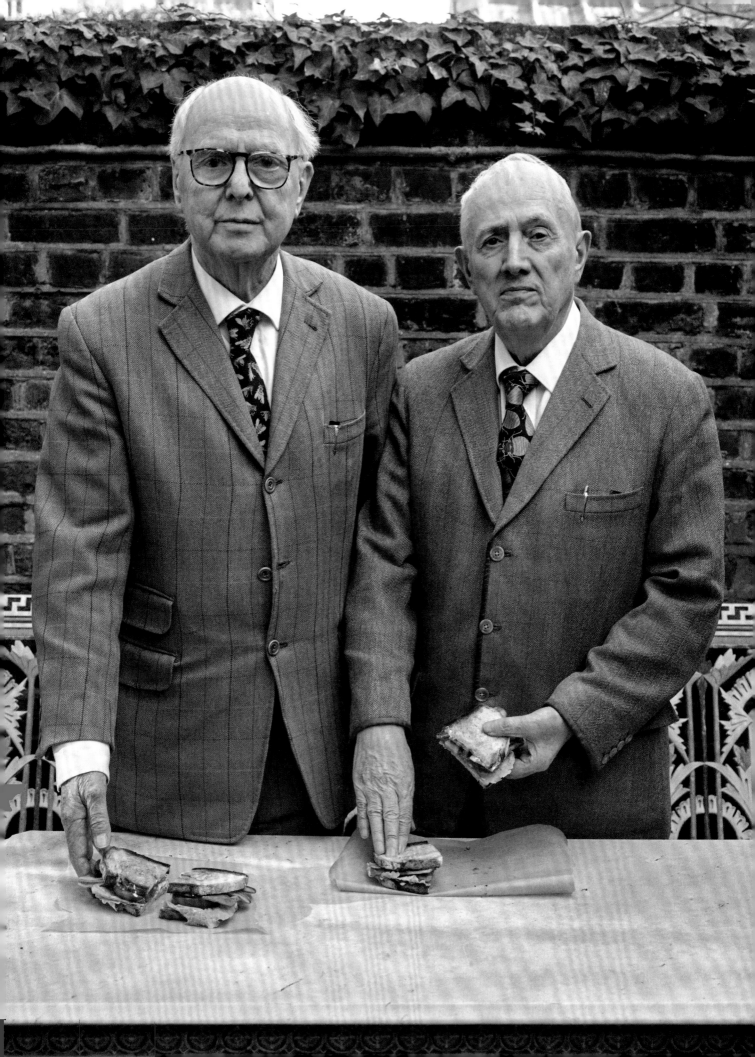

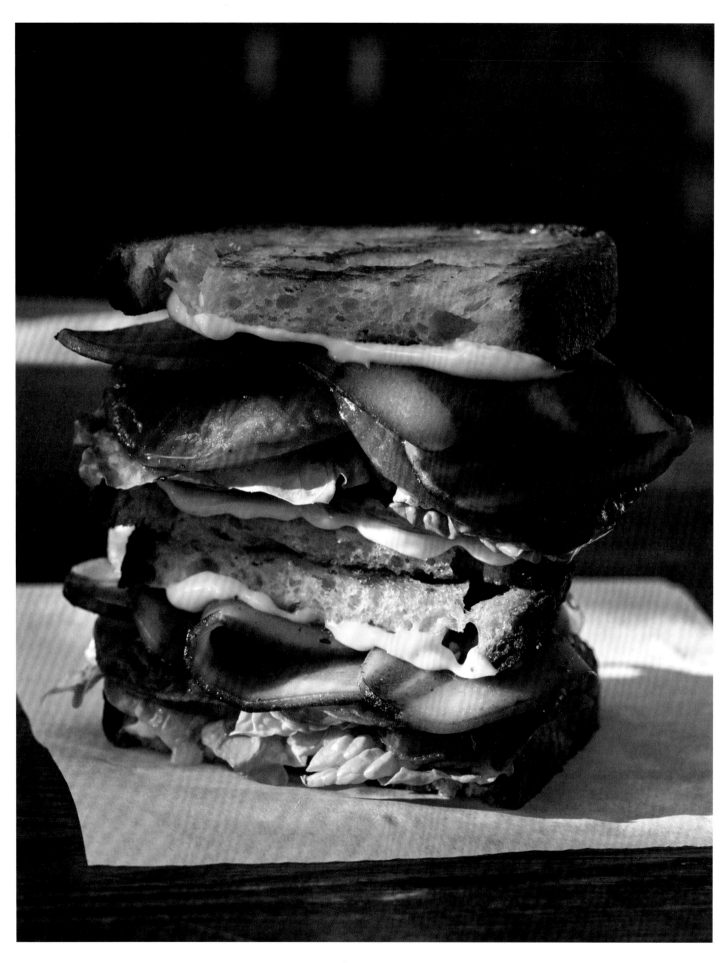

All of the taste of a classic BLT, made by simply swapping out with plant protein bacon.

PBLT SANDWICH

Ingredients

2 slices of lightly toasted sandwich bread
of your choice
1 tablespoon mayonnaise (vegan),
or as much as you prefer
1 teaspoon Dijon or whole-grain mustard,
or as much as you prefer
Baby gem lettuce
1 thinly sliced tomato
½ teaspoon balsamic, a little drizzle
Sea salt and black pepper to taste
3 slices plant-based bacon, fried as
per pack instructions

Method

Spread one of the pieces of toast with mayonnaise and the other piece with mustard.

Place the lettuce on top of the mustard, and then lay on the tomatoes. Season the tomatoes with a drizzle of balsamic vinegar, a pinch of sea salt and a little black pepper. Add the fried plant-based bacon and finish by placing the slice of toast with mayonnaise on top.

Press the sandwich down, slice in half and enjoy!

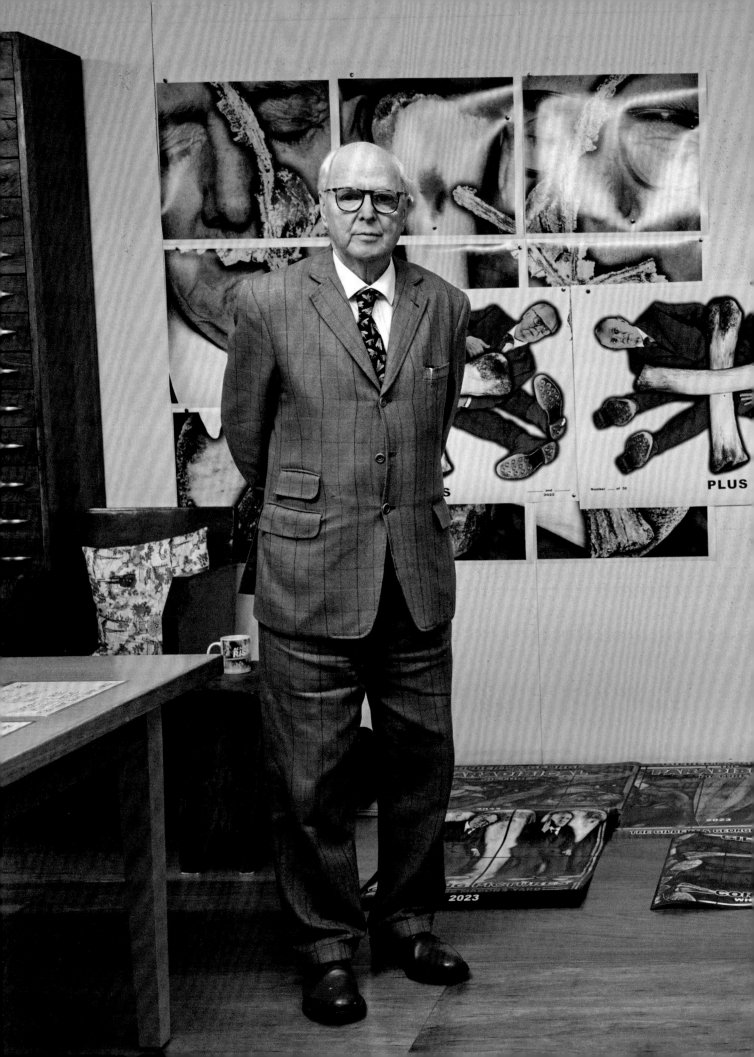

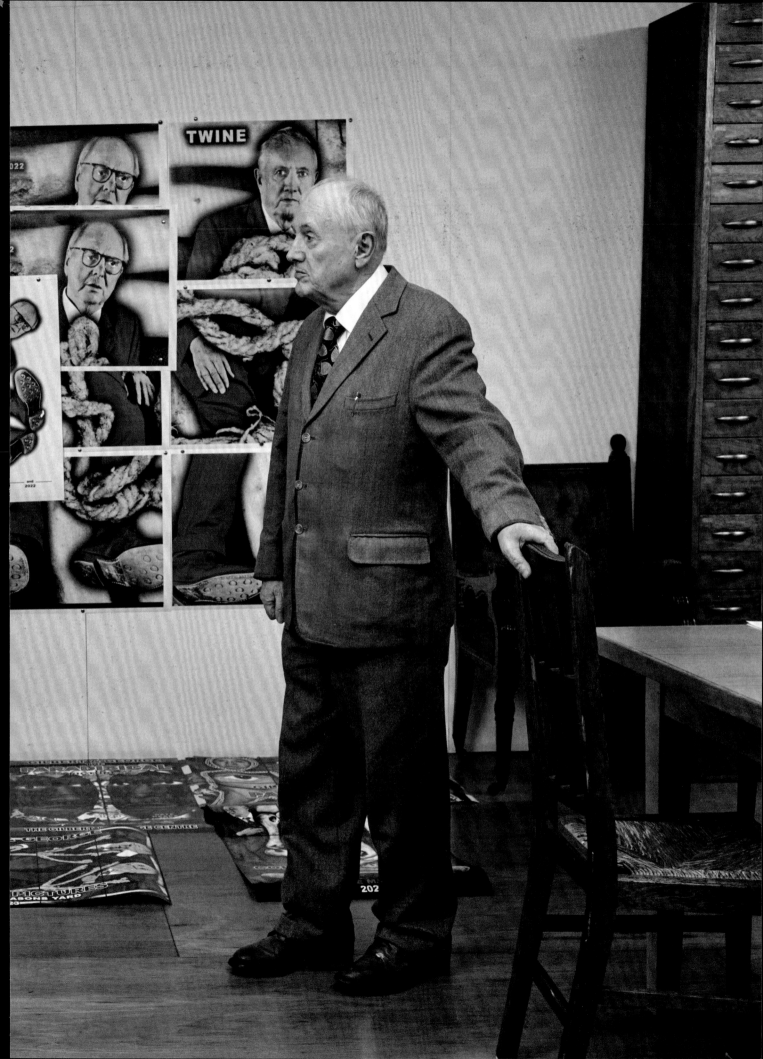

MAINS

SIMONE ASHLEY

Mains

SMOKED TOFU PAD THAI

Studio Kitchen, London

While filming season three of my Emmy-nominated cooking show, *Mary McCartney Serves It Up!*, I was thrilled to be joined in the kitchen by leading actor Simone Ashley, who shares my passion for cooking; it felt apt that we met for the first time in my kitchen. I was immediately struck by her vibrant personality and infectious enthusiasm. Simone arrived, make-up and wardrobe done, ready for the cameras to roll. As we bonded in the kitchen, we discovered that our shared love of food was heavily influenced by growing up watching our mothers cook.

She also noticed we were both lefties (left-handed). Our friendship was now complete. Before we got to cooking, she asked me whether I wanted to play the lemon knife game. I had never heard of it. She explained that it involved her holding a large sharp kitchen knife and me hurling a lemon up in the air for her to catch

on it! We did it in three tries! And it was caught on camera as proof. I had chosen a Smoked Tofu Pad Thai for us to make together—fresh, quick, stress-free and delicious. Simone mentioned that, although she loved cocktails, she had never actually made one herself. So, first on the menu was the cocktail I had earmarked for the occasion. I filled a tumbler with ice, added 50 ml (2 oz) vodka, 25 ml (1 oz) ginger and lemongrass cordial (or similar) and used a vegetable peeler to cut a twist of lime peel/zest. Then I squeezed in the juice of half of that lime, poured in 100 ml (4 oz) soda water and added 1 hot red chilli, pricked with holes with a toothpick to release the spice. Simone named it M's Kick, as the red chilli gives it a kick of heat. Drinks at the ready, we got on with prepping the veg, whipping together that hero sauce and mixing in the noodles. Ready, with bowls in hand, we tucked in.

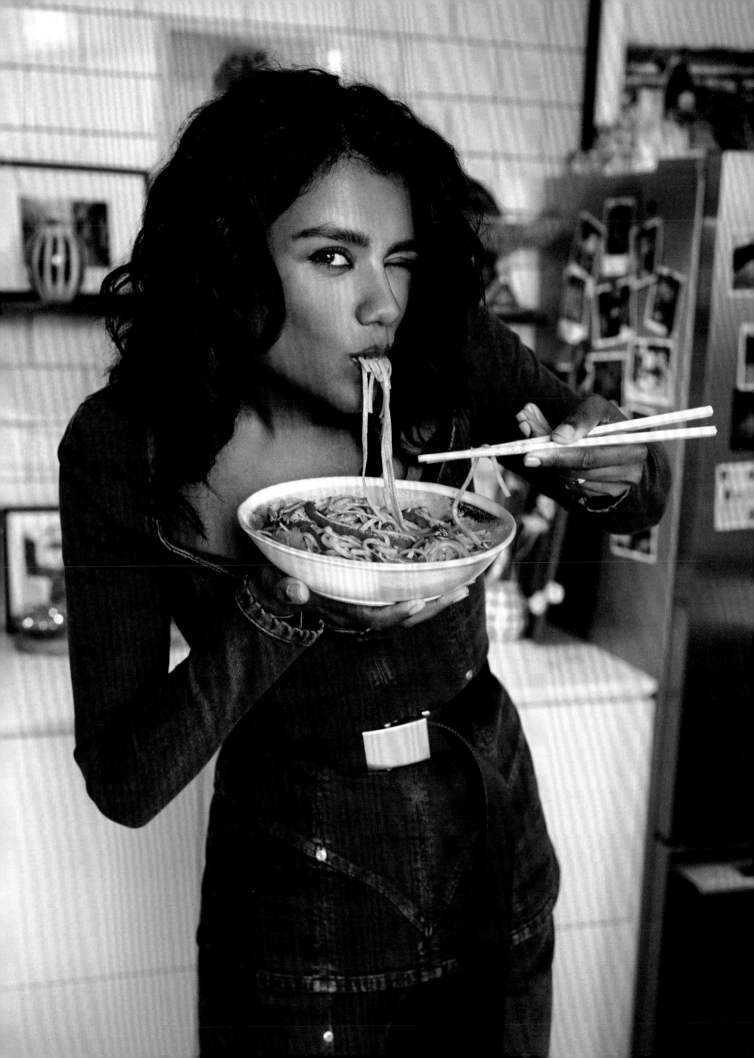

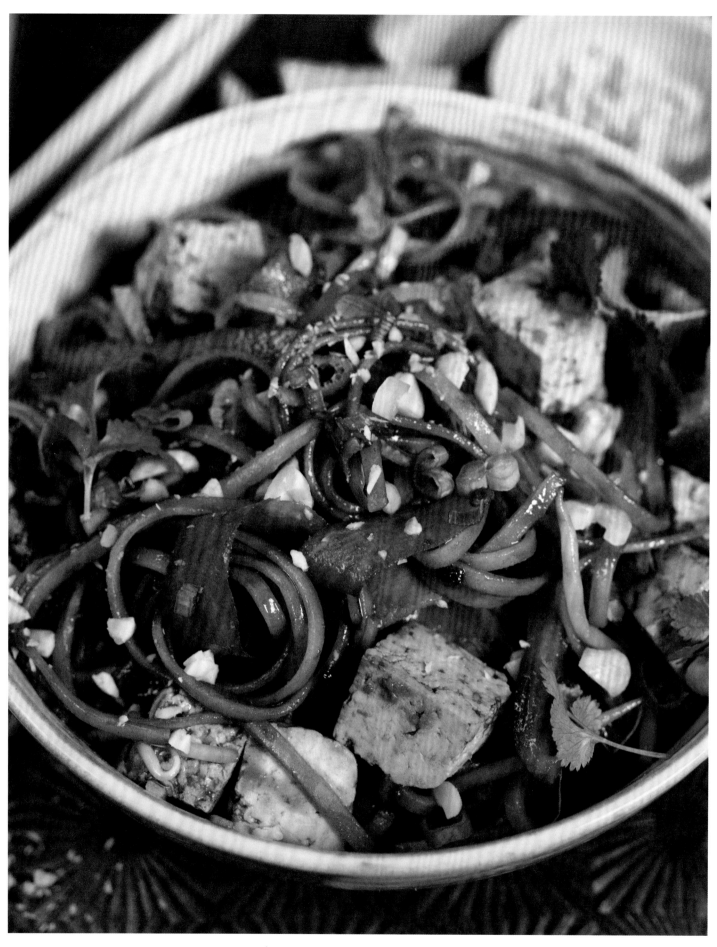

Stir fried rice noodles, vegetables and smoked tofu for
extra protein— all coated in a classic tamarind sweet, sour
and salty sauce. Served with M's kick cocktail.

SMOKED TOFU PAD THAI

Ingredients

Sauce
2 tablespoons tamarind paste
60 ml (¼ cup) low sodium soy sauce
 (or tamari for gluten-free)
3 tablespoons vegan fish sauce
2 tablespoons chilli jam or sweet chilli sauce

Noodles
200 g (7 oz) flat rice noodles
2 tablespoons toasted sesame oil
3 garlic cloves, finely chopped
225 g (8 oz) smoked firm tofu, cut into bite-sized cubes
1 red chilli, deseeded and finely chopped
1 red pepper (capsicum), deseeded and thinly sliced
1 medium carrot, thinly sliced into ribbons
 using a vegetable peeler
5 cm (2 in.) ginger, peeled and grated
5 spring onions (scallions), green and white
 parts thinly sliced
150 g (5 oz) fresh bean sprouts

To serve
Handful of coriander (cilantro) or parsley, chopped
Red chilli, thinly sliced
60 g (½ cup) roasted peanuts, chopped
1 lime, chopped into wedges

Serve with M's Kick

Method

Sauce
Add the tamarind paste, soy sauce or tamari, vegan fish sauce and chilli jam to a small mixing bowl and stir well.

Noodles
Add the noodles to a large heat-proof mixing bowl and cover them with boiling water until completely submerged. Leave to soften until al dente, according to pack instructions. Then drain the noodles and place them in cold water, preventing them from sticking together until ready for the next step.

In a large frying pan or wok, heat the sesame oil on medium-high heat. Add the garlic, smoked tofu, chilli, red pepper, carrot, ginger and spring onions and stir-fry for a minute. Drain the noodles in a colander, then add them to the vegetables along with the bean sprouts.

Now gently stir in the sauce and bring all of the ingredients together by mixing them and ensuring they are coated in the sauce. There should be enough heat to hear all the vegetables and noodles sizzling as they cook. Cook for a couple of minutes so that all the ingredients are heated through, but do not begin to wilt.

To serve
Sprinkle over the chopped coriander or parsley, red chilli and chopped peanuts, and top each plate with a wedge of lime to squeeze over the noodles.

PETER BLAKE

Mains

BLACK LENTIL SWEET POTATO COCONUT CURRY

Artist's Studio, London

The first artist I approached to be in this book was my dear friend Peter Blake. Our ongoing collaborative relationship means that I've spent a lot of time at his West London studio over the years, as Peter would often ask me to take portraits of his sitters for him to then paint from; subjects have included the boxer Ricky Hatton, musician Eric Clapton and Glastonbury Festival founder Michael Eavis. His studio, an art-making hideaway, is also home to his treasure trove of diverse and wide-ranging British memorabilia and collectibles. Unlike the rest of the space, however, the kitchen is a small, clutter-free area in the corner of the studio. Peter explained that he originally imagined this room to be a sparse space, almost like a prison cell, adorned simply with a small, green-tiled table, chairs and a practical little Belling oven topped with a two-ring hob. When he moved into the studio in 1997, the idea was that he could simply heat up soup, or hastily fry something, while he was in the middle

of his creative process. He told me the oven had never been used.

Peter said that I was one of the only people who has brought him lunch at his studio. We chatted while struggling to reach the power socket behind the cupboard, as we needed to power up the hob. Peter decanted my Black Lentil Sweet Potato Coconut Curry into a small saucepan and put the rice into a frying pan to heat it up. I had come up with this simple recipe thinking of Peter and wanting to create something that would be hearty and warming to eat in his studio kitchen during the colder months. He stood diligently stirring and heating my offerings. Peter, his lovely wife Chrissy and I sat down at the table to eat. We talked about everything from art to boxing to music to family and the collaborations we have done over the years. After lunch, Peter gave me a sneak peek at the new collages he is working on. As ever, I left feeling inspired.

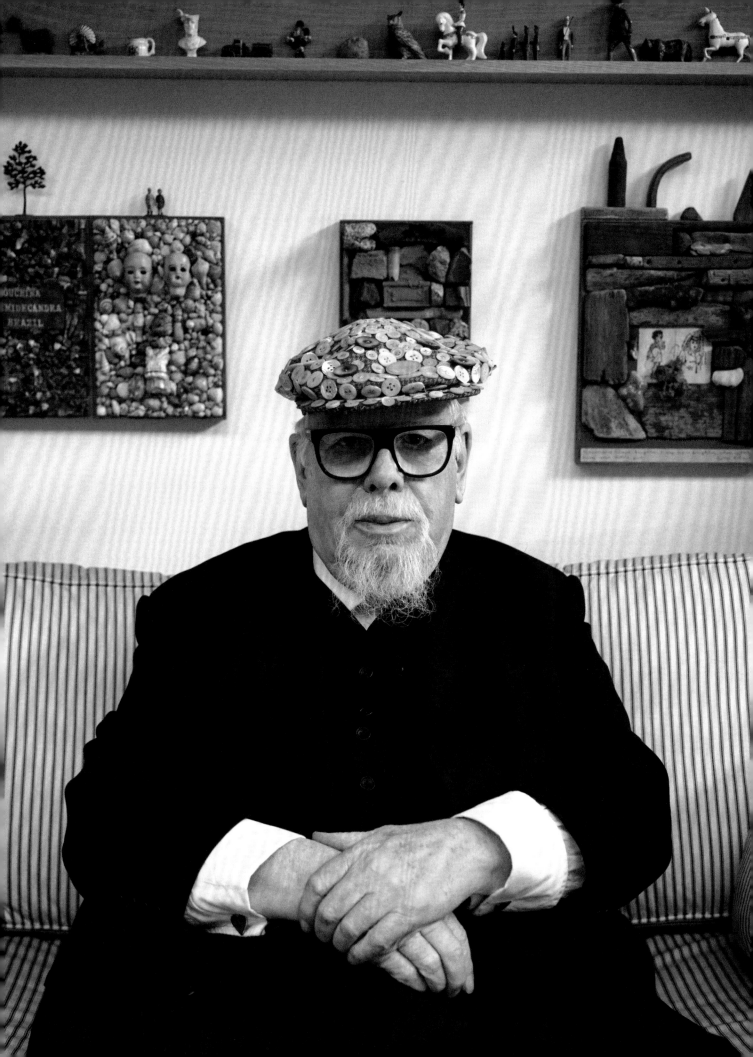

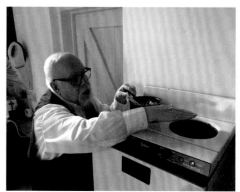

Simply delicious: Black lentils
and sweet potato gently simmered
in a spice infused coconut sauce.
Can be served with steamed rice,
or naan bread or both!
I often make extra to freeze for
a go to midweek meal.

BLACK LENTIL SWEET POTATO COCONUT CURRY

Ingredients

2 tablespoons olive or vegetable oil
1 medium onion, finely chopped
5 cm (2 in.) ginger, peeled and grated
500 g (1.1 lb) sweet potato, peeled and chopped
 into bite-sized pieces
3 medium garlic cloves, chopped finely
½ teaspoon chilli flakes, or more if you like it hotter
½ teaspoon ground turmeric
½ teaspoon ground cumin
1 tablespoon tomato paste
200 g (1 cup) cooked black lentils
 (as they hold their shape, I use Puy)
1 × 400 ml (14 oz) can of coconut milk
Pinch of sea salt to taste

Serving suggestions (optional)
Chopped fresh parsley or coriander (cilantro)
Basmati or long-grain rice of your choice
Cauliflower rice
Naan bread
Lime wedges
Mango chutney

Method

Heat the vegetable oil in a large saucepan, add the onions and ginger and cook for 2 minutes. Then add the sweet potato pieces and bring up to a gentle sizzling heat.

Add the garlic, chilli flakes, turmeric and cumin and stir. Cook for 2 minutes to toast the spices, then add the tomato paste. Stir and cook for an additional minute.

Mix in the cooked black lentils. Now stir in the can of coconut milk. Bring to a gentle simmer and stir well. Allow to cook for 10–15 minutes, until the sweet potato is cooked through. Season with sea salt to taste.

To serve
Spoon the curry into bowls and garnish with fresh parsley or coriander. Serve with rice or naan.

DAD AND RINGO

Mains

CREAMY GREEN PASTA

Home, London

Ringo and his wife, Barbara, were over from LA to visit their kids and grandkids. While they were in London, I interviewed Ringo about his recollections of the time he spent at Abbey Road Studios for the documentary I was directing. Dad was also in town, so I seized the opportunity and arranged a get-together over lunch at Dad's place. These days, Dad and Ringo live miles apart, so they don't get together that often, but when they do, it's magical. With over 60 years of friendship, it's so full of love, it's like they've never been apart. They just pick up where they left off, and it's always great to hear their banter.

When it comes to food, Dad is a pleasure to cook for—that's easy and I do it all the time. Ringo, on the other hand, is much more complicated, as he is allergic to onion and garlic. I have seen this throw waiters into a panic! Intrigued by a life without onions and garlic, I have often grilled Ringo about what he likes to eat. Armed with that knowledge, I opted for a recipe that is delicious, even without these staple ingredients—a large bowl of creamy pasta, infused with lemon, peas and asparagus, well-seasoned and topped with herby toasted breadcrumbs (*pangrattato*) for extra texture. Ringo arrived and did his best to distract me, with his brilliant sense of humour leaving me in stitches. I served the meal family-style so that everyone could get stuck in, feeling content to cook for such an appreciative group of loved ones.

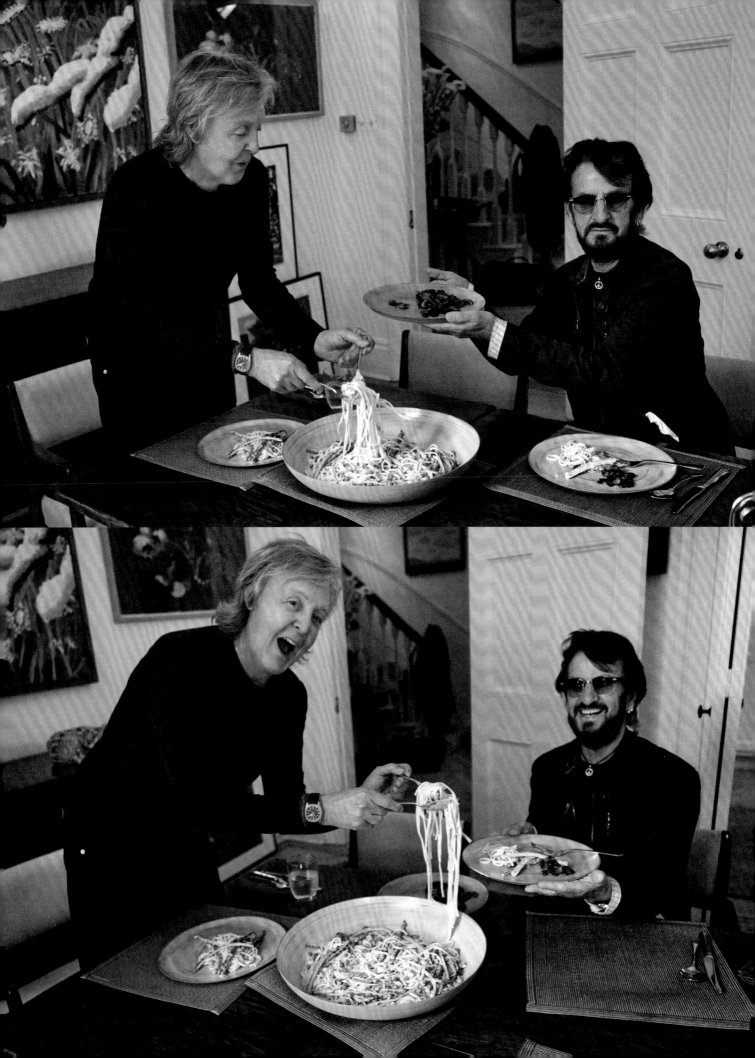

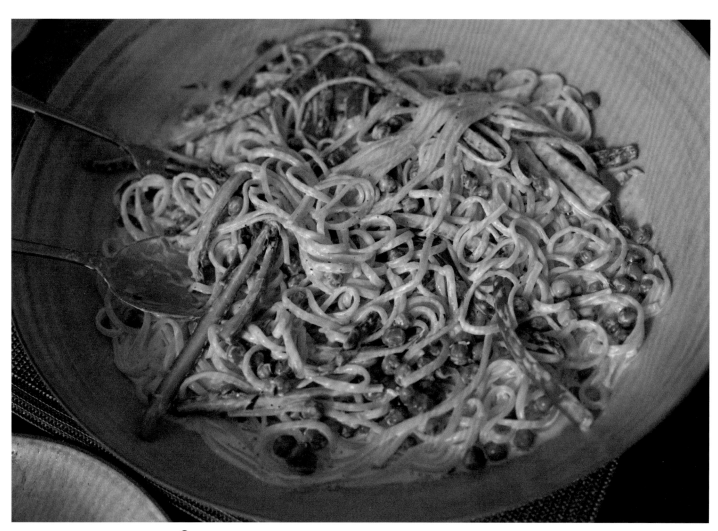

Get tucked into this citrus infused creamy, asparagus and pea tagliatelle. Plus you can swap out for any pasta you fancy at the time.

CREAMY GREEN PASTA

Ingredients

400 g (14 oz) tagliatelle or spaghetti
 (or pasta of your choice)
Pinch of sea salt

Toasted Breadcrumb Topping
1 tablespoon olive oil
2 slices of stale bread, blitzed to fine crumbs
Generous pinch of sea salt
Pinch of freshly ground black pepper
2 tablespoons fresh parsley, finely chopped

Creamy Sauce
200 g (7 oz) asparagus, woody ends broken off
400 ml (1¾ cups) unsweetened plant-based cream
4 tablespoons B_{12} nutritional yeast flakes
Zest of 1 lemon
Sea salt and freshly ground black pepper, to taste
140 g (1 cup) frozen peas, thawed

To serve
Basil leaves (optional)

Method

Bring a large saucepan of water to a boil (add a large pinch of sea salt, but do not salt the water if using gluten-free pasta) and boil the pasta according to the packet instructions until al dente.

Toasted Breadcrumb Topping
Place a large, tall-sided frying pan over medium-high heat and add the olive oil, breadcrumbs and a good pinch of sea salt and black pepper. Fry, shaking the pan and stirring frequently until the breadcrumbs are golden and crisp. Remove from the heat and stir in the chopped parsley, then tip the mix into a bowl and set aside (no need to wash this pan, as it can be used for the pasta sauce).

Creamy Sauce
Slice the asparagus into long, thin strips. Place in a medium heat-proof bowl and cover with boiling water to allow it to soften and cook until al dente (about 5 minutes) then drain.

Using the same tall-sided frying pan as before, gently heat the cream. Once it's warm, season with the B_{12} nutritional yeast flakes, lemon zest, a generous pinch of sea salt and lots of freshly ground black pepper.

Add the drained asparagus and the peas to the cream. Bring to a gentle simmer for a couple of minutes to infuse all the flavours. Stir well.

Drain the cooked pasta in a colander and add to the pan, gently tossing to coat it in the sauce. Taste to check if it is seasoned to your liking

To serve
Plate up the pasta with lots of sauce and top with the toasted breadcrumbs. Finish with basil leaves as a garnish, if using.

EDWARD ENNINFUL

Mains

PARTY PIE WITH SCOTCH BONNET HOT SAUCE

Vogue House, London

As editorial adviser of British *Vogue* and global creative and cultural adviser of *Vogue*, Edward is regularly invited to some of the fanciest restaurants on earth. So, I was thrilled to find out from his husband, Alec, that he still loves pies, as that's what I'd had in mind to cook for him. Edward is of Ghanaian heritage and loves strong chilli heat, so I devised a new hot sauce recipe to serve on the side and opted for extra-hot Scotch bonnet chillies in the recipe. I could feel the heat by just breathing in the fieriness as I was cooking, thinking he was braver than me.

When I arrived, Edward was finishing off his last meeting of the afternoon. While I waited, his team helped me find a plate and cutlery. I noticed the navy-blue linen napkins that I had brought from home matched the colour of his three-piece suit perfectly. A lucky omen.

In his office, I was momentarily distracted by the inspiring collection of art reference books filling every inch of the wall, and the majestic orchid in full bloom on his windowsill. Edward was full of smiles, saying he had seen my sister Stella the day before, and told her I was bringing him lunch, so we sent her a selfie together, sending our love. While I was serving him a slice of the pie, he commented on how he loved the different layers inside, and then I put the lethal hot lava of a sauce on the side. Completely undaunted, Edward told me that he had come across only one hot sauce he couldn't handle, and admitted that, in doing so, he had probably destroyed many a taste bud over the years. We were seeing each other later at a roller boogie party for his husband's company, KLOSS films. I was longing to see him roller skate in that beautiful blue suit.

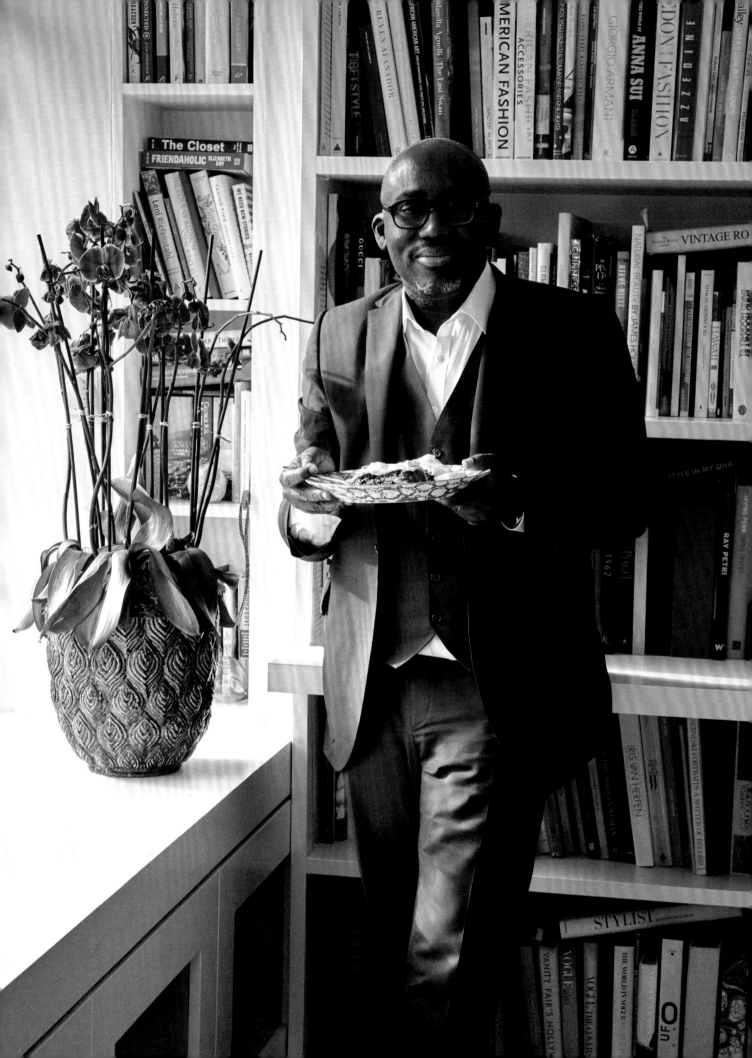

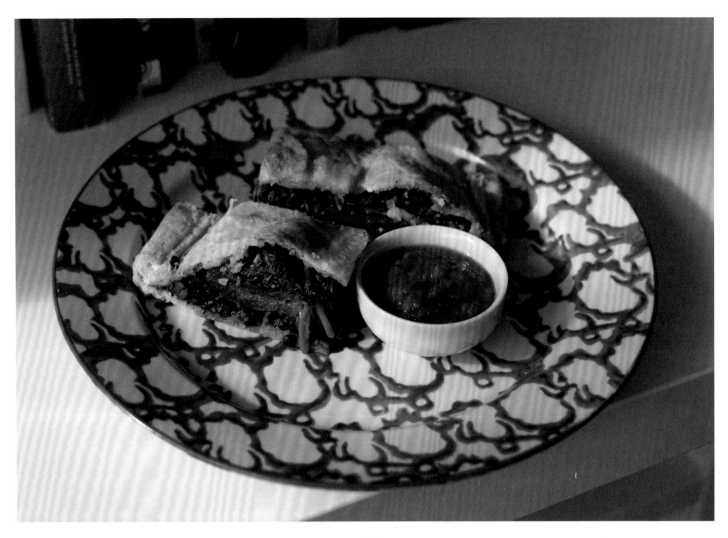

The perfect pie for any occasion, filled with three colourful layers.
I love a short cut and this recipe uses ready roll pastry.
Served with my hot sauce on the side for extra fire.

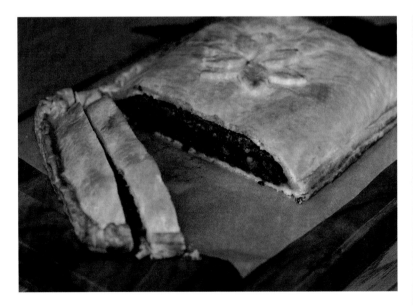

PARTY PIE WITH SCOTCH BONNET HOT SAUCE

Ingredients

Onion and Black Lentil Layer
1 tablespoon olive oil
3 medium red onions, peeled and thinly sliced
1 tablespoon balsamic vinegar
1 tablespoon soy sauce
½ teaspoon paprika
250 g (9 oz) cooked black lentils (I use Puy)

Garlic Spinach Layer
1 teaspoon olive oil
300 g (10½ oz) frozen spinach, thawed and drained
 (or 440 g (16 oz) fresh baby leaf spinach)
2 garlic cloves, finely chopped
Pinch of sea salt
1 teaspoon fresh lemon juice

To assemble
2 sheets of ready-rolled shortcrust pastry
 (made with vegetable shortening)
450 g (1 lb) jar of roasted red peppers, drained
2 tablespoons unsweetened plant-based milk

To serve
Hot sauce (optional)

SCOTCH BONNET HOT SAUCE

MAKES 500ML (2 CUPS)

Ingredients
4 Scotch bonnet chilli peppers, stalks removed
 and left whole
4 garlic cloves
1 small red onion, peeled and halved
5 cm (2 in.) ginger, peeled
1 vegetable stock cube or 1 teaspoon
 of vegetable bouillon
1 x 400 g (14 oz) can of chopped tomatoes
2 tablespoons extra virgin olive oil
1 tablespoon chopped parsley leaves (optional)

Method
Put all the ingredients, except for the parsley, into a blender and blitz until smooth (about 40 seconds).

Gently warm the oil in a lidded saucepan over a low heat. Add the blended mixture and turn up the heat to a gentle simmer; cover with the lid and cook for 20 minutes, stirring occasionally.

Remove from the heat and stir in the parsley, if using. Leave to cool and store in an airtight container.

Method

Preheat oven to 200°C/400°F.

Onion and Black Lentil Layer
Add the oil to a medium frying pan and fry the red onions over a medium heat for 2 minutes to soften. Stir in the balsamic vinegar, soy sauce, paprika and lentils. Heat through for a couple of minutes to infuse the flavours. Tip into a bowl and set aside.

Garlic Spinach Layer
Using the same pan, add 1 teaspoon of olive oil along with the spinach and garlic. Cook for a minute to heat through (or, if using fresh spinach, until it has just wilted). Turn off the heat and pour away any extra liquid from the cooked spinach. Then season with sea salt and a light squeeze of lemon juice, and set aside.

To assemble
Roll out one of the pastry sheets onto a baking tray (leaving the baking parchment paper from the packet underneath). Cut away a 3 cm (1 in.) strip of pastry from one end and set it aside for decorating.

Spoon the lentil mixture evenly onto the centre of the pastry sheet, leaving a 3 cm (1 in.) gap around the edge.

Lay the roasted red peppers neatly, like a blanket, over the lentils to form the second layer, then spoon the spinach layer on top of the roasted red peppers and spread it out evenly.

Carefully lay the second pastry sheet over the top of the spinach and crimp the edges of the two sheets together all the way around to seal.

Use a knife to pierce the top of the pie in the centre to allow steam to escape during baking. Cut 4 or 5 leaf shapes from the reserved strip of pastry and arrange them on top of the pie around the incision.

Brush the pastry with plant milk and bake for 30–35 minutes, until the pastry is crisp and golden brown.

To serve
Serve hot from the oven or at room temperature with the Scotch Bonnet Hot Sauce in a bowl on the side.

CHRISSIE HYNDE AND JOHNNY MARR

Mains

MODERN SHEPHERD'S PIE

Home, London

Chrissie and I go way back, and I adore her. One thing I know for sure is Chrissie doesn't cook. So I offered to make her lunch, and decided on my nourishing and comforting Modern Shepherd's Pie — and I made extra for her to keep and reheat during the week. I texted Chrissie to ask her to preheat the oven. Her reply: *"I will try"*, another true indicator of her lack of interest in cooking. She suggested we also invite Johnny Marr to join us. A great idea, as I had always wanted to meet him to find out the story behind The Smiths inviting my mum to play keyboards on their seminal album *The Queen Is Dead.*

When I got to Chrissie's, they were hungry and ready to eat. I stalled them for as long as I could while I took the food photograph, and then it was time to tuck in. I loved listening to their recollections and was surprised to hear that, having left The Smiths, Johnny had joined The Pretenders with Chrissie for two years. I asked him about my mum. He said The Smiths had always admired her as a musician, and that they particularly loved her vocals on the Wings songs. He said they had never asked anyone else other than her to play with them. I have wondered why she declined the offer. Maybe she was shy or didn't have faith in her undoubted talent. I really wished she had done it.

When we were finished, we went outside to the garden to carry on our conversation and get some fresh air. As always, it was a joy to see Chrissie, and I loved spending time with Johnny and getting to know him.

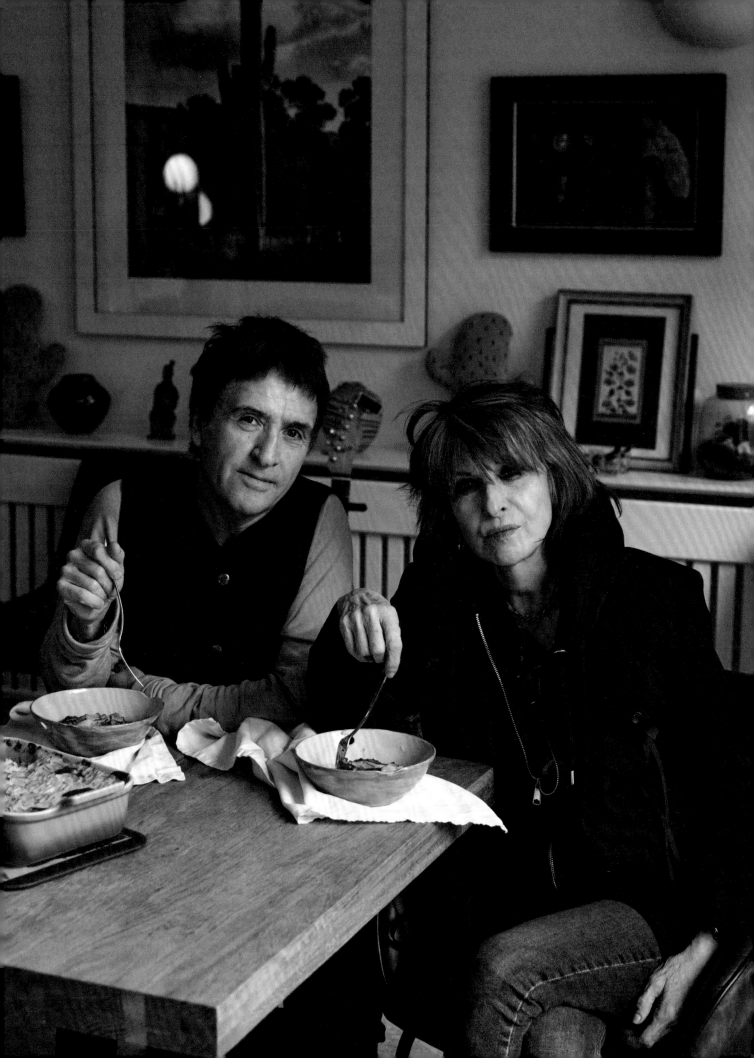

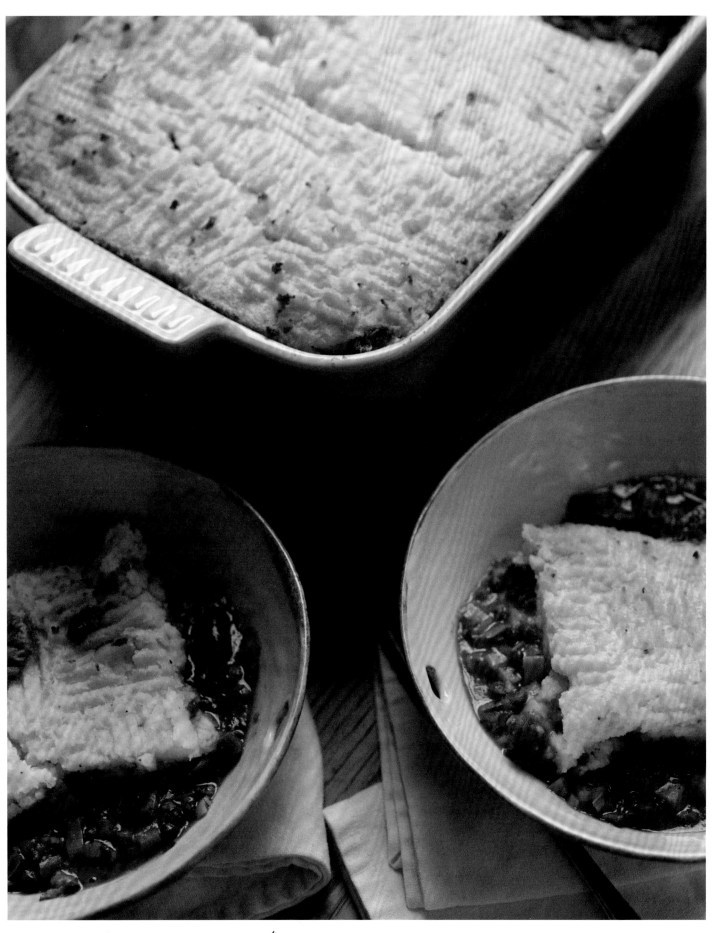

A real crowd pleaser! Smooth gravy infused with herbs and a touch of chilli heat, the bite of dark beans and lentils for texture all topped with fluffy olive oil and sea salt mashed potatoes. Make ahead, and freeze any left over.

MODERN SHEPHERD'S PIE

Ingredients

Pie Filling
2 tablespoons olive oil
1 leek (about 175 g/6 oz), trimmed, rinsed
 and finely chopped
2 medium carrots, peeled and chopped
120 g (4 oz) green beans, trimmed and finely chopped
1 stick of celery, finely chopped
1 teaspoon dried mixed herbs
½ teaspoon chilli flakes
1 × 400 g (14 oz) can of red kidney beans, drained
250 g (9 oz) cooked black lentils
 (as they hold their shape, I use Puy)
720 ml (3 cups) vegetable stock
2 tablespoons cornflour (starch), mixed with
 2 tablespoons water (to avoid lumps)
1 tablespoon Worcestershire sauce (vegan)
1 tablespoon soy sauce (or tamari for gluten-free)
1 sprig of rosemary
Sea salt and black pepper to taste

Olive Oil Mashed Potato Topping
1.2 kg (2.5 lb) floury potatoes
 (I like Yukon Gold or Maris Piper)
6 tablespoons extra virgin olive oil
1 tablespoon Dijon mustard (or mustard
 of your choice)
Generous pinch of sea salt and freshly ground
 black pepper
60 ml (¼ cup) unsweetened plant-based milk
2 tablespoons chopped fresh parsley (optional)

Method

You will need an oven-proof baking dish, about 20 × 30 cm (8 × 12 in.). Preheat the oven to 200°C/400°F.

Pie Filling
Heat the oil in a medium-large saucepan and add the chopped leek, carrots, green beans and celery, and sauté for 2 minutes. Stir in the dried herbs, chilli flakes, kidney beans and lentils. Pour over the stock and stir in the cornflour mix, followed by the Worcestershire sauce, soy sauce or tamari and sprig of rosemary.

Gently simmer for around 10 minutes, then remove from the heat. Remove the rosemary sprig and discard.

Olive Oil Mashed Potato Topping
Peel and cut the potatoes into equal-sized pieces so that they cook evenly. Put the potatoes in a large saucepan and cover with cold water. Bring to the boil, then reduce the heat to a simmer. Cook the potatoes until tender, which will take around 10–25 minutes, depending on the size of the potato — check well.

Drain the potatoes in a colander, then return them to the saucepan. Using a potato masher, mash really well. Drizzle in the extra virgin olive oil and add the mustard, sea salt and black pepper. Stir in the milk and use a fork to fluff up the mash, getting rid of any remaining lumps at the same time. Finally, stir in the parsley (optional).

To assemble, pour the filling into the base of the baking dish. Spoon the mash on top and use a fork to even it out.

Bake in the oven for 20–25 minutes, until golden brown, crisp on top and bubbling.

BETH DITTO

Mains

SMOKEY BLACK-EYED BEAN STEW

My Home, London

My pal Beth Ditto was in town, and when we get together it's impossible to shut either of us up. We get on like a house on fire. And, little known fact, she can beat me hands down at arm wrestling.

We first met when I was commissioned to take her portrait for *Interview* magazine. She was bright, quick-witted and up for creating characters with her hair, make-up and styling. We had a great day shooting together. Dusty Springfield's "Son of a Preacher Man" came onto my playlist and Beth started to sing along. It was the first time I had heard her sing live. That voice! I was hooked.

I couldn't quite decide what to make for her. She's a Southern girl, and we have discussed food often. I opted for the smooth and smokey flavours of the South to reflect Beth's roots. Rummaging through my kitchen cupboard I found inspiration with black-eyed beans, smoked paprika, for the distinctive smokiness, spicy Tabasco and chard to reflect the traditional collard greens.

Beth arrived and, as this was the first time she had been back to London in a while, there was much to catch up on. As always, she reminded me of a shoot where she was getting constantly distracted, and I blurted out, *"Working with you is like being with a two-year-old!"* We laugh about it now, but she has never let me live it down. We ate, we chatted and the time spent with her, as always, fed my soul.

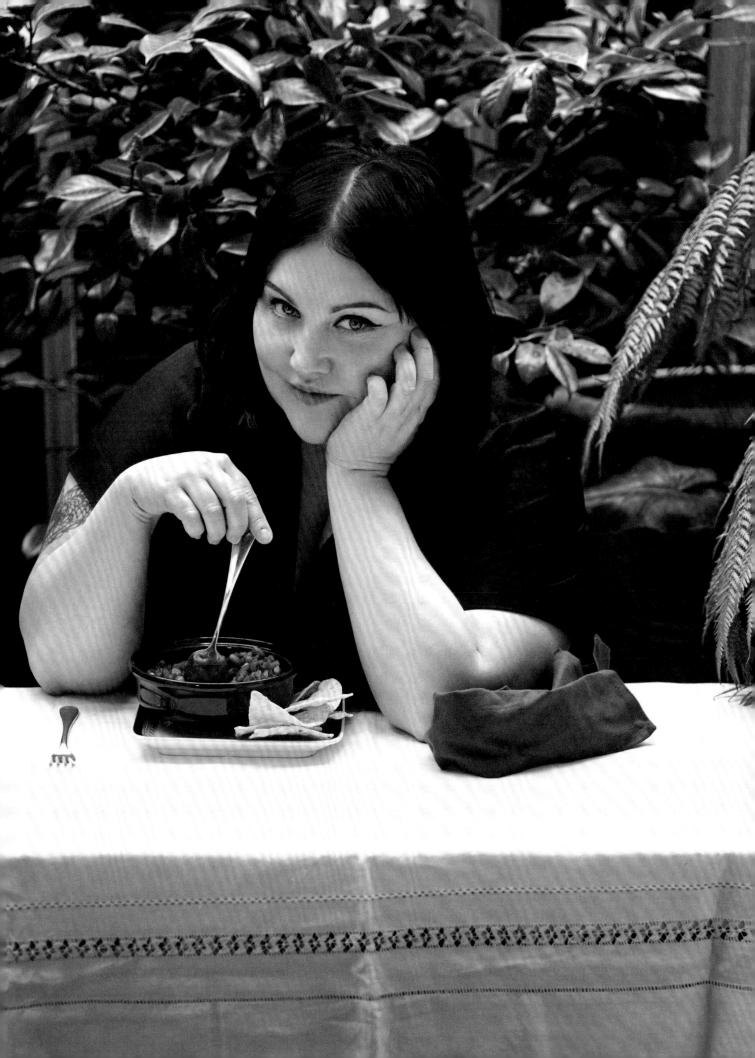

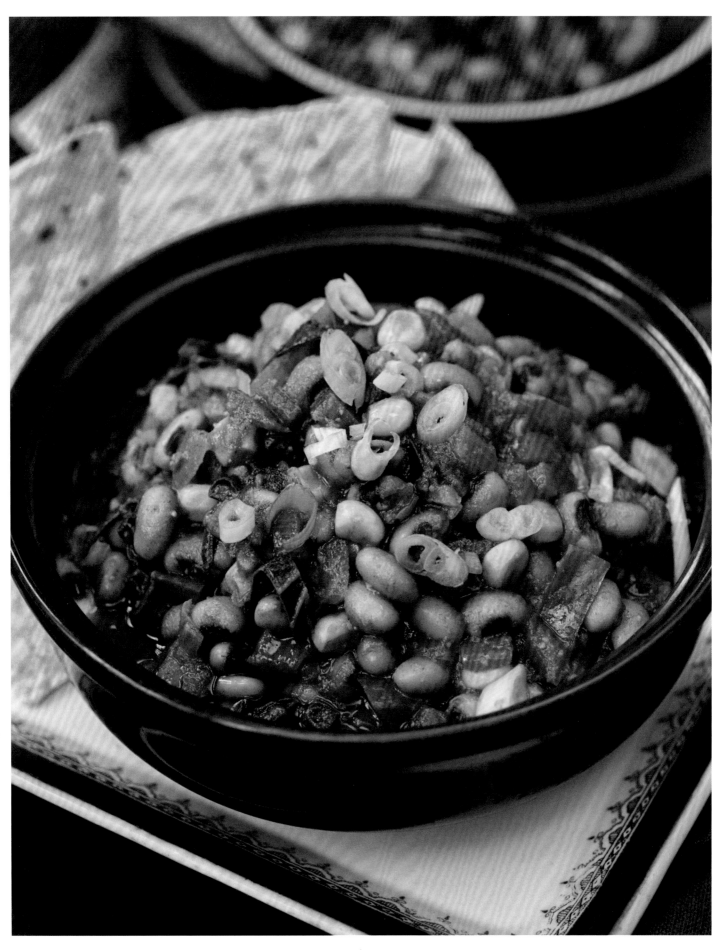

144

Colourful and nourishing, I love to serve this stew with lightly salted corn tortilla chips on the side to dip in for some extra crunch.

SMOKEY BLACK-EYED BEAN STEW

Ingredients

2 tablespoons olive oil
1 medium onion, chopped small
1 red pepper (capsicum), deseeded
 and chopped small
2 bay leaves
2 teaspoons smoked paprika
1 teaspoon Cajun seasoning (or other similar
 chilli blend seasoning)
170 ml (¾ cup) vegetable stock
1 tablespoon tomato paste
1 × 400 g (14 oz) can of black-eyed beans, drained
50 g (2 oz) chard leaves, thinly sliced (or kale
 or cavolo nero, stem removed)
50 g (⅓ cup) sweetcorn (frozen, fresh from
 the cob or canned and drained)
1 teaspoon cider vinegar
½ teaspoon Tabasco, or to taste
Pinch of sea salt

To serve
1 spring onion (scallion), sliced
Lightly salted tortilla chips

Method

Heat the olive oil in a medium saucepan over a medium heat. Add the onion, red pepper and bay leaves and sauté for 4 minutes until softened. Add the smoked paprika and Cajun seasoning and stir well, until fragrant, then add the vegetable stock and tomato paste and bring to a gentle bubbling simmer.

Mix in the black-eyed beans, chard leaves and sweetcorn to the pan and warm through for 5 minutes. Finally, stir in the vinegar and as much Tabasco as you like (I use about ½ teaspoon) and season with a pinch of sea salt if necessary. Fish out the bay leaves before serving.

To serve
Spoon the stew into two bowls and garnish with sliced spring onions on top. Serve with tortilla chips on the side for dipping (optional).

JAKE CHAPMAN

Mains

LOADED CORN TORTILLA

Artist's Studio, London

Jake Chapman and I have known each other socially for over 20 years, but I had never spent much time with him one to one. I was looking forward to it. I packed our lunch into my wicker picnic basket and headed off to Jake's studio in East London. There were models, figures and sculptures everywhere, and in the corner of the studio a small, very functional kitchenette (one of my favourite words!).

Jake explained he had a simple approach to food and would be quite happy just eating lentils and rice. Not for me, as I satisfy my food indulgences through a wide variety of colours, textures and tastes — otherwise, I'd turn to junk food all day long. I set about heating up and assembling the food. First up, the warm corn tortilla, then a layer of creamy avocado, then black Venus rice and smoked paprika pinto beans, topped with crunchy bright salad and pickled red onion. We were ready to tuck in. Typically, our chat skipped around all over the place, from family and food, to art and childhood memories. Making contented sounds as he ate, I was pleased when Jake kept going back for more. He showed me around his studio while I took photos along the way. He stopped to pull out several Ronald McDonald figures from a box (used in his artwork), to decorate the top of his second helping. That was a first for me.

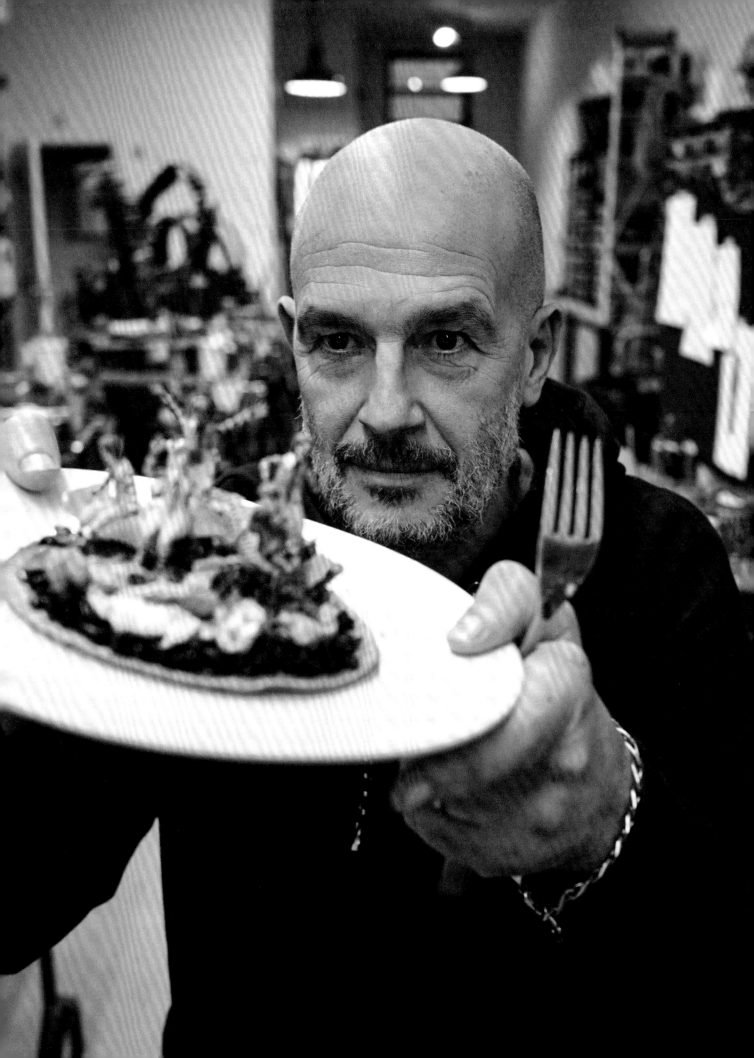

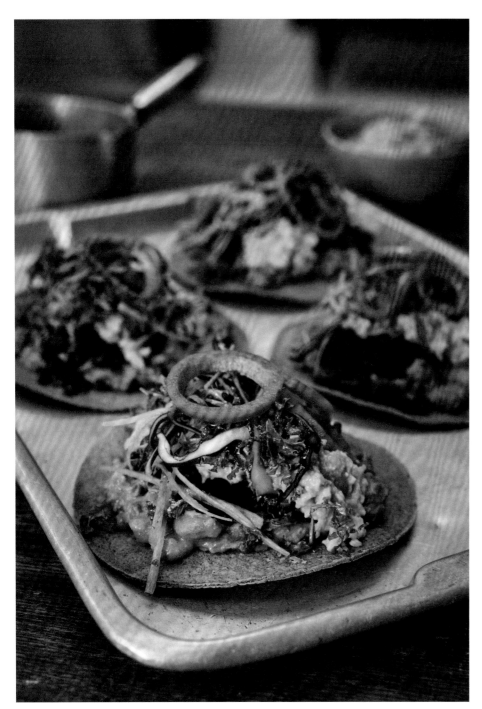

Warmed tortillas loaded with layer after layer – chilli pinto beans, creamy avocado, black rice, pickled red onion and chopped salad. Perfect for a light meal or served family style with the harissa BBQ jackfruit.

LOADED CORN TORTILLA

Ingredients

Pickled Red Onion
1 small red onion, peeled and thinly sliced
240 ml (1 cup) apple cider vinegar
Pinch of sea salt

Black Rice
100 g (½ cup) black Venus rice
2 garlic cloves, roughly chopped
1 bay leaf
360 ml (1½ cups) boiling water

Chilli Pinto Beans
2 tablespoons olive oil
1 × 400 g (14 oz) can of pinto beans,
 drained and rinsed
½ teaspoon chilli flakes
1 garlic clove, finely chopped
½ teaspoon smoked paprika
1 tablespoon soy sauce (or tamari for gluten-free)

Creamy Avocado
1 ripe avocado, cut in half and stone removed
2 tablespoons fresh coriander (cilantro) or parsley,
 chopped (optional)
½ teaspoon chilli flakes (optional)
Juice of 1 lime
Sea salt to taste

Colour Burst Salad
2½ tablespoons extra virgin olive oil
1½ tablespoons apple cider vinegar
Pinch of sea salt
60 g (2 oz) kale, thinly sliced
60 g (2 oz) red cabbage, thinly sliced
1 carrot, grated or thinly sliced

To serve
4 corn tortillas, warmed

Method

Pickled Red Onion
Place the thin onion slices into a jar or jug, pour over the vinegar to cover the onion and sprinkle on the sea salt. Leave to pickle while you prepare the rest of the tortilla toppings.

Black Rice
Place a medium, lidded saucepan over a medium heat, and warm the rice, garlic and bay leaf. Pour in boiling water, stir and bring to a gentle simmer. Cover to cook (check the cooking time on the side of the rice packaging). During cooking, check to add a little more boiling water if the rice dries out before it has cooked through. Remove the bay leaf and discard.

Chilli Pinto Beans
Heat the oil in a frying pan, add the pinto beans and bring to a gently sizzling heat. Mix in all the remaining ingredients and cook for 3–5 minutes, until all the flavours infuse. Remove from the heat.

Creamy Avocado
Mash the avocado until smooth. Stir in the chopped fresh coriander, chilli flakes, lime juice and a pinch of sea salt.

Colour Burst Salad
To make the dressing, whisk together the oil, vinegar and a pinch of sea salt. Place the chopped kale, red cabbage and carrot in a bowl, then drizzle the dressing over the vegetables and toss well.

To serve
Place the warmed corn tortilla on a plate, spread on a spoonful or two of the pinto bean mix, followed by a layer of the black rice and a spoonful of the creamy avocado, then top with the salad and pickled onions.

WOODY HARRELSON

Mains

SMOKEY DOGS

Home, Los Angeles

Woody Harrelson and I became friends when he spent time in London filming his directorial debut, *Lost in London*, and to play Tobias Beckett in *Solo: A Star Wars Story*. He is a complete one-off, generous and dedicated to equal opportunity and freedom of speech. On a rare day off from filming, he and his wife, Laura, came for a spontaneous lunch at my West London studio. Woody and Laura have a shared passion for a plant-based lifestyle, which they have embraced and thrived on for decades.

This time, I was on the West Coast, so we met up in Los Angeles. It took me a while to find his place, hidden deep in the Hollywood Hills. I heard chat coming from the garage, so wandered that way and found Woody having a meeting based around a large red pool table, testing the quality of cannabis samples for his new cannabis lounge called The Woods.

They had worked up quite an appetite, so Woody and I headed to the kitchen to heat up the Smokey Dogs, packed with the savoury-sweet flavours of smoked paprika and sweet red peppers and the umami of miso paste, all rolled up and stuffed into a toasted hot dog bun and topped with caramelised red onions, American mustard and ketchup. Woody fried the dogs for me, while I prepped the rest. We ate standing in the kitchen, happily stuffing our faces, and then wandered outside to take in the view and the Californian sunset, perfectly content.

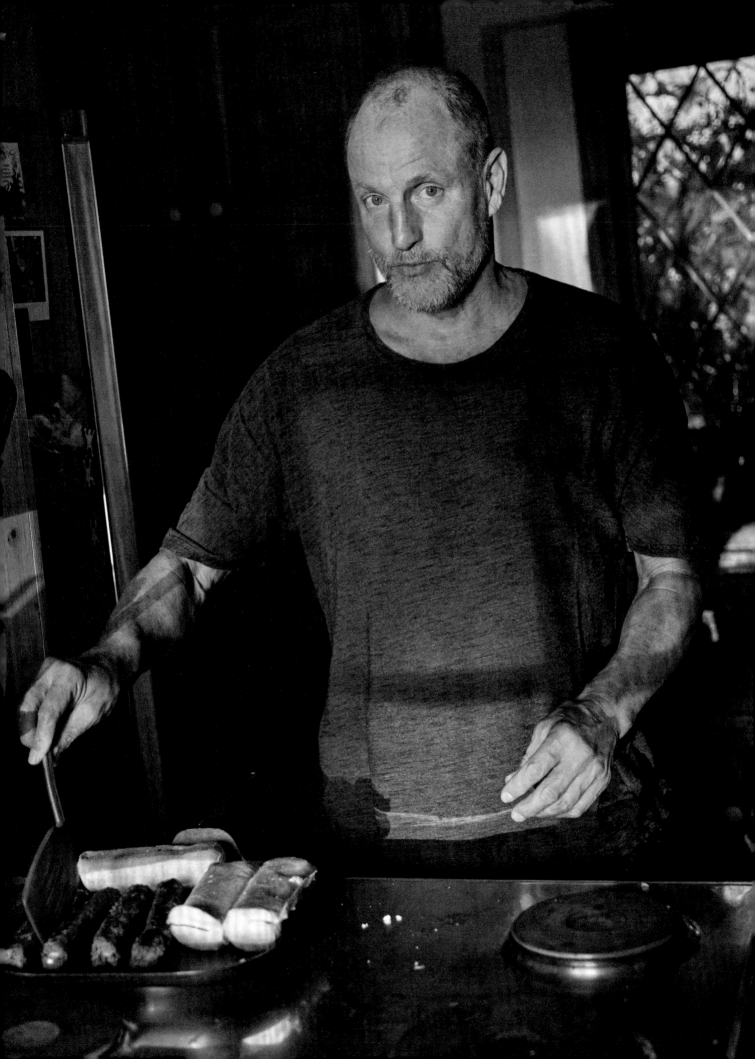

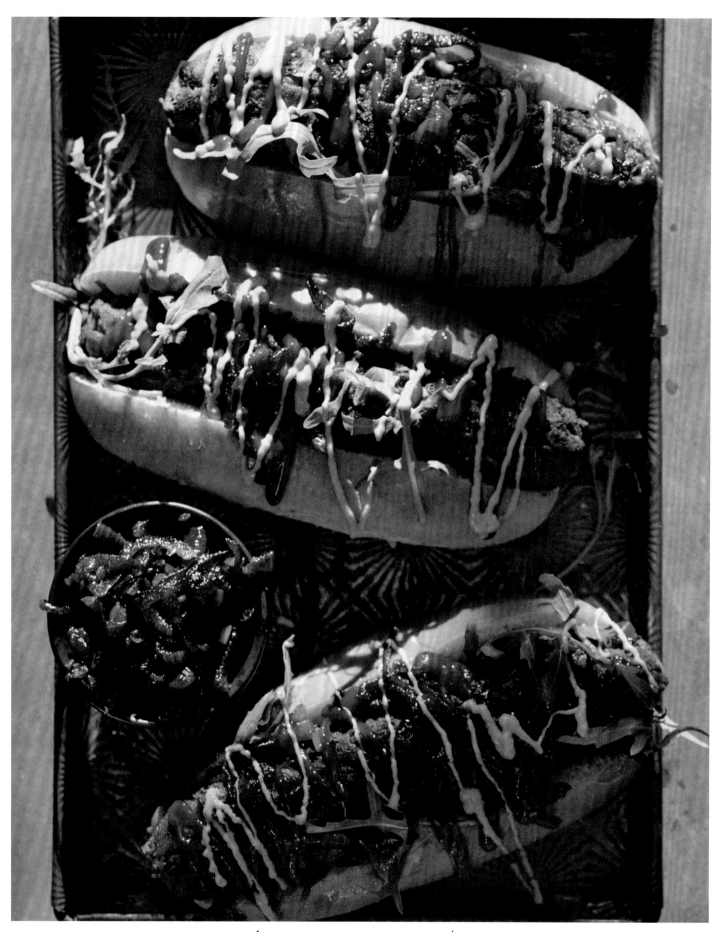

My tried and tested hot dog alternative, all made in one pan. Bursting with umami flavours, and stuffed into a hot dog bun, then smothered in caramelised onions and your favourite condiments (for me its tomato ketchup and yellow mustard). Make ahead and chill or freeze for ease.

SMOKEY DOGS

Ingredients

Smokey Sausages
4 tablespoons olive oil, divided
1 medium red onion, finely chopped
1 medium red pepper (capsicum), deseeded
 and finely chopped
2 garlic cloves, finely chopped
3 tablespoons sun-dried tomatoes, finely chopped
3 tablespoons mixed fresh herbs, finely chopped
 (I use sage and rosemary)
1 tablespoon smoked paprika
2 tablespoons brown miso paste
1 × 400 g (14 oz) can of kidney beans, drained
 and rinsed
4 tablespoons buckwheat flour (or plain/all-purpose)
1 tablespoon milled flaxseed (optional, otherwise
 use 5 tablespoons flour in total)

Caramelised Onions
2 tablespoons olive oil
3 medium red onions, peeled, halved
 and thinly sliced
1 tablespoon balsamic vinegar

To serve
4 hot dog buns
Mayonnaise (vegan)
Small handful of rocket (arugula) leaves
American mustard
Tomato ketchup

Method

Smokey Sausages
Heat 2 tablespoons of the olive oil in a large frying pan and cook the onion and red pepper gently over a medium heat for 1–2 minutes. Stir in the garlic and fry for 3 more minutes.

Next, stir in the sun-dried tomatoes, chopped herbs, smoked paprika, miso paste and drained kidney beans, and sauté for 2 more minutes to heat and infuse the flavours. Turn off the heat and mix in the flour and milled flaxseed.

Using a potato masher, press the mixture together; you want to retain some of the texture, so be mindful not to over-mash the mixture. Using clean hands, bring all the ingredients together firmly and shape them into a large ball, then cut the ball into four equal pieces. Roll each of the four equal pieces into long hot dog/sausage shapes (I like to measure each Smokey Dog up against the hot dog bun to shape them to the perfect length).

Chill in the fridge for at least 30 minutes to allow them to firm up before frying.

Heat 2 tablespoons of olive oil in a medium-large sauté pan, and fry the Smokey Dogs for 8–10 minutes over medium sizzling heat, turning occasionally until crispy and browned all over.

Caramelised Onions
Put 2 tablespoons of olive oil in a sauté pan over a medium heat, add the onions and stir in the balsamic vinegar. Cook for 10–15 minutes on a gently sizzling heat, stirring occasionally until the onions are soft and caramelised.

To serve
Spread a layer of mayonnaise (vegan) on the inside of the hot dog bun and lay a few rocket leaves over the mayonnaise. Now add the Smokey Dog, and spoon some caramelised onions on top. Finish with a squeeze of tomato ketchup and mustard to taste.

JILL BUTLER AND TED GREEN

Mains

ALE STEW WITH HERB DUMPLINGS

Windsor Great Park, Berkshire

Jill Butler and Ted Green are rock stars in the world of trees and nature conservation. I first heard about them in connection with the rewilding of the Knepp Castle Estate in Southern England. I was fascinated by them and sought them out to arrange to meet up. In his mid-80s, Ted has a wicked sense of humour and a twinkle in his eye. When I told them both about this cookbook, Ted turned to Jill and said, *"Wouldn't it be nice to have lunch inside an ancient oak tree together?".* She smiled as she knew exactly the perfect specimen he had in mind. We made a plan to meet in Windsor Great Park. I wanted to make them something with an appropriately traditional feel, for our oak rendezvous. I opted for a comforting stew, with herb dumplings.

We met at Ted's base in Windsor Park, and before we ate, Jill and Ted introduced me to some key

ancient trees, explaining the importance of allowing them to go through their natural ageing process. They explained that natural decay is crucial, as the dead wood becomes home to insects and microorganisms for hundreds of years, so they must be respected and protected. Jill and Ted have such a deep love for these trees, talking to them as friends, and it's heartwarming to see. We made our way to the thousand-year-old oak and set up two camp chairs inside the hollow trunk. It was magical—we pondered how long this tree had survived and flourished to provide an enchanting backdrop for our feast. The most incredible venue, and a thing of natural beauty, so statuesque. We wiped our plates clean and packed up, thanking the tree for its generosity in hosting us. I even gave it a little hug.

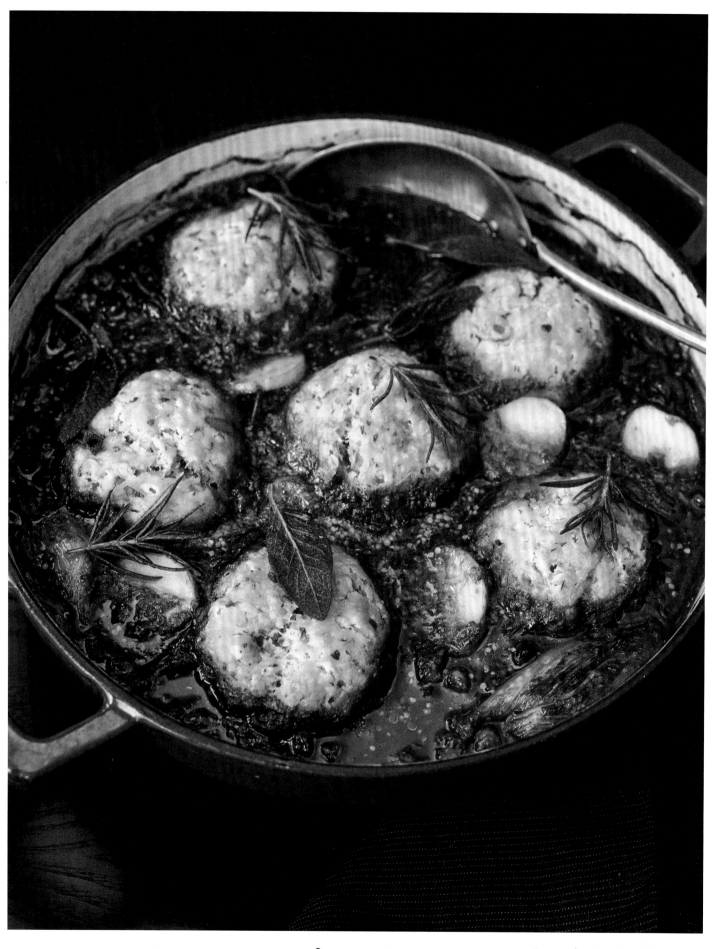

The ultimate stew: Cooked in the casserole dish with home made dumplings that steam and cook in the juices of the stew to become light, fluffy and golden.

156

ALE STEW WITH HERB DUMPLINGS

Ingredients

Stew

340 g (12 oz) new or small potatoes,
 sliced ½ cm (¼ in.) thick (no need to peel)
2 tablespoons olive oil
3 medium onions (about 250 g/9 oz),
 peeled and sliced into thin rings
1 celery stick, finely chopped
2 medium carrots, peeled and thinly
 sliced into rounds
2 medium leeks, sliced into rounds
1 tablespoon tomato paste
80 g (3 oz) pearl barley, cooked to pack instructions
1 × 400 g (14 oz) can of black beans,
 drained and rinsed
2 bay leaves
350 ml (1½ cups) ale
720 ml (3 cups) vegetable stock
1 tablespoon whole-grain mustard
1 tablespoon Worcestershire sauce (vegan)
2 tablespoons soy sauce

Herb Dumplings

250 g (2 cups) plain (all-purpose) flour
1½ teaspoons baking powder
125 g (4½ oz) vegetable suet
1 teaspoon sea salt
1 tablespoon chopped fresh thyme leaves
 (or 1 teaspoon dried thyme)
1 tablespoon fresh parsley, chopped
200 ml (¾ cup plus 2 tablespoons) cold water

Crispy Herbs (optional)

2 tablespoons olive oil
6 sage leaves
2 sprigs of rosemary

Method

You will need a 3 litre (100 fl oz) ovenproof casserole pan or baking dish. Preheat the oven to 200°C/400°F.

Stew
Place the sliced potatoes in a saucepan and cover with cold water. Bring to the boil for a minute, then drain straight away (to remove excess starch).

Heat the oil in the casserole pan (or a saucepan), add the onion, celery, carrot and leek, and sauté for 4–5 minutes to soften. Stir in the tomato paste, cooked pearl barley, black beans, bay leaves and drained potatoes, and fry for a couple of minutes. Stir in the ale, vegetable stock, mustard, Worcestershire sauce and soy sauce. Simmer gently for 5–10 minutes while making the dumplings. Remove the bay leaves and discard.

Herb Dumplings
Combine the flour, baking powder, suet, salt and herbs in a medium mixing bowl. Make a well in the centre and slowly add 200 ml (¾ cup plus 2 tablespoons) cold water, stirring with a wooden spoon. Use clean hands to bring together into a springy dough, adding 1–2 tablespoons more cold water if necessary. Divide the dumplings into 6–8 pieces, roll them each into a ball and lay the pieces on top of the stew. Place the casserole pan in the oven and cook for 20–30 minutes, until the dumplings are lightly golden on top and the stew has thickened.

Crispy Herbs (optional)
While the stew is cooking, heat the olive oil in a frying pan over medium-high heat. Place the herbs in for 1 minute to crisp up and then remove onto kitchen paper to drain any excess oil. Decorate the cooked stew with the crispy herbs, and serve.

EMILY EAVIS

Mains

LOADED DOUBLE BEAN BURGERS

Glastonbury Site, Worthy Farm, Somerset

I took the train to Castle Cary in Somerset, where my friend Emily Eavis greeted me at the station. We headed straight to Worthy Farm, home of my favourite music festival. Emily is now the full-time organiser of Glastonbury, the largest greenfield music and performing arts festival in the world. The iconic event is attended by more than 200,000 people each year and is famed for its forward-thinking approach to the environment and sustainability. It amazes me how they build what is effectively a small town, requiring planning, constructing and then dismantling. It's an enormous undertaking, but the result is epic.

After a cup of tea and a catch-up in her kitchen, I fried the burgers. Assembled and ready, Emily drove us in her Land Rover to the Pyramid field, where I had planned to take Emily's portrait, seated on the bonnet of the Land Rover, with the framework of the legendary Pyramid stage in the background. Although she thought the field may be too wet, we drove on, undeterred... and soon got stuck in the mud. We decided, as we were here, we may as well get the photo first, then think about how to get out. Emily is a force of nature, packed with positive energy. By the time we had finished, she had a solution. Hopping into the driver's seat, she literally put the pedal to the metal, the wheels chewing up the ground, spitting mud everywhere. She didn't give up; yanking the wheel sharply to the left, we slowly started creeping forward, and soon we were safely back on the road. A month later Emily messaged an update photo, which showed the tracks had not quite gone away, but she assured me that the grass would have regrown in time for the festival. And it had.

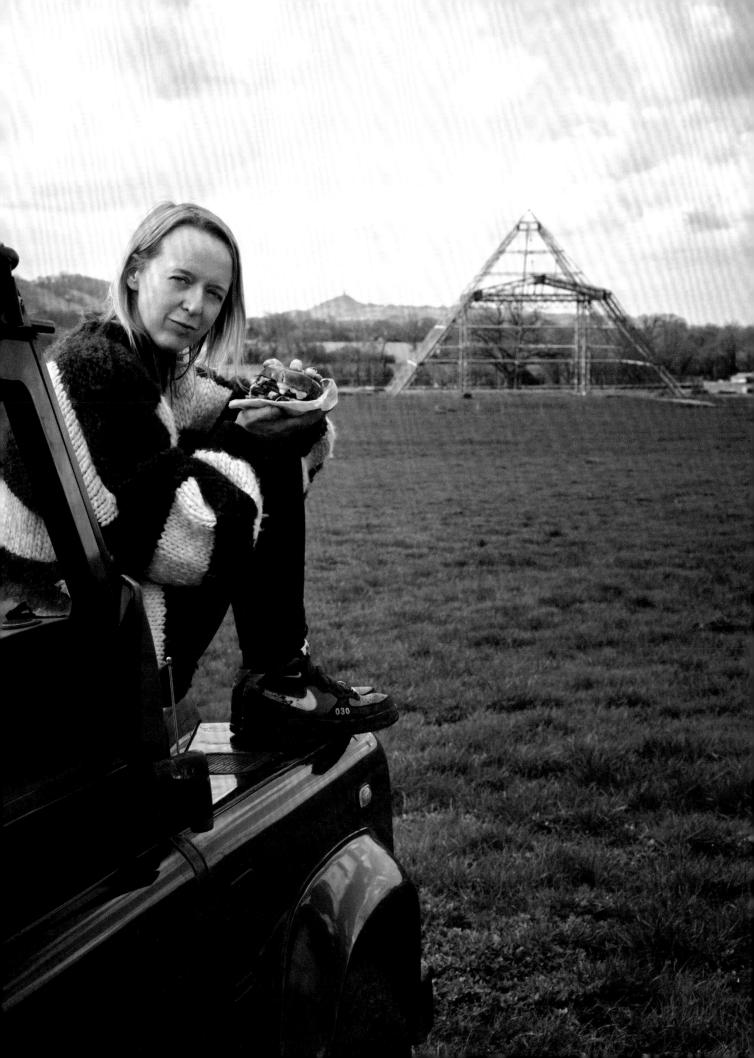

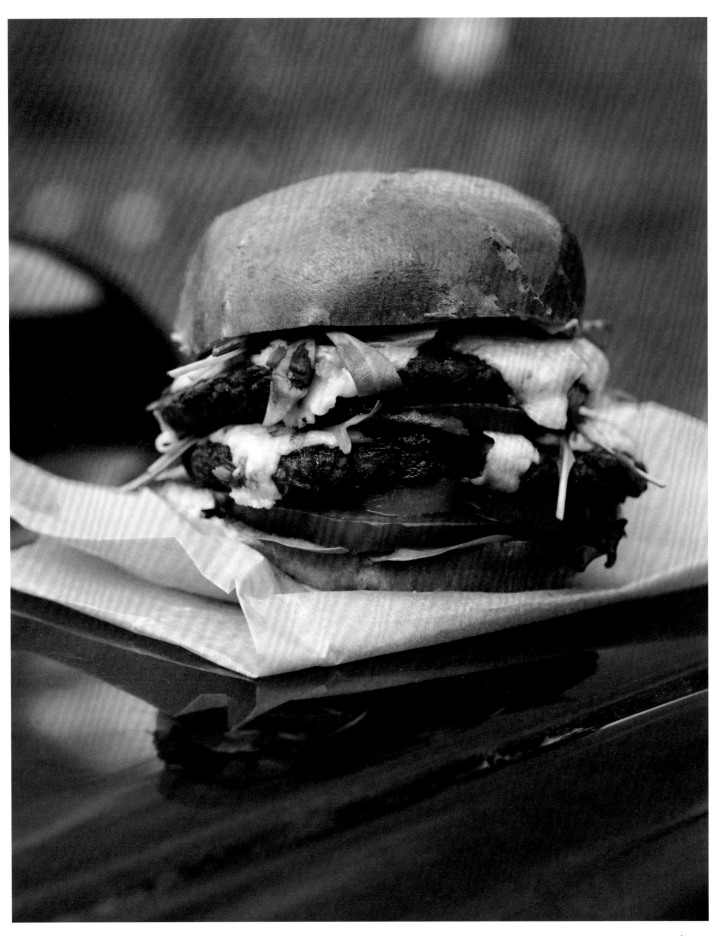

My favourite bean burgers flavoured with sweet red pepper, Worcestershire and soy sauce and cheesy nutritional B12 flakes. Simply fry or get them onto the BBQ. Serve topped with all the trimmings – don't be shy! Make ahead, and freeze any extra to have ready at a moment's notice.

160

LOADED DOUBLE BEAN BURGERS

Ingredients

Red Bean Burgers
3 × 400 g (14 oz) cans of red kidney beans, drained
60 ml (¼ cup) plus 2 tablespoons olive oil for frying
6 garlic cloves, crushed
3 red peppers (capsicum),
 deseeded and finely chopped
90 ml (¼ cup plus 2 tablespoons) Worcestershire
 sauce (vegan)
30 g (¼ cup plus 2 tablespoons) B_{12} nutritional
 yeast flakes
3 tablespoons soy sauce
65 g (½ cup plus 1 tablespoon) plain (all-purpose) flour
40 g (¼ cup plus 2 tablespoons) milled flaxseed,
 mixed with 3 tablespoons boiling water

Burger Assembly Ideas
Cheese slices (vegan)
Tomato ketchup
Mayonnaise (vegan)
Mustard of your choice (I like Dijon
 or American mustard)
6 burger buns, halved and toasted
Mixed salad leaves
Jarred sliced pickled jalapeños, drained
Avocado, sliced
Tomatoes, sliced
Red onion, sliced into rounds

Method

Red Bean Burgers
Add the drained red kidney beans to a large frying pan over a medium heat and dry-fry for 3 minutes to get rid of some moisture so that the texture of the burger will have more bite. Stir in 60 ml (¼ cup) of olive oil, along with the garlic and chopped red peppers. Fry for 2–3 minutes, until slightly softened.

Then add the Worcestershire sauce, nutritional yeast flakes and soy sauce to the pan. Mix and sauté for 1–2 minutes, until the liquid just about evaporates.

Take off the heat and stir in the flour, followed by the flaxseed mixture. Using a potato masher, crush until it comes together, but still has texture. Then, using clean hands, shape to form 12 equal-sized burger patties; I like them very thin to double up in the bun.

Add the remaining 2 tablespoons of olive oil to a large frying pan over a medium-high heat. Once the pan is hot, add 4 patties and cook for 2 minutes on each side until crisp and dark brown. Remove from the pan, and stack 2 burgers on top of one another with a cheese slice in between (if using) and a second cheese slice on top. Keep warm while you cook the remaining 2 batches.

My Preferred Burger Assembly
You can do as you like, however I prefer to spread the ketchup, mayonnaise and mustard on the toasted buns, then add the double burger stacks, followed by the salad leaves, jalapeño slices, avocado, tomatoes and red onion, or extras of your choice.

161

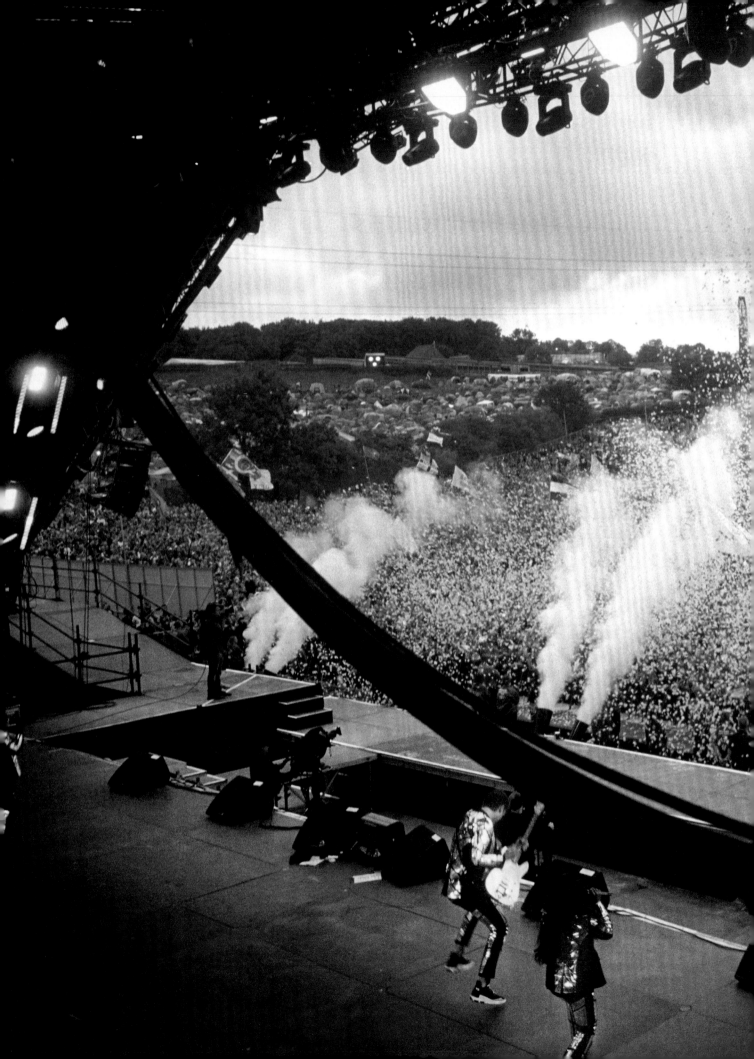

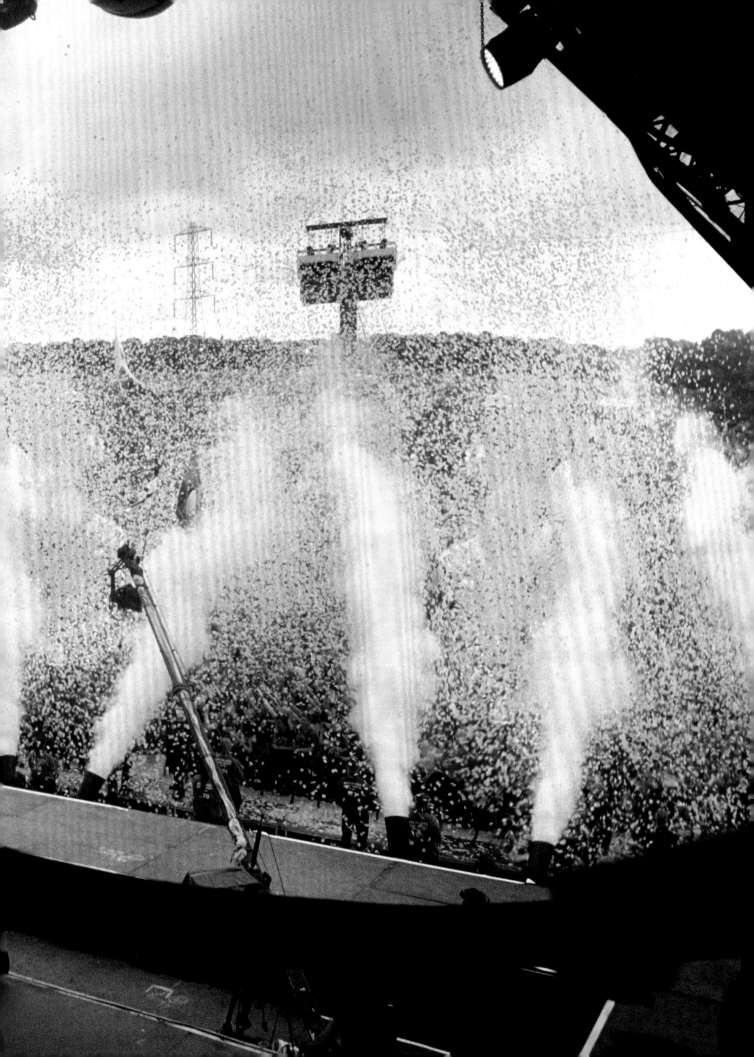

THERESA LOLA

Mains

STICKY CASHEW TOFU AND GINGER RICE

My Photo Studio, London

I was searching for a narrative thread for a short film I was directing about a sustainable fashion collaboration between London fashion brand Mother of Pearl and the plant-based restaurant Farmacy. The idea of having a spoken-word poet writing something original for the piece led me to Theresa Lola. I phoned her to introduce myself and see if my ideas sparked her imagination. She was inspired to write *Keeping the Glow*, a lyrical and inquisitive poem about becoming aware of our carbon footprint. One thing led to another, and I suggested she play the lead role and read the piece directly to camera. The sincerity of her performance was really impressive.

After that experience, we stayed in touch. Theresa mentioned she was teaching creative writing in West London, not far from my studio, so I invited her over to lunch. I asked her to choose sweet or savoury as an option, and got an instant reply: savoury and spicy, plus something gluten-free, please.

Great; as I'm good with a brief, I set to experimenting. Cashew nuts, tofu and green beans for bite, texture and protein, stir-fried in my spicy red chilli sticky sauce, served on a bed of ginger and garlic-infused steamed rice — quick, easy and bursting with character. We caught up as we ate, and as this was a new recipe, I was eager for her opinion. She said it was exactly the type of meal she loved: *"satisfying and spicy"*. She was soft-spoken and very calming to be around, and I found it very easy to get lost in conversation with her. All too soon it was time for her to get back to her students, and I couldn't help thinking how lucky they were to have such an inspirational teacher.

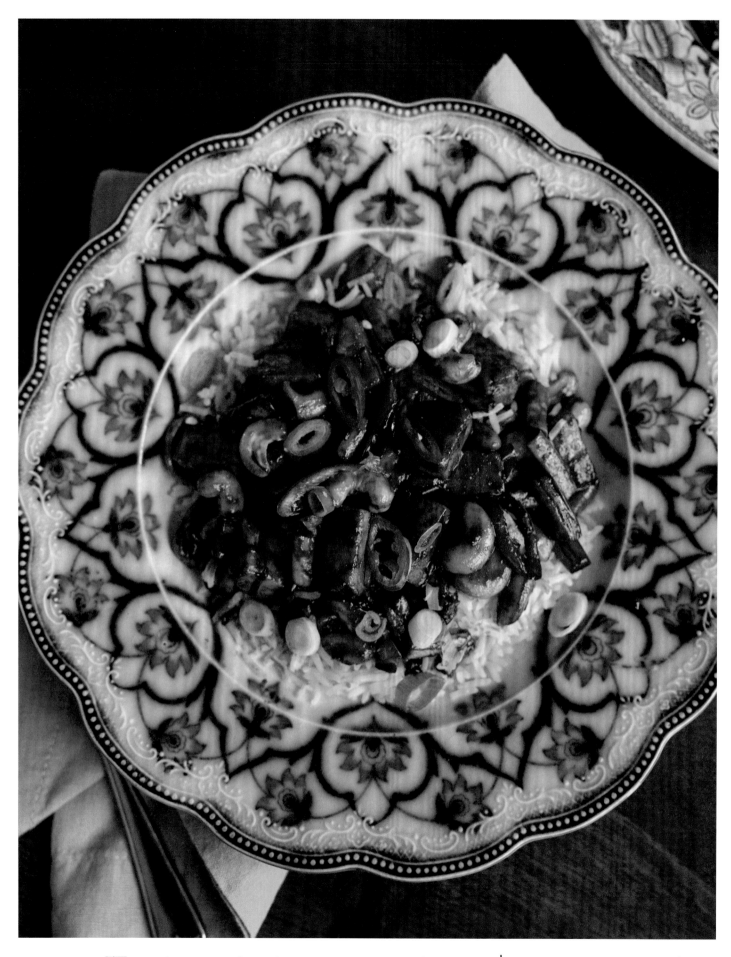

Firm tofu and cashew nuts coated in a glossy, sticky sweet and sour sauce - served with ginger and garlic infused steamed rice. Makes an excellent midweek meal.

STICKY CASHEW TOFU AND GINGER RICE

Ingredients

Rice
1 tablespoon sesame oil
5 cm (2 in.) ginger, peeled and grated
2 garlic cloves, finely chopped
185 g (1 cup) long-grain rice

Sticky Tofu
280 g (10 oz) firm tofu
1 tablespoon cornflour (starch)
1 tablespoon sesame oil
½ teaspoon turmeric
⅓ cup raw unsalted cashew nuts
100 g (4 oz) green beans, sliced into bite-sized pieces
4 tablespoons maple syrup
5 tablespoons low sodium soy sauce
 (or tamari for gluten-free)
2 tablespoons rice vinegar or apple cider vinegar
1 medium red chilli, sliced, deseeded
 and finely chopped

To serve
1 red chilli, sliced
1 spring onion (scallion), sliced thinly

Method

Rice
In a medium lidded saucepan, heat one tablespoon of sesame oil together with the grated ginger and garlic, and cook for 1 minute until fragrant. Stir in the rice, and heat through for another minute.

Pour 480 ml (2 cups) of boiling water into the rice and bring to a gentle simmer. Cover with the lid and leave to cook. Check the rice packaging for instructions on cooking time. If the water dries up before the rice is cooked, add a little more boiling water.

Sticky Tofu
Meanwhile, pat the tofu dry with a paper towel or a clean tea towel, then cut it into bite-sized pieces. Add to a mixing bowl and lightly dust with the cornflour.

Heat a medium frying pan over a medium-high heat and add 1 tablespoon of toasted sesame oil. Stir in the tofu and cook on a sizzling heat for 5–8 minutes, until crispy on all sides. Add the turmeric, cashew nuts, chilli and green beans and fry for 2 minutes, stirring often or shaking the pan.

Stir in the maple syrup, soy sauce, vinegar, chilli and 2 tablespoons of water and simmer, mixing often, until the sauce becomes sticky and coats all of the ingredients, which will take about 5 minutes.

To serve
Plate up the rice, top with the Sticky Cashew Tofu and garnish with sliced red chilli and spring onion.

MARC QUINN

Mains

SESAME TOFU AND TERIYAKI NOODLES

Artist's Studio, London

I'm surprised when I realise that I have known Marc for over 20 years. I appreciate his dry sense of humour, his inquisitive nature and his constant curiosity. He has a uniform of a baseball cap and the best tracksuits and always looks on point. I love to accept an invitation to lunch at his studio in East London, as it's not only guaranteed delicious food, but also a treasure trove of everything he has created. I've been there many times for dinner too, and there's always a great mix of people and new artworks to see.

The studio houses a selection of his sculptures and paintings, including one of my favourites, a painted bronze called *Young Dancer (Summer of Love)* (1988), which has a large, yellow smiley face as its head. It was this sculpture that greeted me on arrival.

It was now my turn to cook for Marc. I know he likes healthy food, focusing on nutritious ingredients, and that he enjoys plant-based dishes. With this in mind, I had made him a flavourful dish of sesame-encrusted tofu, my homemade teriyaki sauce, noodles and stir-fried pak choi/bok choy. Artistically, Marc is always up to something new, so as we settled to eat at the long table in his studio, we discussed his latest project, the *HISTORYNOW* paintings. They started life as smartphone screen grabs of specific global news stories. He then enlarged them onto canvases and painted over them with gestural strokes that blur and distort the images. As I had made so much food, Marc invited his studio team to come and eat with us. We ended up in a deep conversation, so immersed that I lost track of time.

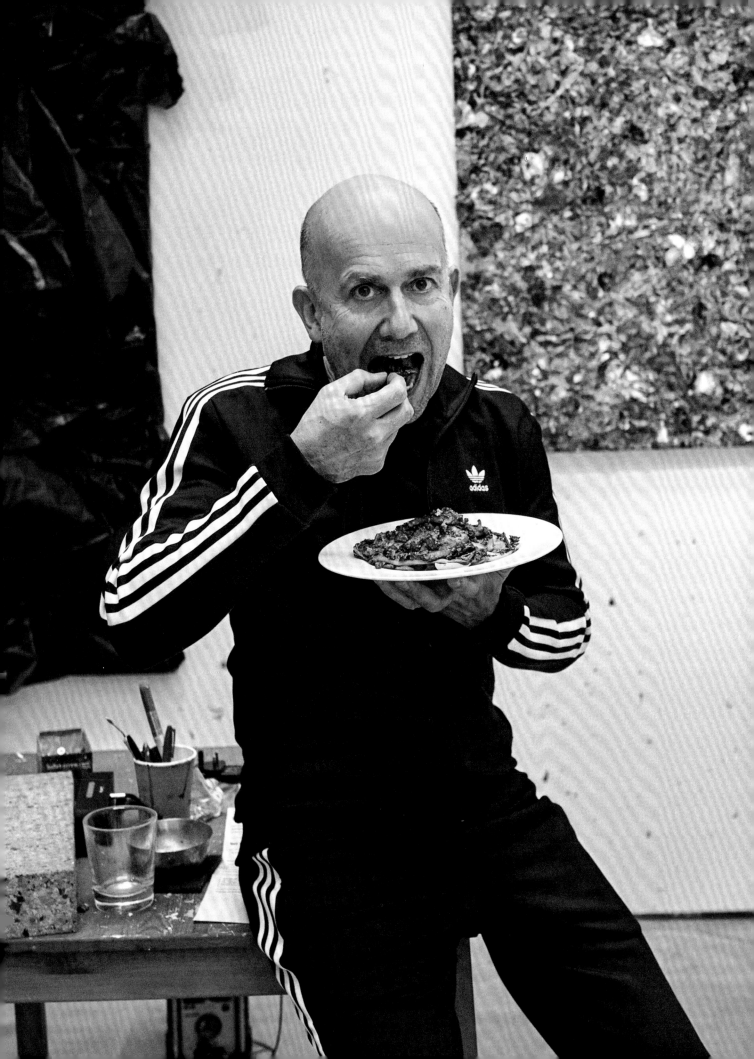

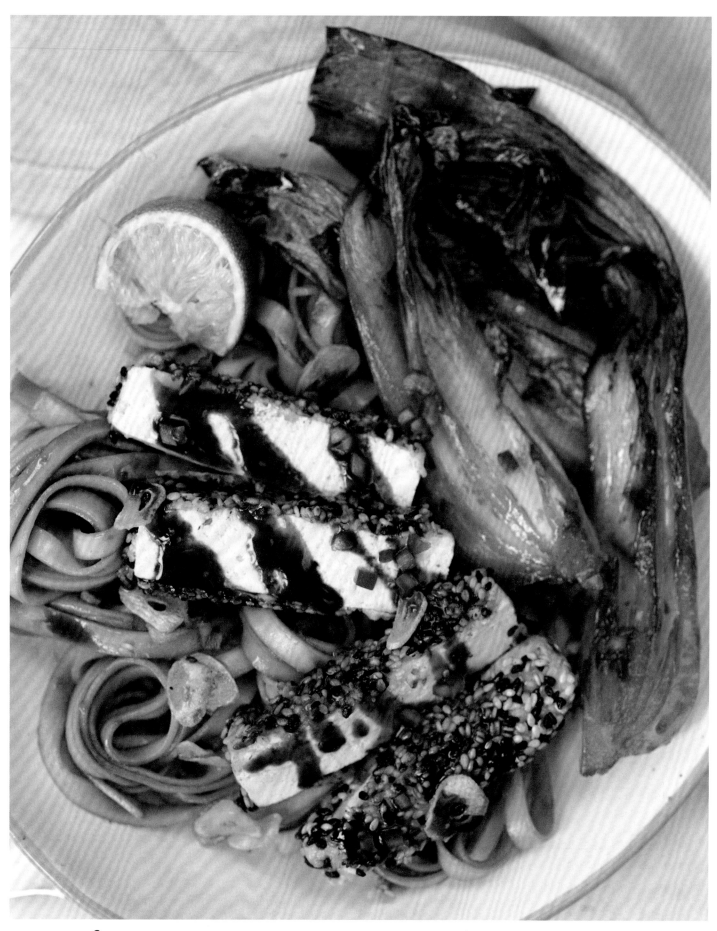

Crispy sesame seed coated tofu steak, leafy green pak choi and udon noodles absorb all of the flavours of my teriyaki sauce luxuriously. Any extra sauce can be stored in an airtight container in the fridge to use in stir fries.

SESAME TOFU AND TERIYAKI NOODLES

Ingredients

Teriyaki Sauce
3 garlic cloves, peeled and thinly sliced
5 cm (2 in.) ginger, peeled and grated
1 tablespoon sesame oil
60 ml (¼ cup) low-sodium soy sauce
 (or tamari for gluten-free)
60 ml (¼ cup) maple syrup
2 teaspoons rice vinegar
Juice of 1 lime
2 teaspoons cornflour (starch)

Sesame Tofu
2 × 300 g (10½ oz) blocks of firm smoked tofu,
 sliced into large steaks
1 × 400 g (14 oz) can of chickpeas for the liquid
 (aquafaba), or a carton of aquafaba
 (egg substitute)*
100 g (1 cup) cornflour (starch)
8 tablespoons sesame seeds
3 tablespoons vegetable oil, for frying

Noodles
2 pak choi or bok choy, quartered through the root
400 g (14 oz) udon noodles (flat rice or soba
 (buckwheat) noodles for gluten-free)

To serve
1 red chilli, deseeded and finely chopped
Squeeze of lime

*Drained chickpeas can be used in my Chickpea
"Tuna" Salad Sandwich recipe, page 111

Method

Teriyaki Sauce
In a saucepan over a medium heat, fry the garlic and ginger in 1 tablespoon of oil for 2 minutes, until golden, then stir in the soy sauce, maple syrup and rice vinegar. Gently bubble for 3–4 minutes. Then mix together the lime juice and cornflour in a small bowl and pour the mixture into the sauce, stirring until it thickens and coats the back of a wooden spoon. Remove from the heat.

Sesame Tofu
Drain the chickpeas in a sieve over a clean bowl and retain the liquid (keep the chickpeas for another recipe). Stir together the sesame seeds in a shallow bowl. Dust the smoked tofu steaks in cornflour, then coat them in the chickpea liquid (aquafaba) and place them in the sesame seeds, covering all sides of the tofu. Add the vegetable oil to a large frying pan and cook the tofu steaks for 3 minutes, until crispy and browned. Flip and cook for a further 3 minutes. Carefully remove the tofu to a board and slice each steak into 4 pieces.

Stir-fry the pak choi/bok choy in the tofu pan (it doesn't matter if some sesame seeds are still in there). Add a tablespoon of the Teriyaki Sauce to coat and flavour. Remove from the heat after 2–3 minutes of cooking, once caramelised and wilted.

Cook the noodles according to packet instructions, drain well and return to the pan. Drizzle most of the teriyaki sauce over the noodles and toss to coat (retaining a little sauce to drizzle on top to finish).

To serve
Divide the noodles amongst bowls or plates, lay the sesame tofu on top and the pak choi on the side and finish with a drizzle of the Teriyaki Sauce, chopped chilli and a squeeze of lime.

JAMIE DORNAN

MUSHROOM STEAK, BEURRE-LESS BLANC AND FRIES

Studio Kitchen, London

Jamie had agreed to be a guest on my cooking show. Despite his huge success as an actor, he has kept his feet firmly on the ground. On arrival he took the time to introduce himself to all my film crew. I know he is a meat eater but very open-minded about trying new things. I'd been playing with an alternative to steak and chips. I seasoned large succulent portobello mushrooms to fry like a steak, cut hearty-sized fries, liberally seasoned them and got them into the oven. The idea behind my Beurre-less Blanc sauce came from was watching the chef Rick Stein make beurre blanc sauce on his series, *Cornwall*. I was curious to see how it would taste if I swapped out the butter for olive oil, used plant-based cream and added a touch of corn powder to add gloss. The result was that it tasted fantastic!

While I set about cooking, we chatted, and Jamie opened a bottle of red wine. I told him that, when we were young kids, Mum and Dad would take us on tour around the world with their band, Wings. He said that, when he can, he takes his daughters with him when he's away filming, explaining, *"They'll only be this age once, and I don't want to miss out on it"*.

I could see Jamie was intrigued by the idea of a beurre-less blanc sauce, and as we tucked in, I was eager to hear his verdict. It was a big thumbs up. Then we wiped our plates clean with a traditional chip butty of buttered soft white sandwich bread, stuffed with chips, a squeeze of tomato ketchup and folded over. There is nothing better!

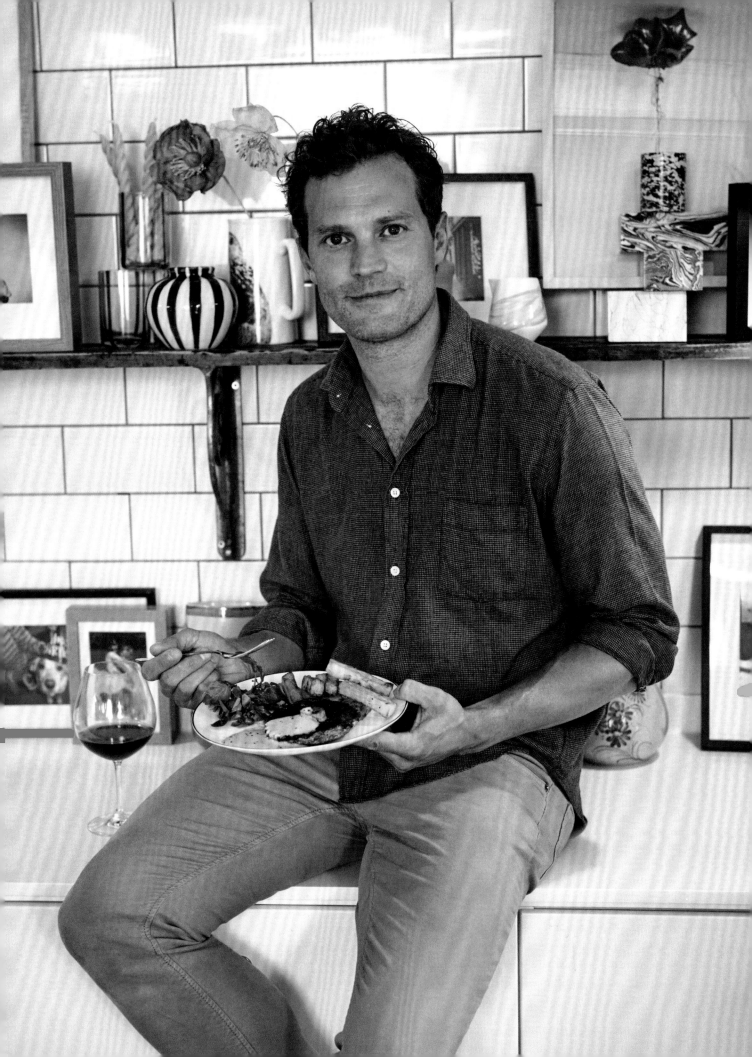

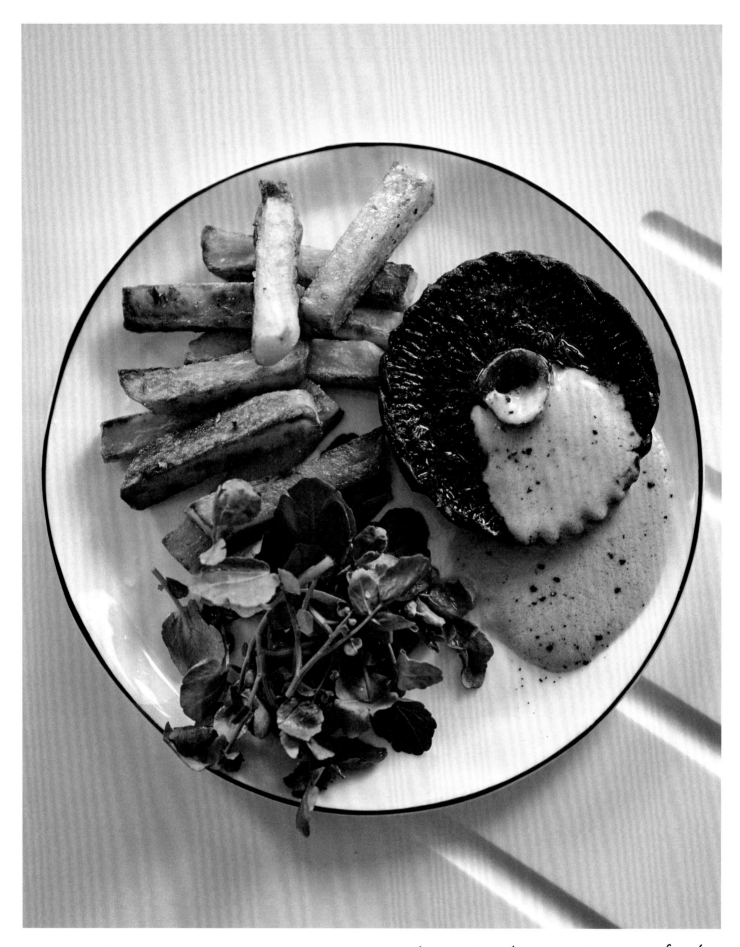

Inspired by the classic steak and chips, this hearty plate of food is composed of succulent large fried mushroom steaks, a tangy creamy white wine sauce and thick cut oven chips. Any extra chips can be stuffed into a piece of buttered bread to make a chip butty!

174

MUSHROOM STEAK, BEURRE-LESS BLANC AND FRIES

Ingredients

Chunky Fries
450 g (1lb) waxy potatoes, (I use russet), peeled
 and cut into 1½ cm (½ in.) wide long batons
3 tablespoons vegetable oil
Pinch of sea salt, to taste
Freshly ground black pepper, to taste

Beurre-less Blanc Sauce
5 round shallots, finely chopped
4 long sprigs of thyme
1 tablespoon olive oil
240 ml (1 cup) vegetable stock
240 ml (1 cup) dry white wine
1 teaspoon cornflour (starch),
 mixed with 1 tablespoon cold water
1 tablespoon Dijon mustard
120 ml (½ cup) unsweetened plant-based cream

Mushrooms
4 large portobello mushrooms, cleaned
 of dirt and stems trimmed
1 tablespoon olive oil
1 teaspoon garlic powder
1 tablespoon thyme leaves, chopped
Pinch of sea salt and freshly ground
 black pepper to taste

To serve
Handful of watercress (optional)

Method

Preheat the oven to 200°C/400°F and place an oven rack on the top shelf.

Chunky Fries
Add the potato batons to a medium/large saucepan and cover with cold water. Bring to a boil and parboil the potatoes for about 4 minutes. Drain and leave to steam-dry in the colander for a few minutes to get rid of any excess moisture.

Pour the vegetable oil onto a large baking sheet. Add the parboiled potatoes, season with salt and pepper and toss to coat in the oil.

Bake for 30 minutes, turning over halfway through, until crisp and golden.

Beurre-less Blanc Sauce
Meanwhile, in a small saucepan over medium heat, sauté the shallots and thyme sprigs in the olive oil for 5 minutes, until the shallots are soft and translucent. Add the stock and white wine, and gently simmer for around 5 minutes. Strain through a sieve into a bowl to remove the shallots and thyme, retaining the liquid. Return the liquid to the pan and stir in the cornflour mixture, mustard and cream. Gently simmer for a couple of minutes longer, until the sauce is glossy and thickened, and coats the back of the wooden spoon.

Mushrooms
Place a large frying pan over a high heat to heat up. Rub the mushrooms in the olive oil, garlic powder, thyme, salt and pepper. Place the mushrooms in the frying pan, stalk-side down, and cook for 3 minutes. Turn and cook the other side for another 3 minutes, until succulent.

To serve
Place 2 mushrooms on each plate and arrange the fries alongside them, in addition to a handful of watercress on the side, and spoon the sauce over the mushrooms.

DAVID OYELOWO AND FAMILY

Mains

SPEEDY VEGGIE BOLOGNESE

Home, Los Angeles

I first met David in London when I took his portrait. Meeting someone for the first time on set really keeps me on my toes. I can set the scene, preparing the location, the lighting, etc., but then it's down to their personality and seeing if we have good chemistry together. And that's what has kept it so interesting for me over the years.

I had a time constraint with David, as he was coming from his film set to do our photoshoot, and was then heading straight to the airport to go back home to his family in LA. He was collaborative, open to my direction and very engaged in the process. A joy to work with.

We stayed in touch and, when I was visiting California, I caught up with him, his talented wife Jessica and their kids at their home. Brits living in America. They wanted a quick meal before going to the cinema. I knew exactly what they'd all love. Something

quick, satisfying and in one bowl was the way to go. I opted for my Speedy Veggie Bolognese recipe, which I had adapted from the slow-cook version Dave Grohl had taught me.

I arrived armed with the sauce ready-made, and just the pasta to cook. I found myself surrounded by this warm, creative family, with musical instruments scattered around the house and two dogs filling a happy, relaxed home. Their daughter was out, but their eldest son's girlfriend was there to complete the picture. They gathered around, curious to know what I had cooked for them. As they ate, I directed them to stop and look at the camera before each bite. They kindly obliged, but once they had tucked in, they just kept eating. Six clean plates, the perfect compliment. I packed up and was on my merry way, as they set off to see *Everything Everywhere All at Once*.

176

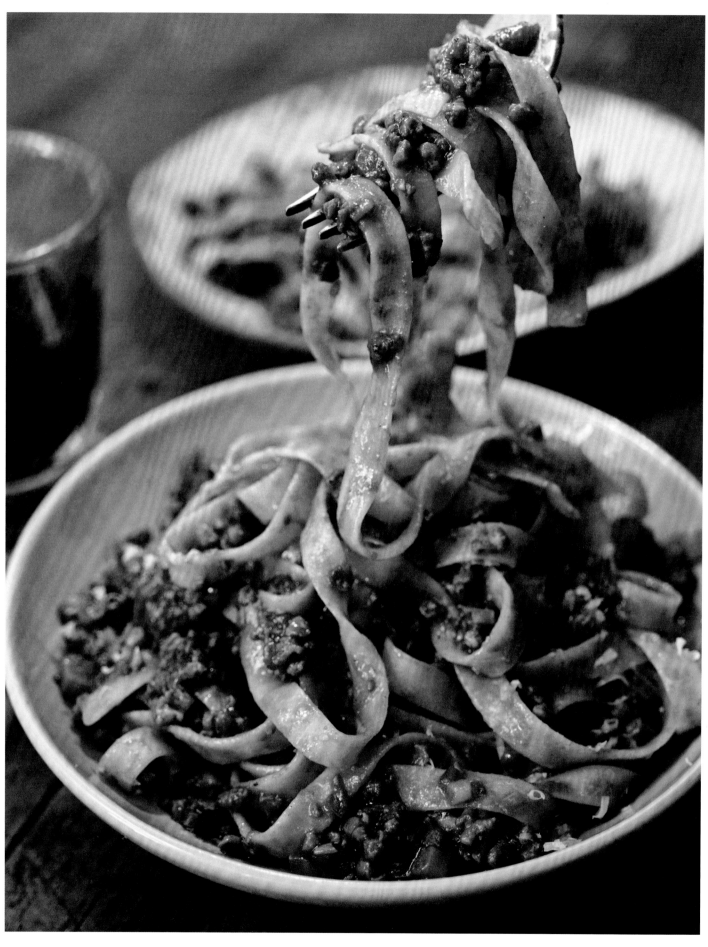

My speedy, flavor driven version of the slow cook classic.
Incredibly satisfying and all made in just 20 minutes!

SPEEDY VEGGIE BOLOGNESE

Ingredients

Veggie Bolognese Sauce
3 tablespoons olive oil
1 medium stick celery, finely chopped
2 medium white onions, finely chopped
1 medium carrot, finely chopped
2 bay leaves
2 garlic cloves, finely chopped
250 g (9 oz) plant-protein mince
1 teaspoon ground nutmeg
240 ml (1 cup) red wine (I use Pinot Noir,
 or something you like to drink at home)
1 × 400 g (14 oz) can of chopped tomatoes
½ tablespoon Worcestershire sauce
1 tablespoon tomato paste
120 ml (½ cup) vegetable stock
Sea salt and freshly ground black pepper, to taste

400 g (14 oz) tagliatelle (or other pasta of your
 choice; you can use gluten-free)
Sea salt

To serve
Handful of basil leaves, torn
Plant-based Parmesan (optional)

Method

Veggie Bolognese Sauce
Heat the oil in a large saucepan. Add the celery, finely chopped onion, carrot, garlic and bay leaves, and stir well and fry for 3 minutes (you want to hear a nice sizzle). Mix in the plant-protein mince, nutmeg and red wine, and bring to a vigorous simmer. Stir in the chopped tomatoes, Worcestershire sauce, tomato paste and vegetable stock. Simmer for 15–20 minutes, stirring often. Season with sea salt and freshly ground pepper to taste. Remove the bay leaves and discard.

While the sauce is cooking, add the pasta to a large saucepan of salted boiling water and cook according to the packet instructions (leave out the salt if using gluten-free pasta).

Drain the pasta and return to the same saucepan. Stir ¾ of the Bolognese Sauce into the pasta pan and toss well to combine, reserving the rest of the sauce to spoon on top of each serving.

To serve
Divide the pasta into bowls, top with a spoonful of the remaining sauce, and garnish with basil leaves. Finish with some finely grated Parmesan, if using.

DAVID HOCKNEY

Mains

RED ONION, PEA AND SPINACH TART

Artist's Studio, Los Angeles

David Hockney's Los Angeles home felt like walking straight into one of his artworks. It was painted that distinctive bright Hockney pink and blue. I was so excited for this one, but I had arrived in LA the day before and had celebrated my arrival a little too hard, and had woken up with the worst hangover ever.

Feeling worse for wear, I realised the only way to get through this was to keep it simple, using ingredients with vibrant colours inspired by David's art. I opted for a shortcut, using ready-rolled pastry as my base—that was my saviour—topped with sliced red onion, sweet peas, wilted baby leaf spinach and a hint of lemon zest. It became a visual feast for the eyes, reminiscent of one of David's beautiful sketchbook drawings.

I found David in his studio, sitting in his comfy armchair, cigarette in hand, perusing the large artworks he was working on which were pinned onto the walls around him. What a privilege to cook for him. He happily munched away and we had a poignant conversation about his mother, and the clever and inventive ways in which she had managed to feed their family during rationing in World War II. His love of her cooking and fond recollections really resonated with me, as so many of my fond memories of my mum revolve around our food experiences too.

180

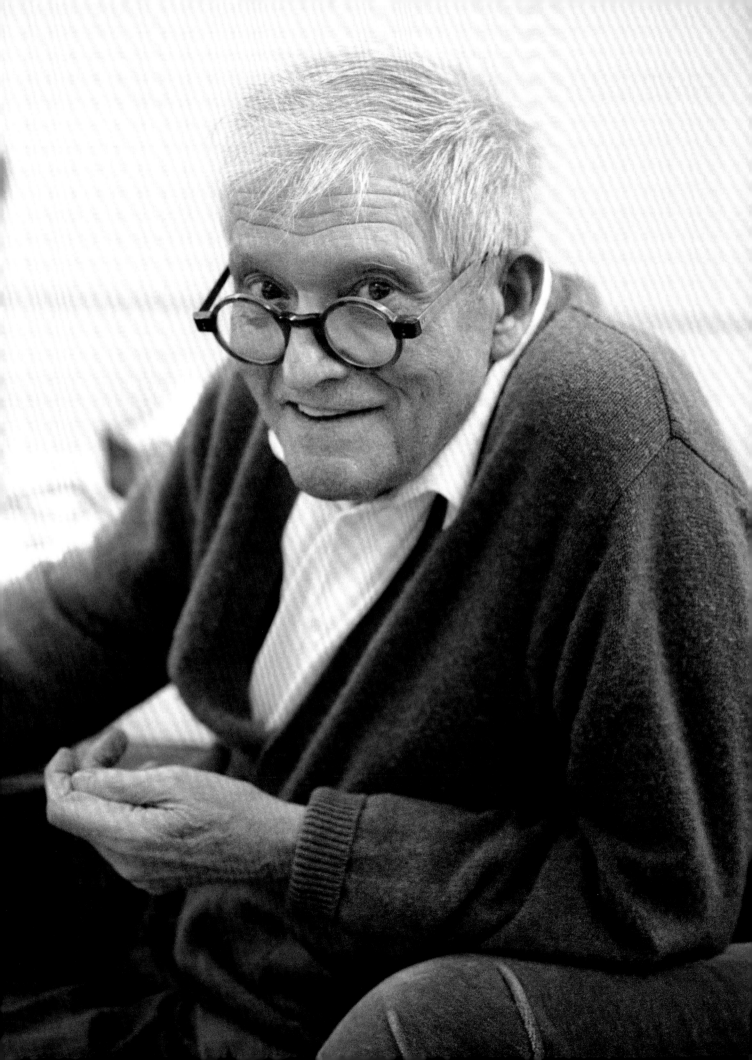

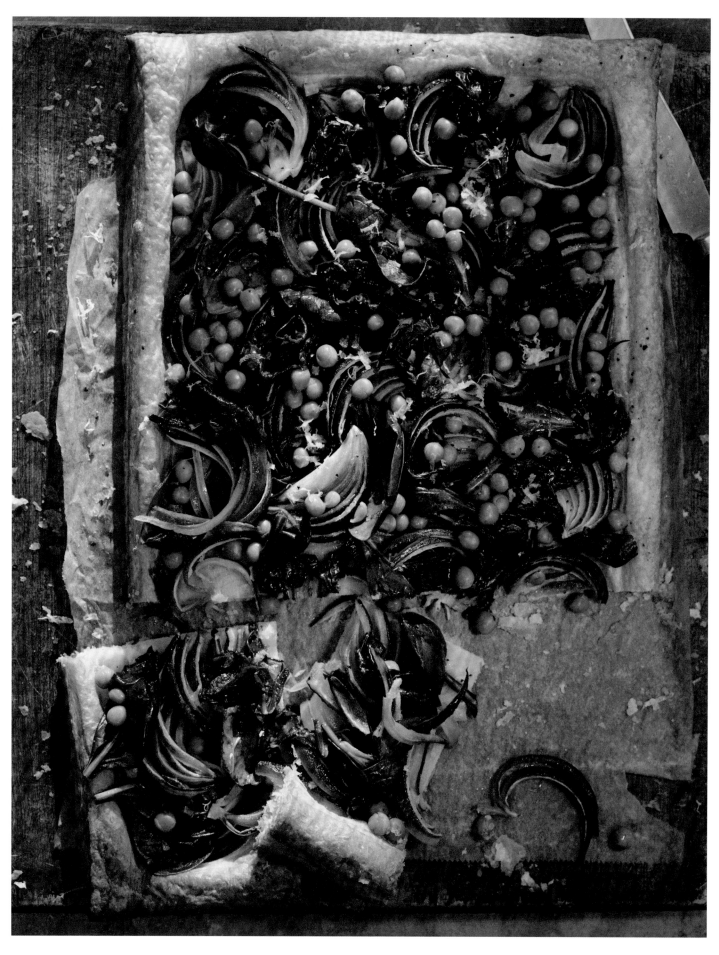

Fresh, colourful and so easy to make, this tart
is a pleasure to behold and equally pleasing to eat.

RED ONION, PEA AND SPINACH TART

Ingredients

Tart Base
1 sheet of ready-rolled puff pastry, 320 g (10 oz),
 (made with vegetable shortening)
1 teaspoon olive oil
1 tablespoon unsweetened plant-based milk

Red Onion Topping
2 large red onions (about 370 g/13 oz), peeled,
 halved, and thinly sliced into half-moons
2 tablespoons olive oil
Pinch of sea salt
1 tablespoon balsamic vinegar

Wilted Spinach
1 teaspoon olive oil
220 g (8 oz) baby leaf spinach
1 garlic clove, finely chopped
Sea salt and freshly ground black pepper, to taste
130 g (1 cup) frozen peas, thawed in boiling
 water and drained well

To serve
Zest of ½ a lemon and a light squeeze of lemon juice

Method

Preheat the oven to 190°C/375°F.

Tart Base
Roll out the pastry sheet onto a baking tray (leaving the parchment paper from the packet underneath). Roll up edges on each side to form a small border to hold in the filling. Mix the olive oil and milk, and brush the mixture over the base and edging of the pastry.

Red Onion Topping
Lay the sliced onions evenly onto the pastry base, overlapping them slightly. Drizzle liberally with olive oil, sprinkle with sea salt and add a drizzle of balsamic.

Bake for 25–30 minutes, until the pastry is crisp and golden.

Wilted Spinach
Add the olive oil to a medium pan on a low-medium heat and wilt the spinach along with the garlic for 2 minutes, until the leaves have just softened. Season with salt and pepper. Drain away any liquid.

To assemble
Once the tart is out of the oven, arrange the wilted spinach over the cooked tart and scatter over the thawed and drained peas.

To serve
Serve with a little lemon zest and a light squeeze of lemon juice on top.

BAKING

DESSERTS

ROSE WYLIE

Baking, Desserts

ICED
SPICED BANANA
CAKE

Artist's Studio, Kent

Rose Wylie and I first met at her exhibition at the Serpentine Gallery. I was attracted by her maverick attitude, her heavy-knit orange sweater and black Dr. Martens boots. She invited me to have afternoon tea at her home and painting studio in Kent—I would catch the train and bring cake. When I arrived, Rose showed me around. Straight away, she led me up the single flight of stairs to her studio, a relatively small room, considering the large scale of the canvases she was working on. It's everything I want an artist space to be: filled with paintings in progress and artist debris, tin cans and paint pots crammed with well-worn paintbrushes and loads of tubes of oil paint in vibrant colours. Entering the room, I immediately stepped onto a generous blob of orange oil paint that was partially hidden under a pile of crumpled newspaper, perfectly placed to use to wipe it off.

I noticed that even her bedroom had a canvas that she was working on, pinned to the wall at the end of the bed. We naturally fell into very open and honest conversation. Rose was in a reflective mood, talking fondly about her late husband, Roy Oxlade, still very much on her mind in this home they had shared together. Kettle on, we decide on coffee to go with the Iced Spiced Banana Cake I had so carefully transported on the train from London. We moved from the kitchen to her magical conservatory, where over time the vines from the garden had intertwined and grown through the gaps in the window frames—it looked magical to me, an artistic vision of bringing the outside in. We sat together sipping perfectly strong coffee and munching the moist iced cake. I savoured the moment with her.

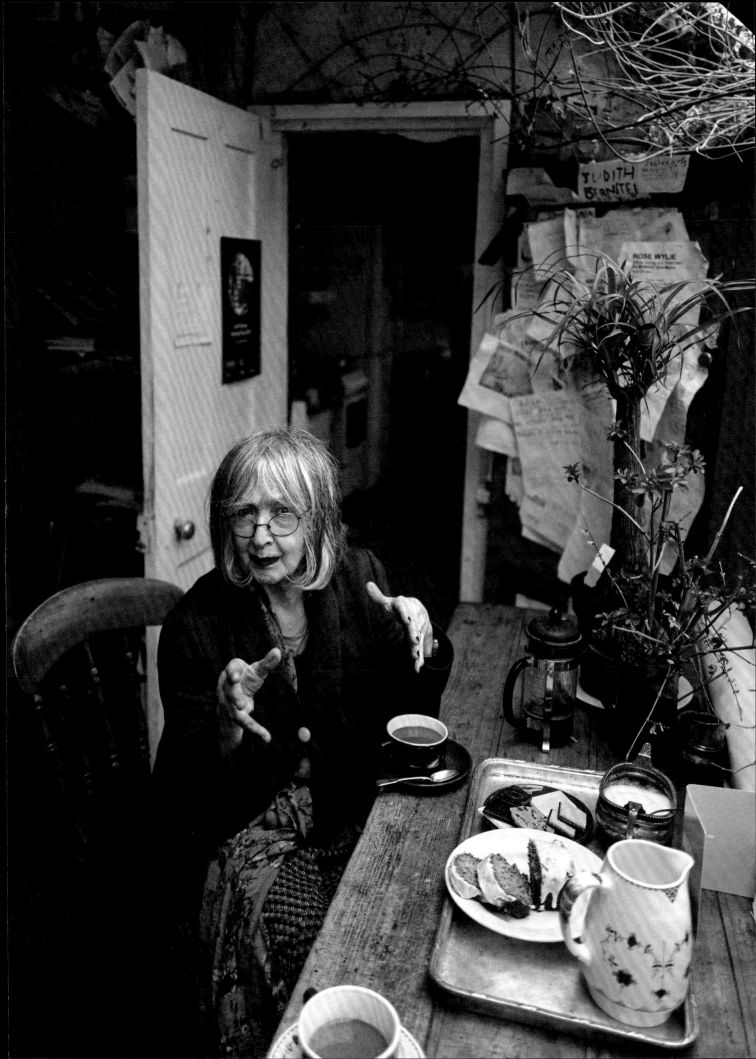

In admiration of the beloved banana cake. The very best way to
use up over ripe bananas in my opinion. I add a hint of ground
cinnamon and decorate it with a glaze icing with orange zest.

ICED SPICED BANANA CAKE

Ingredients

Plant-based butter, or oil, for greasing
Plain (all-purpose) flour, for dusting the cake tin

Cake
350 g (12oz) ripe bananas, peeled
 (the riper, the better)
1 tablespoon vanilla extract
80 ml (⅓ cup) olive oil
2 teaspoons ground cinnamon
100 g (½ cup) soft brown sugar
240 g (2 cups) plain (all-purpose) flour
3 teaspoons baking powder

Icing
200 g (2 cups) icing (confectioner's/powdered)
 sugar, sieved
1 teaspoon vanilla extract
2 or 3 tablespoons unsweetened plant-based milk

Orange zest, to decorate (optional)

Method

Preheat the oven to 180°C/350°F degrees. Grease and lightly flour a 1.2 litre (2lb) loaf tin.

Cake
Add the ripe bananas to a medium-sized mixing bowl and mash well with a fork, then add the vanilla extract and olive oil and mix everything together.

In a medium/large mixing bowl, stir together the cinnamon, sugar, flour and baking powder. Add in the mashed banana mixture and stir until thoroughly combined.

Pour the cake mixture into the prepared loaf tin and bake for 40–45 minutes, until a skewer (or piece of uncooked spaghetti) inserted into the centre comes out clean. Turn out of the tin and allow to cool before topping with the icing.

Icing
Mix together the icing ingredients, adding just enough milk to make a runny, pourable icing; you may not need all the milk, so stir in 1 tablespoon at a time.

Top the cooled loaf with the icing and decorate with orange zest (if using).

191

JOHN WILLIAMS

Baking, Desserts

JEWELLED CHOCOLATE BARK

The Village Recording Studios, Los Angeles

At age 91, John Williams is still a brilliantly prolific and active composer, so it takes a while to lock him into a time and date to meet. He had agreed to be interviewed by me for my Abbey Road documentary, and the prospect of meeting him left me awestruck. This is John Williams, for goodness' sake! This is the man who composed the themes for *Star Wars, Indiana Jones, Jaws* and *Schindler's List*, to name only a few. We arrange to meet at The Village recording studios, as he was in full flow, writing the score for the new movie *Indiana Jones and the Dial of Destiny*. After the interview, he would get back to work. At the allotted time, John pulled up in his chauffeur-driven car and I greeted him curbside. He was warm and friendly, with a relaxed aura. I vowed to make the most of being in the John Williams "bubble".

We walked into the recording studio, where I showed him straight to his chair. He sat down and we got started on our interview. I asked him all about his personal history with Abbey Road Studios, having recorded there with George Lucas and Steven Spielberg many times. I wondered what kept him coming back. He was incredibly eloquent and charming in his answers, and he said he felt *"Abbey Road is a gift to music"* and recording with the London Philharmonic Orchestra there was like *"driving a Rolls-Royce"*. As I asked my last question, about pop music in the '60s, as if on cue (which it definitely wasn't), Ringo walked into the studio to meet John. He was coincidentally recording in the studio next door. It was a perfect moment, and I was happy to catch it on camera. When we finished, we shared a moment eating the chocolate bark I had made for him. Then John calmly stood up, and we walked back to his car and I waved him on his way. It was like a dream.

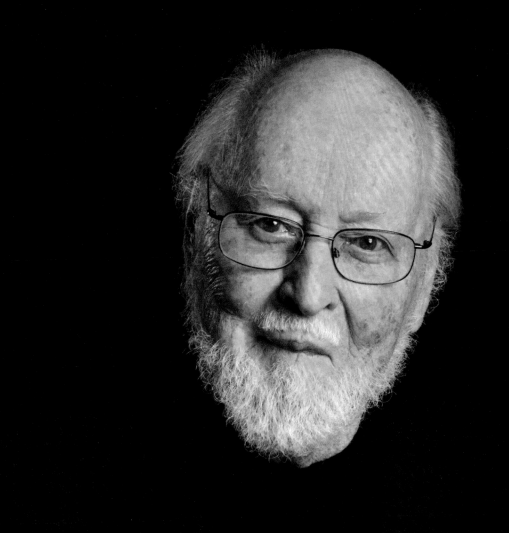

The perfect treat to have to hand when the chocolate craving hits. Simply melt the chocolate and adorn with the toppings and leave it to set. Especially good broken into pieces and presented on a wooden board at the end of a meal or crumbled onto the overnight chia pudding pot.

196

JEWELLED CHOCOLATE BARK

Ingredients

Bark
90 g (3½ oz) dark chocolate (70% cocoa)
2 tablespoons coconut oil or plant-based butter
60 g (2 oz) lightly salted pretzels,
 crushed into chunky pieces
60 g (2 oz) toasted hazelnuts, roughly chopped

Topping
2 tablespoons freeze-dried strawberries, chopped
2 tablespoons shelled and toasted
 pistachio nuts, chopped
30 g (1 oz) sea-salted pretzels, broken

Method

Line a 25 × 35 cm (10 × 14 in.) baking sheet with parchment paper.

Bark
On a gentle, low heat, melt the chocolate and coconut oil together in a saucepan. Alternatively, you can melt the chocolate in a microwavable bowl in 30-second bursts, stirring between each burst, and then stir in the coconut oil once the chocolate has melted.

Add the 60 g (2 oz) crushed pretzels and toasted hazelnut pieces to the melted chocolate and mix to coat thoroughly. Pour the mixture onto the lined baking sheet, smoothing it to the edges so it is thin and evenly spread.

Topping
While the chocolate is still melted, sprinkle the strawberries, pistachios and broken pretzel pieces on top and leave somewhere cool or put in the fridge to set.

Once set, cut or break the bark into pieces. I like to serve this on a wooden board at the end of a meal. It also keeps well in an airtight container in the fridge or a cool, dark cupboard.

JEFF KOONS

Baking, Desserts

RAINBOW SPRINKLES CAKE

Artist's Studio, New York

I was in New York exploring the city with my husband, when up popped an exciting message inviting us to go see Jeff Koons that afternoon at his studio, and it seemed like the perfect opportunity to cook him something too. My husband and I talked about it and decided on baking Jeff a cake for afternoon tea, just like a good British friend would—maybe not the cleverest idea, as we were a long way from home. Inspired by Jeff's vivid imagination and his love of pop culture and colour, I came up with the idea of a Rainbow Sprinkles Cake. I had never made one before, but it somehow felt perfect for Jeff's upbeat personality.

Armed with the iced cake, we headed to Midtown Manhattan. Knowing the scale of the work that Jeff makes, I was not surprised to see that his space spanned three floors, with an army of people developing the meticulously planned and engineered art he imagines. Greeting us with his trademark beaming smile, Jeff proceeded to give us the most incredible, personal guided tour, a memory that will last forever. We ended the tour talking about his upcoming show *Apollo*, at the old slaughterhouse in Hydra, Greece. His plan was to transform the space into a temple, with paintings, music and sculpture, giving the viewer a visual and sensual experience reflecting the dialogue between ancient and contemporary worlds. Jeff enjoyed the cake very much, which justified my last-minute decision to make it. I was pleased to notice a Pantone colour chart left out on his desk with reference colours for the painting he was working on, which coincidentally perfectly matched the sprinkles on the cake I had brought him.

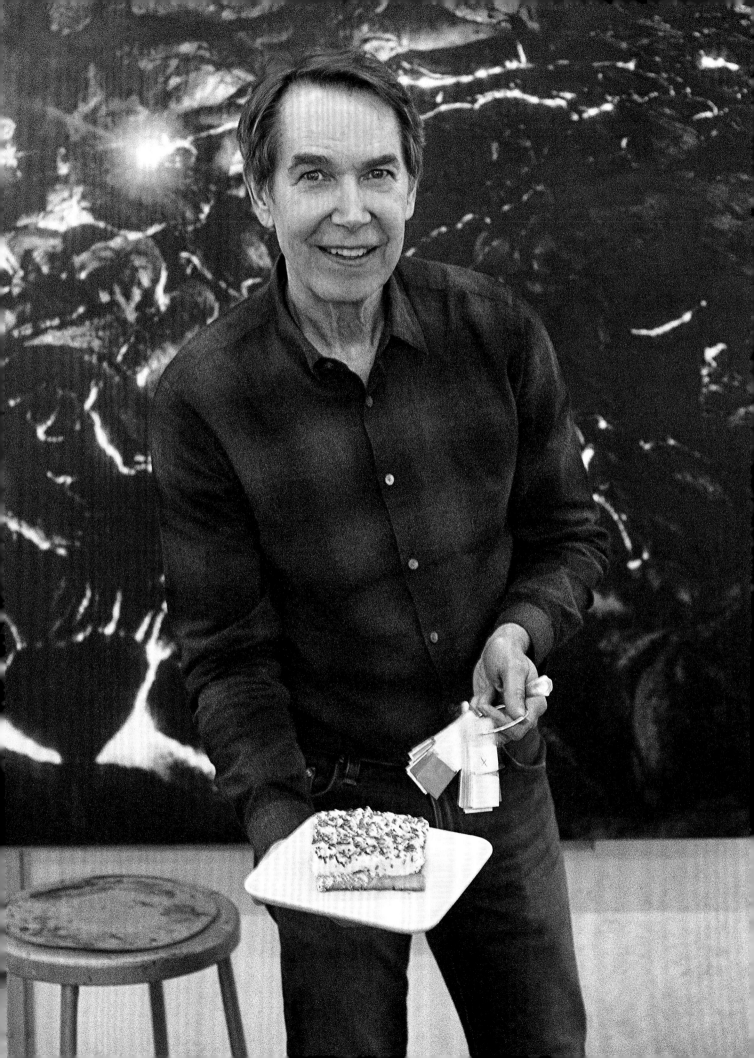

The perfect party cake, when cut open it reveals colourful sprinkles baked within the vanilla cake. It's then frosted with a generous layer of vegan buttercream icing and then more sprinkles. What's not to love about this?!

RAINBOW SPRINKLES CAKE

Ingredients

Plant-based butter, for greasing
Plain (all-purpose) flour, for dusting

Cake Batter
175 ml (¾ cup) unsweetened plant-based milk
2 teaspoons apple cider vinegar
150 g (¾ cup) sugar
60 g (¼ cup) plant-based butter
2 tablespoons vanilla extract
180 g (1½ cups) plain (all-purpose) flour
2 teaspoons baking powder
2 tablespoons rainbow sprinkles

Icing
180 g (¾ cup) plant-based butter
600 g (21 oz or 2½ cups) icing (confectioner's /
 powdered) sugar (sieved)
2 tablespoons vanilla extract
1 tablespoon unsweetened plant-based milk

Rainbow sprinkles to decorate

Method

Preheat the oven to 180°C/350°F. Grease and dust a 20 cm (8 in.) cake tin — either square or round — with flour.

Cake Batter
Measure out milk using a measuring jug and stir in the apple cider vinegar. Set aside while making the rest of the batter.

Beat the sugar and butter together in a medium mixing bowl, then stir in the vanilla extract. Add in the flour and baking powder and stir well to combine. Slowly pour in the milk and vinegar mix to form a nice cake batter consistency. Finally, stir in the rainbow sprinkles.

Pour the batter into the prepared cake tin and spread it out to the edges in an even layer.

Bake for 45 minutes, until a skewer (or piece of uncooked spaghetti) inserted into the centre comes out clean.

Take the cake out of the oven and allow it to cool to room temperature (so the icing will not melt when spread on top). If you only want the soft sponge, you can cut away the edges (and save for something else).

Icing
Whisk the icing ingredients together until fluffy (using an electric beater makes this process much quicker, otherwise use a wooden spoon or hand whisk).

Spread the icing on the top of the cooled cake using a metal knife to smooth it.

To Serve
Decorate with sprinkles scattered on top and slice into pieces to serve.

TRACEY EMIN

Baking, Desserts

STICKY BLACK RICE AND MANGO

Artist's Studio, Margate

Tracey and I first met over 20 years ago. I had spontaneously emailed her to ask if she would sit for me for a portrait, dressed as Frida Kahlo. To my surprise she immediately agreed, saying she felt a deep affinity with the artist. From the day of that shoot in East London, we became friends, and that portrait of Tracey, *Being Frida*, became one of my all-time favourites. Having not seen her for a while, I caught the train to visit her in Margate, her hometown on the British South Coast. In 2020 Tracey was diagnosed with bladder cancer and had to undergo dramatic surgery to survive. Having made a miraculous recovery, she had a newfound lust for life. She had become devoted to setting up her art school in Margate, an extraordinary space for artists and students, all subsidised by her and which she is passionately involved in day to day.

I knew Tracey liked Thai food, so with those flavours in mind I devised a Sticky Black Rice and Mango dessert to try out on her. We met at her house, where she hovered in the kitchen with me while I plated up. Then we made our way to her studio space to sit at her desk and eat. We were surrounded by the large-scale paintings she was working on and sketches laid out on the floor, reference works for the grand bronze doors she had been commissioned to make for the newly reopened National Portrait Gallery in London. As we ate, Tracey said she particularly liked the nutty texture of the black rice, something she hadn't tried before. She said the coconut cream sauce, when poured, looked like spunk. She continued with that wicked smile... *"and when you slice the mango, the sauce goes into it, like a vagina."* We talked and talked; I missed two trains home, but eventually I peeled myself away. I left as the sun was setting over Margate Main Sands beach—it looked postcard perfect.

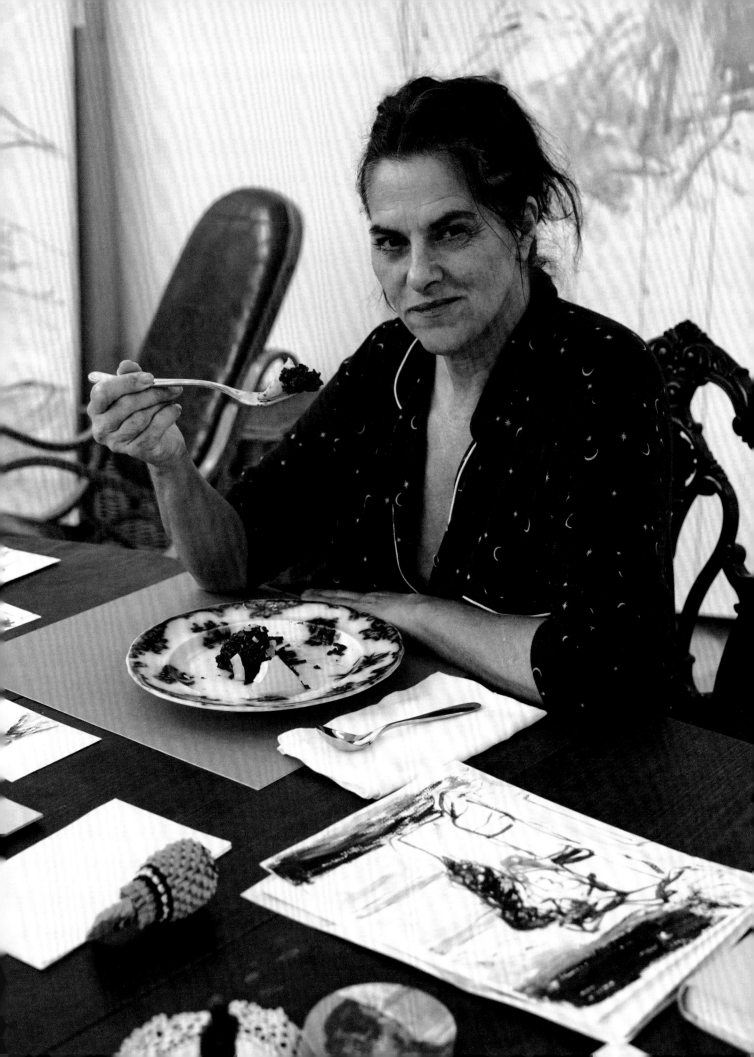

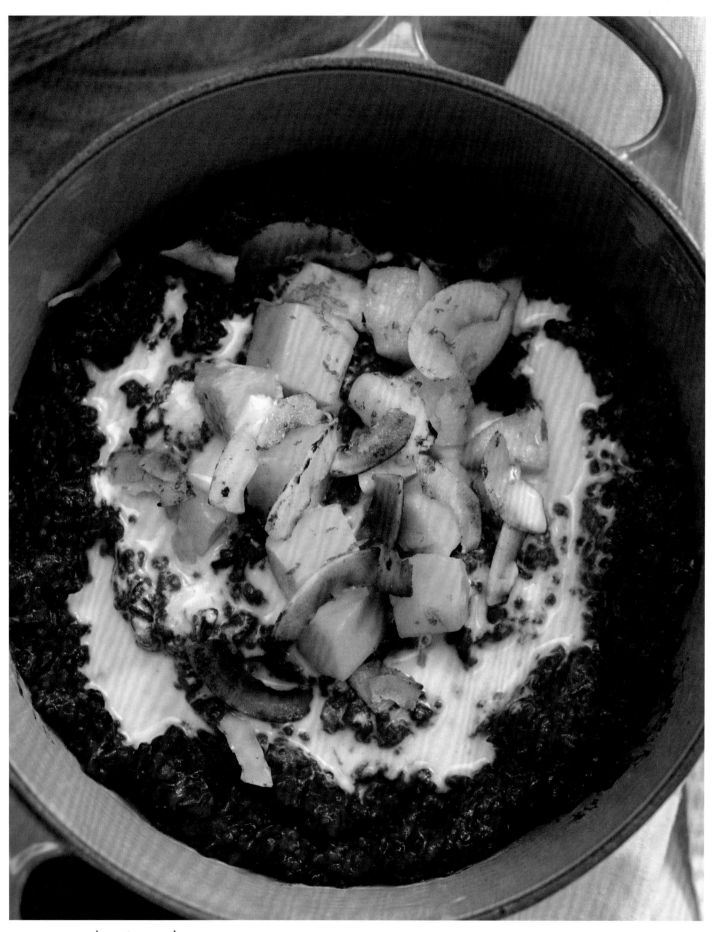

Inspired by the traditional Thai dessert, my sticky coconut rice pudding is made using black rice for an extra nutty flavour and depth of colour. Served with ripe mango and coconut cream. You'll keep coming back for more.

204

STICKY BLACK RICE
AND MANGO

Ingredients

100g (½ cup) black rice
90g (½ cup) white long-grain rice
480ml (2 cups) of unsweetened plant-based milk
(I use cashew or coconut)
1 × 400g (14oz) can of coconut milk
60g (⅓ cup) coconut sugar or any sugar
1 tablespoon vanilla extract

1 ripe mango (if small mangoes, then use 2)

To serve
Plant-based cream
Lime zest
Toasted coconut chips (optional)

Method

Place the black rice and white long-grain rice in a saucepan and stir in the plant milk, coconut milk, sugar (I like to use coconut sugar as it has a nice caramel flavour) and vanilla extract. Bring to a gentle simmer, cover with the lid and cook for 25–30 minutes (check the rice packet instructions for exact cooking time), checking and stirring often.

If the rice starts to dry out, add a little more milk as required. It is ready when the rice is just cooked through (al dente) and sticky.

Peel the ripe mango; cut away the flesh from the stone and cut it into bite-sized pieces.

To serve
Spoon the sticky rice onto a dessert plate, and lay the mango on top or on the side. Finish with a drizzle of cream, a light grating of lime zest and toasted coconut chips on top.

MARTIN FREEMAN

Baking, Desserts

GRILLED PINEAPPLE, RUM SAUCE AND ICE CREAM

Home, London

It was the hottest day of the year, and I had chosen to make my Grilled Pineapple, Rum Sauce and Ice Cream dessert. The journey to Martin's home became a mad dash to prevent the ice cream from becoming a melted milkshake. When I got there, I headed straight for the freezer to put the ice cream—and my head—inside! I was very happy to see some Linda McCartney's frozen ready meals stashed there too. This broke the ice immediately, "ice" being the word of the day.

Martin is one of Britain's best-known character actors, and has played parts ranging from Tim Canterbury in *The Office*, to Bilbo Baggins in *The Hobbit* trilogy, to a police officer in the brilliant TV drama *The Responder*, in which he has an impressive Scouse (Liverpool) accent. It's not surprising that he's won so many awards over the years.

Rooting around in his kitchen for a saucepan to heat the rum sauce, I disapprovingly pointed out that the saucepan was worn and the non-stick surface was scratching off. Maybe not the best move having been invited into someone's home, so I promptly shut up. We ate the dessert in the living room, with Martin's dachshund puppy hopping up onto his lap to check out what was going on. Peeking at his bookshelves, I was flattered to see my first photography book, *From Where I Stand*. I promptly signed and dedicated it to him. I would have stayed all day just chatting, as he is so interesting; it felt like there was so much left to talk about.

As soon as I got home I ordered a replacement saucepan to send as a thank you gift, and I was delighted when Martin sent me a photo of him using the pan to cook a delicious-looking tomato sauce with Linda McCartney's veggie meatballs.

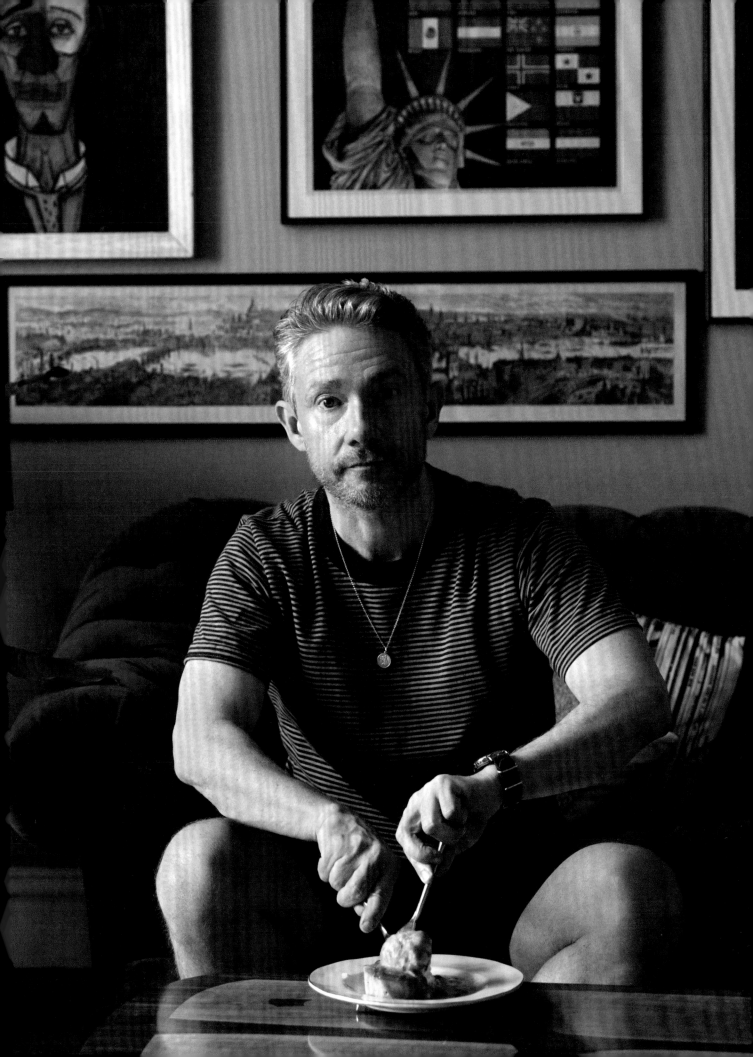

This dessert is guaranteed to bring sunshine into your day! Juicy grilled pineapple, a scoop of vanilla ice cream and a generous helping of rum sauce poured on top. Nice and easy.

GRILLED PINEAPPLE, RUM SAUCE AND ICE CREAM

Ingredients

Rum Sauce
170 g (1 cup) coconut sugar
1 tablespoon cornflour (starch)
180 ml (¾ cup) unsweetened plant-based milk
60 ml (¼ cup) dark rum
60 ml (¼ cup) plant-based cream

Grilled Pineapple
Oil, for grilling
4 round slices of fresh pineapple, 2 cm (1 in.)
 thick, with core removed
1 teaspoon ground cinnamon
2 limes

To serve
4 scoops of vanilla ice cream (vegan)
Lime zest

Method

Rum Sauce
Place the sugar in a small pan on a medium-low heat, and let it start to warm up. Meanwhile, in a small jug or cup, stir the cornflour and milk together until smooth. Slowly pour the milk/cornflour mix into the sugar (the sugar doesn't have to be "melted"), stirring constantly with a wooden spoon; turn up the heat so the sauce gently bubbles. Add the rum and continue to stir until nicely caramelised and glossy, thick enough to coat the back of the wooden spoon. Turn off the heat and stir in the cream.

Grilled Pineapple
Place a griddle or frying pan to warm up over a medium-high heat (or BBQ grill) and lightly oil. Sprinkle the pineapple slices with the ground cinnamon. Place on the pan and grill for about 3–4 minutes, until browned and caramelised, then flip and cook for a further 3–4 minutes on the other side. Remove from the heat and squeeze the juice of half a lime over each piece.

To serve
Place a slice of grilled pineapple on a plate, top with a scoop of ice cream and then spoon over the rum sauce. Finish with a light zesting of fresh lime on top.

FRANCESCA HAYWARD

Baking, Desserts

BANOFFEE CHEESECAKE

Royal Opera House, London

The effortlessly graceful and extremely talented Francesca Hayward is a principal dancer of the Royal Ballet, which has for a home the stunning Royal Opera House in London's Covent Garden. Francesca came to sign me in at the stage door and guided me through a special backstage route to her dressing room. This brought back very fond memories of the first time I fell in love with the Royal Ballet dancers, back in 2004. I was granted exclusive access to shadow the corps de ballet, exploring their life off stage — backstage, in dressing rooms, in the wings, at home and out socialising — for my photographic study *Off Pointe*. I was struck by their friendship, closeness and the devotion and determination required to be at the top of their art form.

Francesca spends a surprising amount of time based in her dressing room due to her gruelling rehearsal and performance schedule. Her room was adorned with a collection of handwritten cards and special photographs decorating her make-up mirror which made it feel much more personal. And I noticed a bouquet of flowers in the sink, a tribute from last night's performance. She cleared a space on her dressing table for me to serve the Banoffee Cheesecake I had made her. To finish it off, I sliced fresh bananas on top and then drizzled over the melted chocolate and homemade caramel sauce. Francesca looked longingly on as it came together and, as she ate, asked me all about how I had made it. Then it was her turn to tell me about preparations for her latest role in *The Limit*, based on the play *Lemons Lemons Lemons Lemons Lemons*. We agreed I would come back to photograph those rehearsals and bring more cheesecake.

212

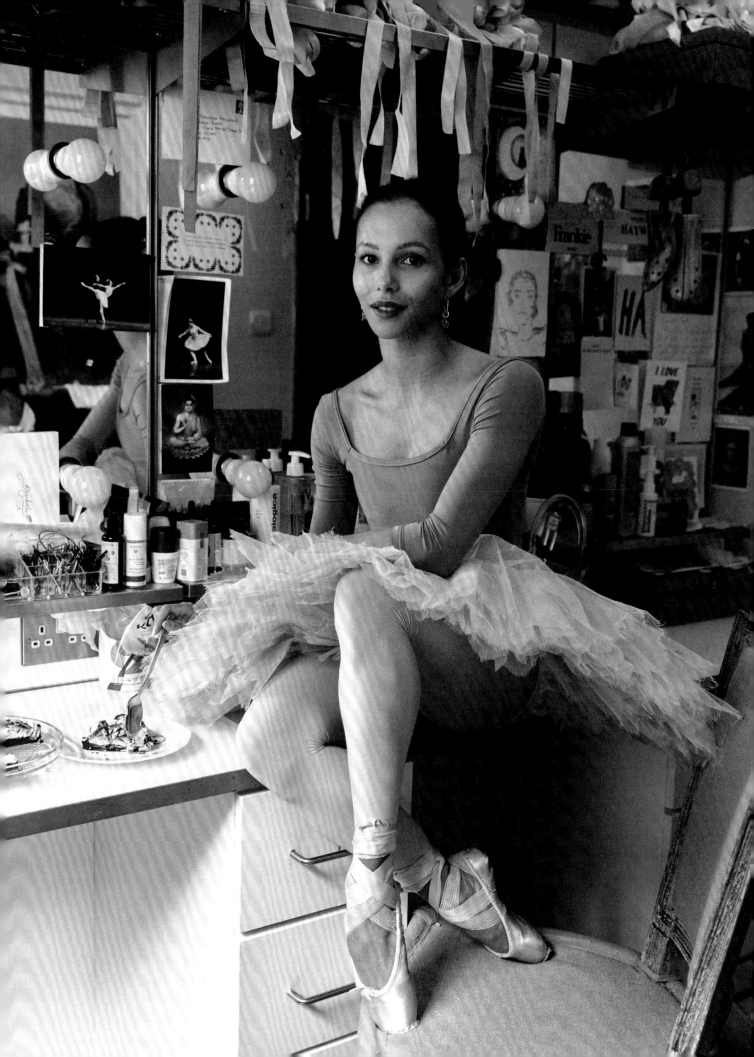

I love banoffee pie and I love cheesecake — so I came up with this dairy-free mash up of them both. Everything can be made ahead and kept in the fridge until ready to add the toppings and serve.

214

BANOFFEE CHEESECAKE

Ingredients

Coconut Sugar Caramel (makes 175 ml/¾ cup)
½ tablespoon cornflour (starch)
120 ml (½ cup) unsweetened plant-based milk
85 g (½ cup) coconut sugar

Base
300 g (10½ oz) Oreo cookies (or similar)
2 tablespoons coconut oil (or plant-based butter)

Filling
400 g (14 oz) plain plant-based cream cheese
2 tablespoons coconut sugar
 (or icing/confectioner's sugar)
1 tablespoon vanilla extract
1 tablespoon of freshly squeezed lemon juice

Topping
60 g (2 oz) plain chocolate (I use 70% cocoa)
2–3 ripe bananas, peeled

Method

Line a 18 cm (7 in.) loose-bottomed, non-stick cake tin with parchment paper.

Coconut Sugar Caramel
Add the cornflour to a jug and stir in the milk. Mix until smooth and free of any lumps.

Warm the sugar in a small pan on a medium heat, then slowly pour the milk/cornflour mixture into the sugar, stirring constantly with a wooden spoon to keep it smooth. Turn up the heat to a gentle bubbling simmer, stirring until thickened to a glossy consistency that coats the back of the wooden spoon.

Cookie Base
Blitz the cookies with the coconut oil or butter in a blender until they have a fine crumb consistency and the oil or butter is well distributed. Alternatively, place the cookies in a resealable plastic bag and bash with a rolling pin to a fine crumb, then pour into a bowl and stir in the melted butter or oil. Tip the mixture into the lined tin and press down with a metal spoon to form an even base. Place in the fridge to set while you make the filling.

Filling
Beat together the cream cheese, coconut sugar, vanilla extract and fresh lemon juice in a medium-sized mixing bowl, until completely smooth. Spoon on top of the set biscuit base, smoothing out evenly with a spatula or metal spoon. Cover and chill in the fridge for at least an hour, or overnight.

Just before serving, melt the chocolate in a heat-proof bowl over a pan of gently simmering water. Once melted, remove from the heat. Alternatively, you can melt the chocolate in a microwavable bowl in 30-second bursts.

To serve
Remove the cheesecake from the tin and transfer it to a serving plate. Thinly slice the bananas on top of the cheesecake, drizzle over 2 or 3 spoonfuls of the caramel followed by 2 spoonfuls of the melted chocolate. You can keep the extra caramel in an airtight container in the fridge for up to two weeks.

DAVID AND CATHERINE BAILEY

Baking, Desserts

TOWERING BERRY TRIFLE

Home, London

David Bailey, or Bailey as he is universally known, is a photographic legend. His black-and-white portraits captured the cultural revolution in Britain in the 1960s. The cult classic film *Blow-Up* was inspired by him. I used to find him quite intimidating because he can be a little brash, shall we say. But one day I realised if I gave it back to him, he stopped. It's a front. He and his wife thankfully have become friends of mine.

Catherine Bailey is a beautiful and elegant woman. Once I travelled to their home in Devon to do a photo session with her. I was quietly hoping Bailey wouldn't be there, as I knew he would heckle me during the shoot. With Catherine swinging on a branch of a cherry tree, I turned around and spotted Bailey peeping out from behind a wall. He started shouting directions, as I expected, but very soon I saw the funny side.

Now what to make Bailey to eat? I knew he could be quite picky when it came to food, so I ran a few suggestions past Catherine, and we decided on trifle, as it's his favourite (and happens to be mine too). I made the fruit jelly at home and packed up the rest of the ingredients to assemble when I got to their house. Using Catherine's electric hand whisk to whip the cream, it soon became a chaotic scene. I managed to flick cream all over myself and the kitchen. So, instead I resorted to my back-up squirt-can whipped cream. The trifle looked perfect. We sat together, spoons in hand, and tucked in. It had been a while since we had spent time together, and it was a reminder of how much I have enjoyed making this book. It's been an opportunity to catch up with loved ones, even the grumpy ones I adore!

216

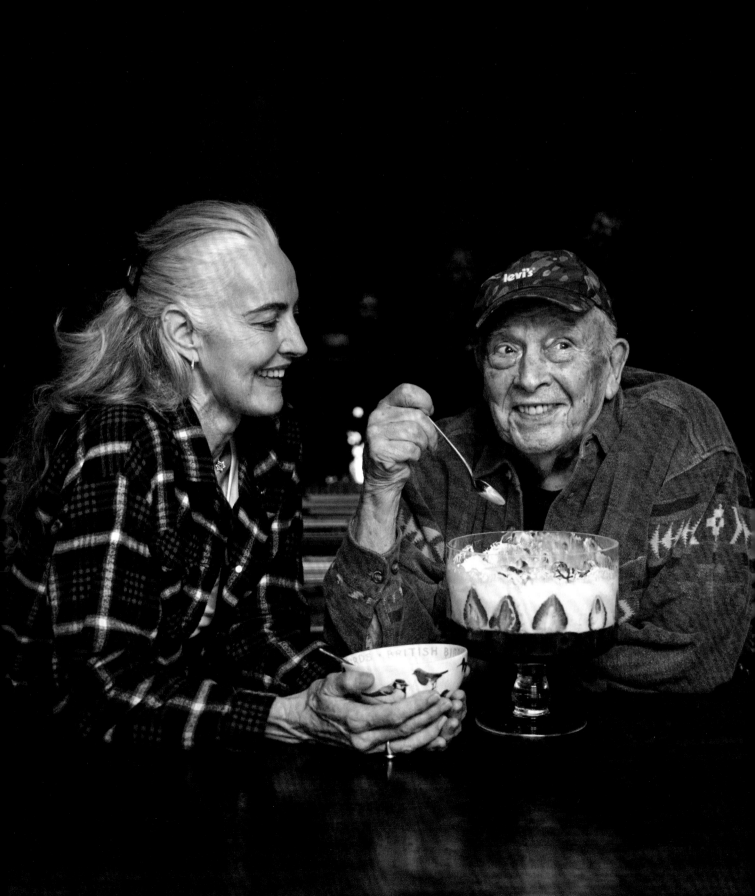

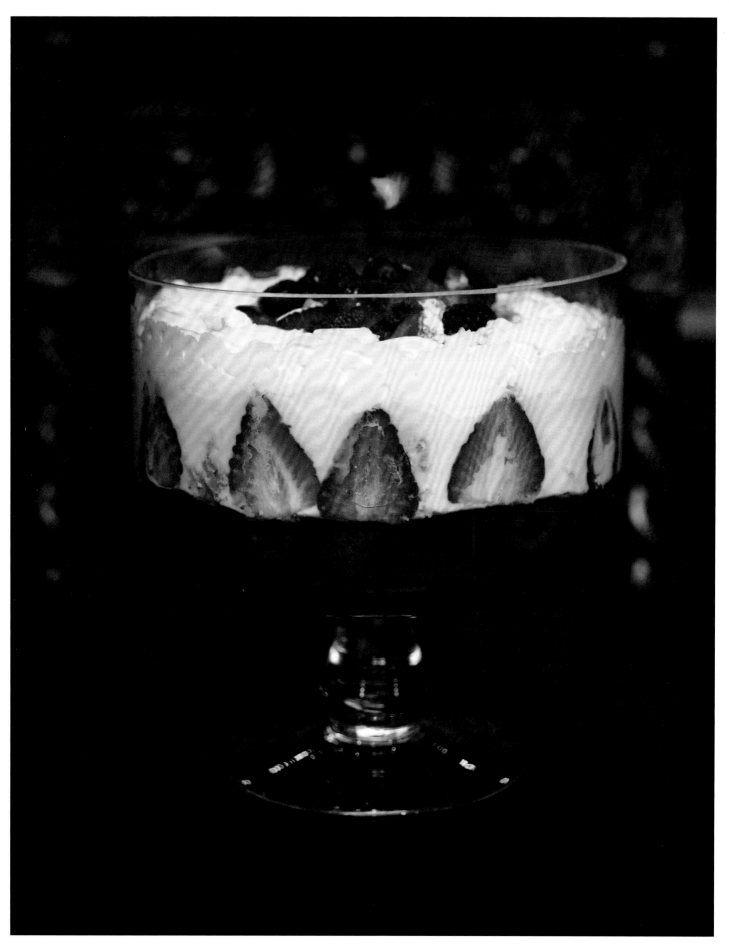

218 This beloved traditional British dessert is all about the generosity of layers: Fruit jelly, sponge cake pieces, custard and whipped cream. Get a spoon and dig in!

TOWERING BERRY TRIFLE

Ingredients

Vanilla Custard (makes 1 litre/4 cups)
960 ml (4 cups) unsweetened plant-based milk
100 g (½ cup) sugar
1 tablespoon vanilla extract
Little pinch of turmeric (use the tip of a teaspoon, as it stains)
40 g (⅓ cup) cornflour (starch), mixed with 2 tablespoons of plant-based milk

Jelly Layer
85 g (3 oz) vegan raspberry or strawberry jelly (jello) granules

To assemble
150 g (5oz) vegan loaf cake (store-bought)
200 g (7oz) fresh berries (I use strawberries, blueberries, raspberries or blackberries)
Zest of 1 orange
220 ml (1 cup) plant-based heavy whipping cream (or vegan squirt can cream) (optional)
4 tablespoons flaked almonds, toasted

Method

You will need a trifle bowl or large glass serving bowl.

Vanilla Custard
Add the milk, sugar, vanilla extract and turmeric to a medium/large saucepan and heat slowly. Once hot, pour in the cornflour mixture and bring to a gentle bubbling simmer. Cook for about 5 minutes, stirring continuously, until the custard is thick enough to coat the back of the spoon. Remove from the heat and set aside to cool completely. It can be kept in the fridge until ready to use.

Jelly Layer
Put the jelly granules into a measuring cup and top up with boiling water according to the instructions on the packet (the one I used called for 600 ml/20 fl. oz). Stir until the granules have dissolved.

To assemble
Pour the jelly into the the trifle bowl. Scatter in a third of the mixed berries. Leave to one side to set.

Once the jelly has set (so it can take the weight of the next layer), break the cake into rough pieces and lay it on top of the jelly. Scatter over another third of the berries and grate over the orange zest.

Starting at the centre and working out to the edges, spoon over about half of the cooled custard (500m (2 cups), depending on the size of your bowl), ensuring the cake is covered evenly. You can keep any extra custard in the fridge for another recipe.

Whip the cream in a medium-large mixing bowl with an electric mixer, beating until it holds soft peaks. Pile the whipped cream evenly on top of the trifle. Decorate with the squirt can whipped cream, toasted almonds, if using, and the remaining third of the berries.

STEVE BUSCEMI

Baking, Desserts

NO COOK CHOCOLATE RASPBERRY TART

Home, New York

Steve is one of the few actors who perfectly alternates between cult and commercial movie roles. His range includes being serious and sinister and being killed off in many ways, to being funny, quirky and charming. Whilst he may come across as deeply dark and aloof in some of his roles, off-screen he's a real gem — kind, engaged and super supportive. It was this Steve Buscemi who invited me over to his girlfriend Karen's apartment in New York. It was a crisp spring afternoon, and as I was away from home and my own kitchen, I decided to take them something simple that didn't require baking, but still had a wow factor. My chocolate tart fit the bill: crisp cookie base, chocolate mousse interior and brightly decorated with fresh red raspberries.

I took the lift to the sixth floor and was greeted at the door with Steve's trademark beaming smile. I handed him the tart, and as he cut us each a slice he asked inquisitively about the ingredients. I told him that the creaminess was not from dairy but actually silken tofu. He looked pleasantly surprised. To be honest, when I was experimenting on this one, I was surprised too. It's delicious and provides a shortcut, as no whipping of cream is required. Slice in hand, Steve took a seat on the couch, revealing the Beatles *Abbey Road* socks he was wearing, which made me smile. Looking around the apartment, I spotted the telltale signs of Karen and Steve's collective sense of humour, like a felt cake slice with a smiley face, complete with a candle. We talked about everything and nothing. Hanging out with these two was a breath of fresh air. They made each other giggle, which made me happy.

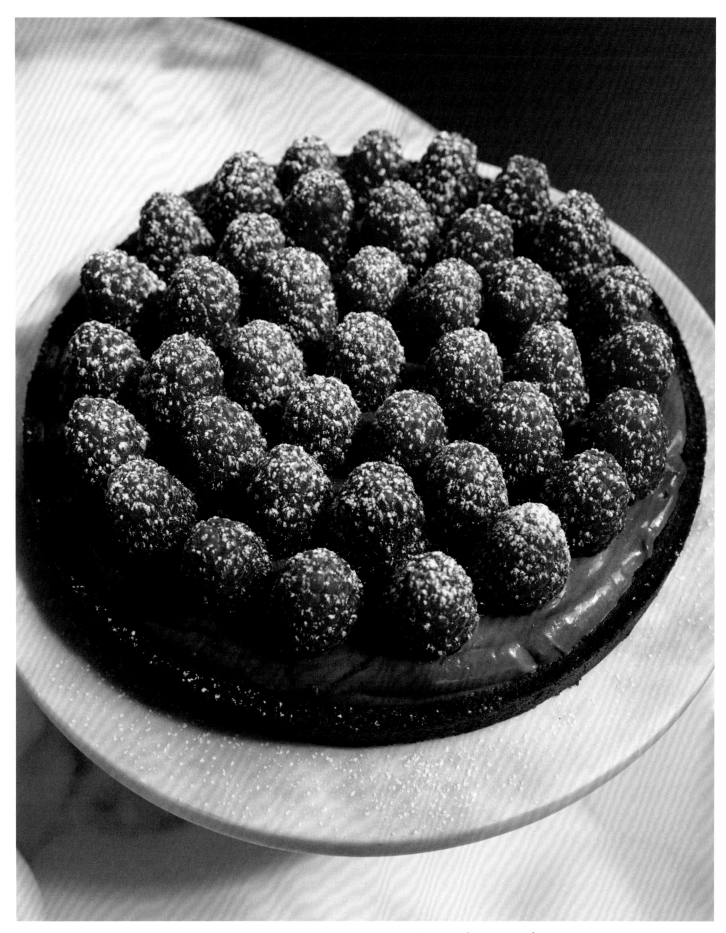

Quick and easy: This no cook tart has a lime zest
infused chocolate cookie base, chocolate mousse filling
(with a surprise secret ingredient). Brightly decorated
with fresh raspberries.

222

NO COOK CHOCOLATE RASPBERRY TART

Ingredients

Base
200 g (7 oz) chocolate cookies (vegan)
3 tablespoons coconut oil (or plant-based butter)
Zest of 1 lime

Chocolate Filling
200 g (7 oz) dark chocolate (70% cocoa), melted
300 g (10½ oz) silken tofu
1 tablespoon vanilla extract
3 tablespoons hot chocolate powder

To serve
200 g (7 oz) raspberries
Icing (confectioner's/powdered) sugar (optional)

Method

Line the base of a 20 cm (8 in.) loose-bottomed tart or cake tin with parchment paper.

Base
Blitz the chocolate cookies in a food processor and process until they resemble fine breadcrumbs. Add in the coconut oil and lime zest and pulse for 10 seconds to combine well. Alternatively, put the cookies in a re-sealable bag and bash them with a rolling pin, then pour into a bowl and stir in the melted coconut oil and lime zest until well combined.

Tip the cookie crumb mix into the base of the lined tin, and press down to make the tart shell, building up the sides a little (½ cm / ¼ in.) to hold in the chocolate mousse filling. Place in the fridge to chill while you make the filling.

Chocolate Filling
Melt the chocolate in a heat-proof bowl over a pan of gently simmering water or in the microwave. Alternatively, put the chocolate in a microwavable bowl and microwave in 30-second bursts, stirring between bursts.

Using a food processor or hand whisk, blitz the silken tofu until smooth. Add in the melted chocolate, vanilla extract and hot chocolate powder. Blitz/whisk until smooth, which will take about 15–20 seconds.

Spoon the chocolate mousse filling onto the cookie base and spread out evenly. Chill the tart in the fridge for at least 20 minutes or overnight.

To serve
Remove from the fridge and decorate with the fresh raspberries on top. Finish with a light dusting of confectioner's sugar all over, if using.

GEORGE CONDO

Baking, Desserts

PEANUT, PRETZEL, CHOCOLATE COOKIES

Artist's Studio, Long Island

Our annual summer family trip to Long Island was coming to an end, and I was getting ready to head home to London. My dad mentioned he was going to visit George Condo at his studio, so I asked him if he would mention the idea of *Feeding Creativity*, to see if George would be interested. Later that day, I was out to lunch and had a message from Dad saying that George had agreed, that I should come to his studio in a couple of hours. That didn't leave me much time, so I headed back to the house and searched the bare cupboards for some much-needed inspiration. I ended up with a bag of salted pretzels, a bar of dark chocolate and a jar of peanut butter — a classic flavour combination for a batch of cookies.

I set about making the cookie dough, and Dad came over to check out what I was baking. I gave him a bite of the cookie dough to test, but could see from his expression he wasn't expecting the crunch of the pretzel. He didn't seem too sure, which set off the panic alarm! The clock was ticking. Maybe my classic flavour combination wasn't so classic after all. I was running out of time, and we couldn't show up late, so I put on my oven gloves and pulled the piping hot cookies out of the oven and carried them straight to the car to be on my way. Dad had decided to drive me there for moral support. Pulling into the driveway, George was waiting for us, and I could see he was curious as I pulled out the tray of cookies. We need not have stressed, as, with a beaming smile, he exclaimed that he loved pretzels and pulled out his phone to show us a photo of a giant pretzel he had coincidentally just sent to a friend! Relieved, we walked over to his studio to have tea and cookies and take a sneak peek at his latest paintings.

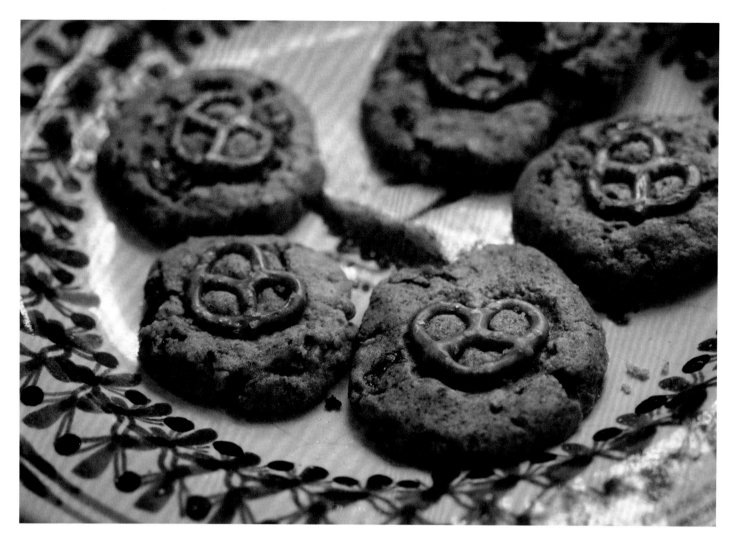

Chewy, peanuty, chocolatey, salty cookies. You can knock
this dough up in minutes and save in the fridge, or freeze,
until ready to bake.

PEANUT, PRETZEL, CHOCOLATE COOKIES

Ingredients

50 g (1 cup) lightly salted pretzels
160 g (⅔ cup) plant-based butter, softened,
 or coconut oil at room temperature
180 g (1 cup) brown sugar
1 tablespoon vanilla extract
5 tablespoons chunky peanut butter
80 g (3oz) dark chocolate (70% cocoa),
 broken into pieces
155 g (1¼ cup) spelt flour
 (or plain/all-purpose/gluten-free flour)

Method

Preheat the oven to 180°C/350°F. Line a large baking sheet with parchment paper.

Keep 10 pretzel pieces aside to decorate the top of each cookie before you put them in the oven. Break the rest of the pretzels into small pieces, keeping some texture, being aware not to grind them to dust.

In a medium/large mixing bowl, beat the butter and sugar together until well combined and lighter in colour. Add the vanilla extract and peanut butter and mix, then stir in the crushed pretzel pieces, chocolate and flour. Mix until the dough comes together into a large ball.

Divide the dough into 10 equal pieces and roll each piece into a ball. Place each on the lined baking sheet and press down slightly. Add one reserved pretzel piece to the top of each cookie and press in lightly.

Bake for 11 minutes, until golden and crunchy on the edges but still soft in the centre.

SAMANTHA MORTON

Baking, Desserts

FROZEN COCONUT KEY LIME PIE

Home, Sussex

I first met Samantha Morton many moons ago in London when I was commissioned to take her portrait for *Interview* magazine. She had just been nominated for an Oscar for her role in *Minority Report*. To be invited into someone's home to take portraits requires respect and care. It becomes more of an intimate process when in someone's private space. That day I could sense that Sam felt most comfortable with just the two of us in the room while I was taking her photo, so I asked the rest of the photo team to stand by in the next room. It was a really rewarding photo session. After that we lost touch for a while, as she was based in America while filming *The Walking Dead*. We reconnected when she moved back to the UK, close to where I grew up.

It was a perfect British summer's day, with blue skies and a gentle breeze. Craving something cold and refreshing, I was experimenting with a new recipe, a Frozen Coconut Key Lime Pie, a classic flavour combo I love. It was time to test it out on someone. I knew Sam was just back from France, playing Catherine de' Medici in the highly acclaimed TV series *The Serpent Queen*, so I messaged her on the off chance she'd be available, and she was. I headed straight over to get her take on my new recipe. As we were tucking in, she confided that Richard Russell from XL Recordings had got in contact with her after listening to her song selection on my favourite BBC radio show, *Desert Island Discs*. He was inspired to use a sample of a Molly Drake record she had selected. Their friendship had grown from there—and now they had formed a band and had been recording an album! I knew music was hugely important to Sam and influenced her craft, but a band—that was a great surprise.

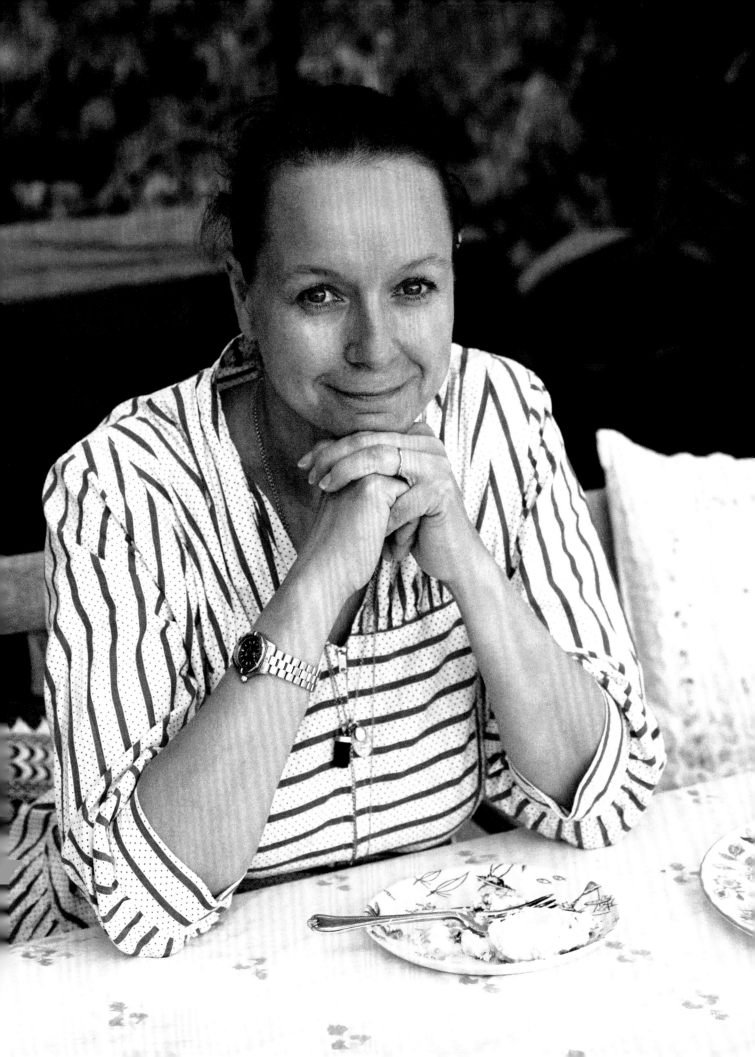

This dessert is especially pleasing on a hot summer's day. Coconut and lime infused frozen filling with a crunchy biscuit base. Make ahead and simply take out to soften a few minutes before serving.

FROZEN COCONUT KEY LIME PIE

Ingredients

Coconut Key Lime Filling
1 × 400 ml (14 oz) can of coconut milk
120 ml (½ cup) unsweetened plant-based cream
Zest of 1 lime
2 tablespoons freshly squeezed lime juice
2 tablespoons icing (confectioner's/powdered) sugar
1 tablespoon vanilla extract
1 tablespoon maple syrup

Pie Crust
150 g (5 oz) digestive biscuits or graham
 crackers (vegan)
Zest of ½ a lime
1 tablespoon coconut oil or plant-based butter

To serve (optional)
Unsweetened plant-based whipping cream,
 whipped (or vegan spray cream)
Thin lime slices

Method

Line a 20 cm (8 in.) freezer-safe pie dish or tin with parchment paper.

Coconut Key Lime Filling
Mix all the filling ingredients in a large saucepan and gently heat until the coconut milk has melted. Pour into a mixing bowl (or the bowl from a stand mixer) and allow to cool. Then put it into the freezer to freeze for 4 hours. Take it out of the freezer 4 times (once an hour) to mix by hand or with the stand mixer so it does not crystallise. Alternatively, if you have an ice cream maker, turn it to "churn" and make the filling according to your machine instructions.

Pie Crust
Meanwhile, blitz the biscuits in a food processor until they are a fine crumb (about 15 seconds). Add in the lime zest and coconut oil until evenly combined. Alternatively, put the cookies in a resealable plastic bag and bash with a rolling pin to a fine crumb consistency, then tip into a bowl and mix in the melted butter or coconut oil and zest.

Tip the crust mixture into the lined pie dish and press down firmly on the base and up the sides. Refrigerate for at least 30 minutes. Once the filling is set, spoon the Key Lime Filling onto the prepared base, and smooth out the top. Place in the freezer to set.

To serve
Remove the pie from the freezer about 30–45 minutes (depending on the temperature outside) before serving so it can soften a little and not be too solid, and therefore smoother and easier to cut. Spoon dollops of whipped cream (if using) around the top of the pie and garnish with thin slices of lime.

DANIEL SILVER

Baking, Desserts

CHERRY CLAFOUTIS

Artist's Studio, London

I had been commissioned to spend the day with the artist Daniel Silver at his studio in East London, for an editorial story in *Luncheon*, a biannual, free-spirited culture magazine. We had not met before, so I wasn't quite sure what to expect, but that's the thrill of this kind of photographic assignment, and it's something I thrive on, my own curiosity taking over. Stepping into his space, I was immediately taken with the large-scale figurative sculptures. Daniel showed me around, introducing me to his sculptures, which were impressive in scale, but also in character. The human body forms, carved out of marble and stone along with plaster and concrete, had an archaeological, classical feel to them—it was as if he was uncovering their character while carving and creating them.

Daniel explained he wasn't that used to having his portrait taken, so he was happy for me to take charge. I suggested he give me the full tour, and I stopped and directed him along the way, getting him to pose alongside his artworks. We broke for lunch with the rest of the team, congregating around a long table at the centre of the studio, surrounded by his sculptures looking down from on high. We served ourselves a delicious array of plant-based dishes, family-style, from large bowls at the centre of the table. Daniel opened a bottle of red wine, while I provided the dessert—a homemade Cherry Clafoutis, freshly baked that morning, picture-perfect and bursting with juiciness. We took our time chatting and eating, then got back to work.

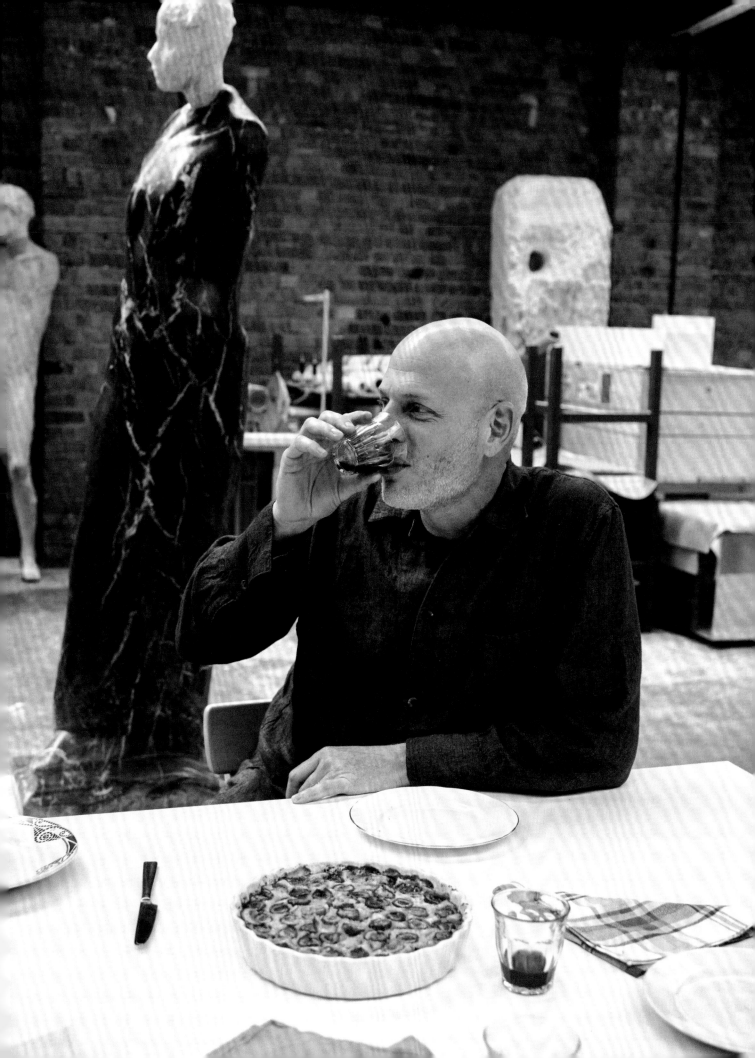

The juicy deep red cherries in this dessert make it look as beautiful as it tastes. Plus cherries are a strong source of antioxidants, another reason to enjoy this satisfying pudding. Also great using ripe apricots.

236

CHERRY CLAFOUTIS

Ingredients

Plant-based butter (or oil), for greasing
3 tablespoons milled flaxseed
4 tablespoons boiling water
150 ml (⅔ cup) unsweetened plant-based milk
(I favour cashew milk)
1 tablespoon apple cider vinegar
600 g (21 oz) fresh cherries, cut in half
and stones removed
1 tablespoon olive oil
1 tablespoon vanilla extract
95 g (½ cup) caster sugar
60 g (⅔ cup) ground almonds (almond flour)
50 g (½ cup) plain (all-purpose) flour
3 tablespoons cornflour (starch)
Pinch of sea salt

Method

You will need a 25 cm (10 in.) round baking dish greased with butter or oil. Preheat the oven to 190°C/ 375°F.

Place the milled flaxseed into a small bowl and add the boiling water, stir well and leave for 5 minutes to set.

Pour the plant-based milk into a jug and add in the vinegar. Stir and then leave this to sit for 5 minutes.

Scatter half the pitted cherries over the base of the greased baking dish.

Add the flaxseed mixture to the milk mixture along with the olive oil and vanilla extract and stir to mix together well.

In a separate medium mixing bowl add the sugar, ground almonds, plain flour, cornflour and a pinch of salt. Gradually pour in the wet mixture, stirring constantly, until well combined.

Pour the batter over the cherries in the baking dish, then evenly arrange the rest of the cherries on top, cut side up.

Bake the clafoutis in the oven for 30–35 minutes or until just set and golden brown.

To serve
Let the dish cool slightly and serve warm or at room temperature.

CAMILLA FAYED

Baking, Desserts

MAPLE VODKA PEACHES

Biodynamic Farm, Kent

Camilla is a dear friend, and I feel proud when I eat at her delicious plant-based restaurant, Farmacy, which she opened in 2016 in London. The place has such a buzz about it and is always packed. It has a strong food philosophy that mirrors hers, with the focus being on provenance, taste and nutrition. I hopped on a short train ride to the Kent countryside, to meet at her bio-dynamic farm, where she grows produce and develops dishes for the restaurant. Like me, she loves to keep her ear to the ground for new food ideas, and we both love to share our findings. When I arrived at midday, her teenage daughter was still in bed. She is a budding photographer herself, and I had enlisted her to assist me that day. It took a while to rouse her, but eventually she surfaced and helped me with the lighting.

I headed straight to the kitchen to prepare the Maple Vodka Peaches, a real crowd-pleaser, and ridiculously easy to make, leaving more time for us to natter. Camilla and I make each other smile, as we share a similarly silly sense of humour. It had turned into the most beautiful spring day, so I wandered outside to nose around the vegetable patch to see what was growing, and to search for a pretty spot for us to sit and eat together. In a little wooded area, I spotted the perfect setting: stone steps, completely covered in soft moss, next to a majestic tree and blue-bell patch, looking like something out of a fairy tale. When it was time to catch my train home, I headed back with that relaxed feeling you get after spending time with good pals.

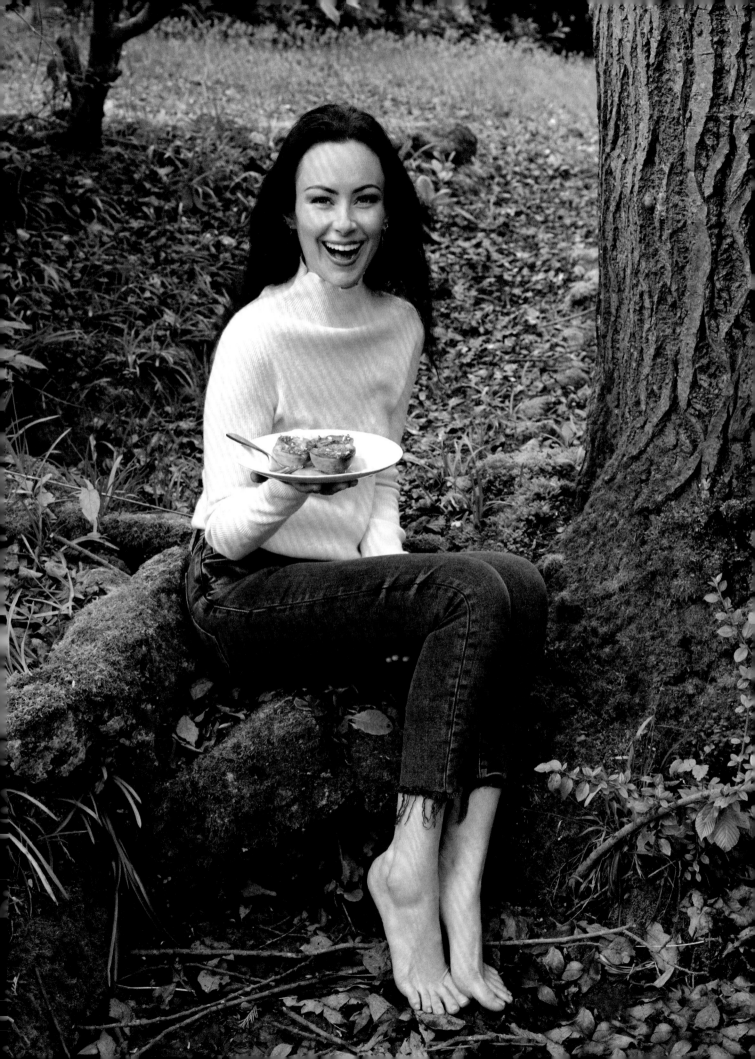

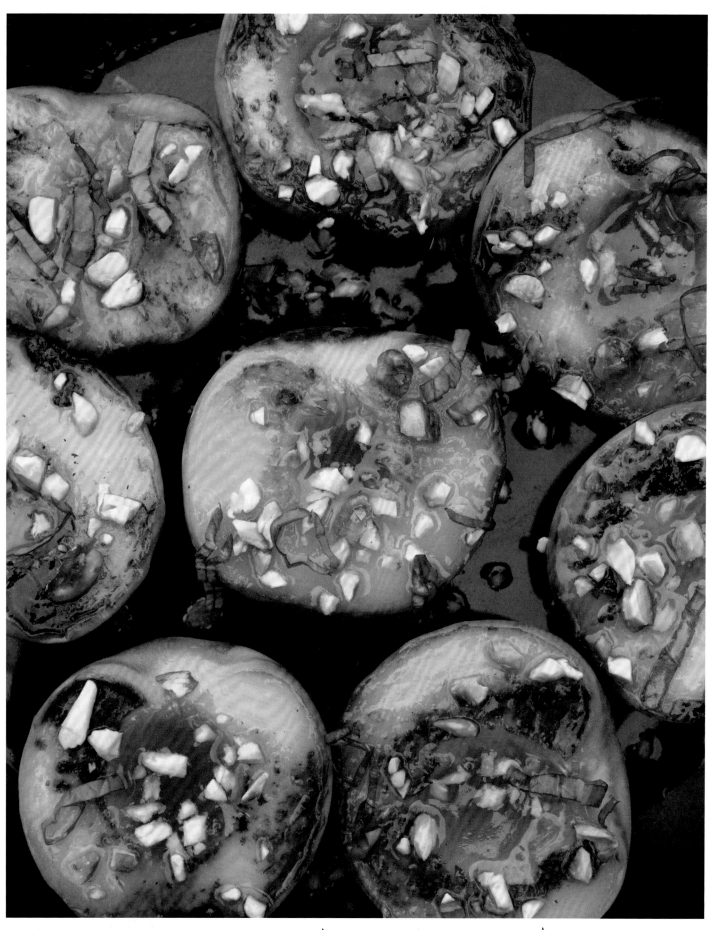

Sweet ripe peaches caramelised in vodka and maple syrup.
Finished with a generous sprinkle of sliced fresh tarragon or
basil leaves and toasted pistachios. Serve as is, or with a
scoop of ice cream on the side.

242

MAPLE VODKA PEACHES

Ingredients

2 tablespoons olive oil
4 ripe peaches, halved and stones removed with
 a teaspoon to make a well
4 teaspoons vodka
4 tablespoons maple syrup
3 tablespoons shelled pistachios
20g (1oz) tarragon leaves (or basil leaves)

To serve
Vanilla ice cream (vegan)

Method

Heat the olive oil in a large griddle/frying pan on a medium heat. Place the peaches cut side up in the pan and carefully pour a teaspoon of vodka into each well. Cook on a gently sizzling heat for 5–7 minutes, until the peaches have softened on the bottom.

Spoon a tablespoon of maple syrup into the centre of each peach and cook for another minute, then flip the peaches over and cook for 5–7 minutes more to allow the peaches to cook through and the sauce to caramelise.

While the peaches cook, toast the pistachios in a dry frying pan for 1 minute, then remove and roughly chop.

To serve
Serve the peaches on a platter or divided between individual dessert bowls or plates. Spoon over any excess sauce, scatter the toasted pistachios over the top of the peaches and sprinkle over the tarragon leaves or torn basil leaves.

Serve with ice cream on the side.

SHARLEEN SPITERI

Baking, Desserts

PECAN BROWNIES

Home, London

Singer-songwriter Sharleen Spiteri is the frontwoman of Glaswegian band Texas. She's sold over 40 million records and is still touring to sold-out crowds, both in the UK and abroad. One highlight was seeing her perform on the Pyramid Stage at Glastonbury this year. I know how much she thrives on the emotions and feedback from a live audience. She works her butt off on stage, singing, jumping around, playing guitar, and telling anecdotes and cracking jokes in her broad Scottish accent (which never seems to wane despite years of living in London). She says it as it is, and we love her for it. Whenever I see her perform, I'm always reminded of her incredible talent and connection with the audience.

She also happens to be one of my close friends. We were pregnant at the same time, and our kids have grown up together. We look on Sharleen and her husband, the renowned chef Bryn Williams, as family. The best invite in town is round to their house. It's tastefully designed, and somewhere you want to curl up and forget about what's going on outside those four walls. There's usually a fire going, a warm AGA, cosy sofas, endless cups of tea and a very relaxed atmosphere. I knew Bryn loved my chocolate brownies, so I whipped up a batch, adding pecans to the recipe for a change, and headed over to Sharleen's to share them. With lots to catch up on, cuppa and brownie in hand, we made our way to the sofa, with her very devoted dog, Socks, by her side. It was the most stunning autumnal afternoon in London and the golden sunlight was streaming into the room. By the time we'd finished yakking, it was already dark outside.

A real family favourite. Fudgy, gooey chocolate brownies covered with toasted pecans and more chocolate!

PECAN BROWNIES

Ingredients

Plant-based butter, for greasing cake tin
Flour, for dusting

Brownie Batter
80 g (3 oz) plant-based butter (or coconut oil)
90 g (3½ oz) dark chocolate (70% cacao)
150 g (⅔ cups) sugar
3 tablespoons milled flaxseed, mixed with
 3 tablespoons boiling water
1 tablespoon vanilla extract
100 g (¾ cup + 1 tablespoon) plain (all-purpose) flour
2 teaspoons baking powder

Pecan Topping
60 g (½ cup) raw pecans
1 tablespoon sugar
1 tablespoon dark chocolate chopped into
 small pieces, or chocolate chips

Method

Preheat the oven to 180°C/350°F. Grease and lightly flour the base and the sides of a 18 cm (7 in.) square tin.

Brownie Batter
Very gently melt the butter and chocolate together over a low heat in a small saucepan. Then set aside.

Place the sugar and flax mixture into a medium mixing bowl, beat together and add the vanilla. Now pour in the slightly cooled chocolate mixture, stir in the flour and baking powder, and mix to form a thick batter. Spoon the batter into the prepared cake tin and spread evenly.

Pecan Topping
Decorate the top of the brownie batter with the pecans, a sprinkle of sugar and chocolate pieces. Bake for 15–17 minutes, until the pecans are golden brown on top but the brownies are still soft and gooey in the centre.

DREW BARRYMORE

Baking, Desserts

CHOCOLATE ORANGEY COOKIES

On the Set of *The Drew Barrymore Show*, New York

I was in New York City, doing press to promote my cooking show, and was more than a little apprehensive, as I had been booked as a guest to cook live on *The Drew Barrymore Show*. I wasn't used to live TV, so my nerves were taking over as I'm much more comfortable behind the camera. My saving grace was that my host was the effervescent and nurturing Drew; on entering my dressing room, she instantly reassured me, telling me to think of it as just the two of us in the kitchen, chatting and cooking. I was shown to the set, where all the ingredients for our cookies were already perfectly set out, with a duplicate set alongside for Drew to cook along with me. While the show was on a short ad break, Drew took the opportunity to introduce me to the studio audience, whilst expressing her love of cookies, so that went some way to calming my nerves.

When it came to our segment, time flew by so fast. At first it felt like an out-of-body experience, but I looked to Drew for reassurance, getting a warm smile back — that was enough for me to pull myself together. I focused on guiding us through the recipe, with her enthusiastically mirroring my every move. She spontaneously munched on the cookie dough and I mentioned that it's safe to eat, as there are no raw eggs in the recipe. Then we turned to eating the fresh-baked cookies (baked earlier). She "ummed" and "ahhed" over this chocolate orange flavour combination, one of my personal favourites too. I took a spontaneous portrait, getting her to hold up two of the cookies in front of the audience, so I could capture this memory. Job done, Drew ran off to get ready for her next segment. And in hindsight, I have to admit I loved every second.

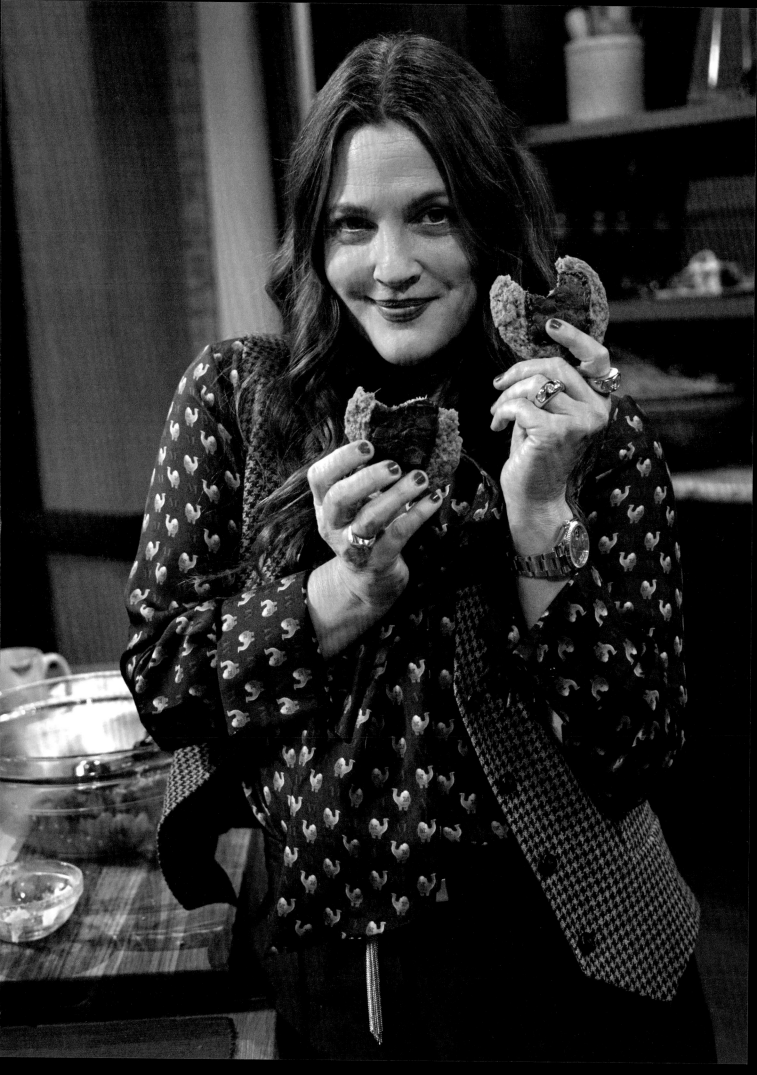

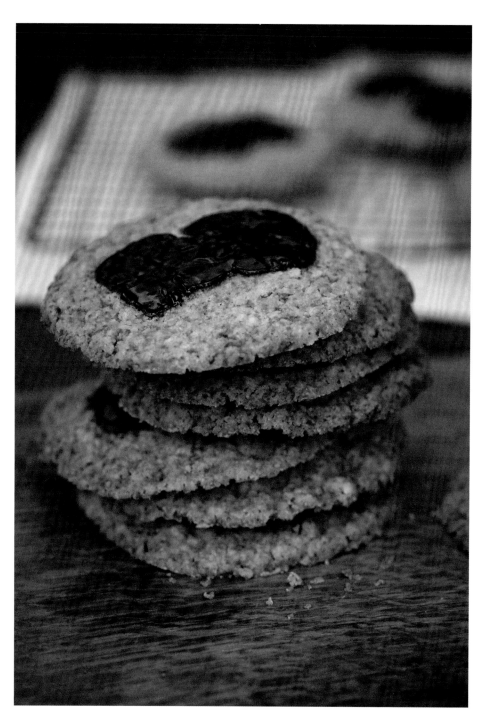

Chocolate and orange is one of my favourite combinations. This simple cookie dough is flavoured with orange zest and juice. Then chocolate chunks are pressed into each ball before baking — so everyone gets an equal share.

CHOCOLATE ORANGEY COOKIES

Ingredients

125 g (½ cup) demerara sugar (or light brown sugar)
110 g (½ cup) coconut sugar (or soft brown sugar)
120 ml (½ cup) odourless coconut oil (or plant-based
 butter), at room temperature
1 tablespoon vanilla extract
180 g (1½ cups) plain (all-purpose) flour
1 teaspoon baking powder
Zest of 1 orange
2 tablespoons freshly squeezed orange juice
90 g (3½ oz) dark chocolate, broken into
 one-piece squares

Method

Preheat the oven to 180°C/350°F. Line two large baking sheets with parchment paper.

In a mixing bowl, beat together the two types of sugar with the coconut oil or butter and vanilla extract. Stir in the flour, baking powder, orange zest and orange juice until the ingredients are well combined and form a dough. You can add another tablespoon of orange juice if the dough feels too dry.

Spoon balls of cookie dough (about 1 tablespoon each) onto the baking sheets, leaving space between.

Gently flatten the dough balls, and press one chocolate piece into the centre of each one. Bake for 10 minutes, until the edges just start to brown.

Remove from the oven and transfer to a wire rack to cool.

MARK RYLANCE

Baking, Desserts

GLAZED BAKED DOUGHNUTS

Apollo Theatre, London

In 2013, Mark invited me to make a photographic study of him and his ensemble cast backstage during the Shakespeare's Globe production of *Twelfth Night* in New York. It was an unprecedented opportunity to photograph the cast, musicians and crew immersed in their backstage world. I also got to know his wife and longtime collaborator, composer Claire van Kampen, who was the musical director of the play. We have all stayed in touch ever since.

Much more recently I was thrilled when I received a personal invitation from Mark to document the end of the journey of Jez Butterworth's iconic play *Jerusalem*, when he came back to the West End to reprise his legendary role of Johnny "Rooster" Byron. It was a real privilege to be trusted as a member of the company,

and I spent time with them discovering their process and various rituals. I noticed they had taken the doors off their dressing rooms to create a feeling of closeness and community. One of my favourite things was a long net they would put up in the stalls to play handball together before the doors opened to the public. This photo was taken as Mark got back to his dressing room after the very last performance on Shaftesbury Avenue. It was a bittersweet time, as I could sense the cast were looking forward to a well-deserved break, but at the same time they were going to miss each other very much. To mark the occasion, I had made the cast doughnuts to accompany the champagne. As I left the theatre for the last time, I looked up to see Mark at his dressing room window waving goodbye to me.

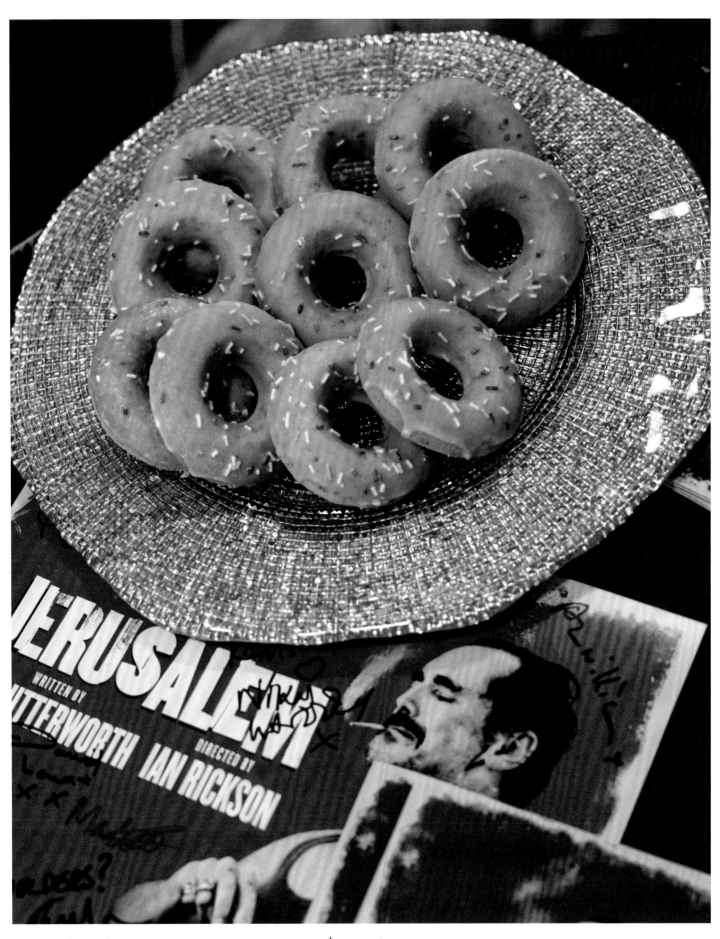

256 I love glazed doughnuts! So I played with the recipe to make them more guilt free — while still retaining their joy. There are two glazes to choose from, but feel free to experiment with your own favourite flavours too.

GLAZED BAKED DOUGHNUTS

Ingredients

Coconut oil, for greasing (or plant-based butter)

Doughnut Mix
110 g (¾ cup) plain (all-purpose) flour
2 tablespoons cornflour (starch)
75 g (⅓ cup) sugar
1 teaspoon baking powder
½ teaspoon sea salt
2 tablespoons milled flaxseed
5 tablespoons boiling water
75 ml (⅓ cup) unsweetened plant-based milk
 (I use cashew)
1 tablespoon vanilla extract
1 tablespoon coconut oil, melted
 (or plant-based butter)

Glaze
90 g (¾ cup) icing (confectioner's/powdered) sugar
5 tablespoons maple syrup (maple glaze)
 or 1½ tablespoons strong black coffee
 (coffee glaze)

Rainbow sprinkles or freeze-dried strawberries
 (optional)

Method

You will need a six-hole, non-stick doughnut tin greased with coconut oil/plant-based butter. Preheat the oven to 190°C/375°F.

Doughnut Mix
Mix the flour, cornflour, sugar, baking powder and salt in a medium-sized mixing bowl.

Place the milled flaxseed in a small bowl, add the boiling water, stir well and leave for 5 minutes.

Whisk the milk, vanilla extract and melted coconut oil or butter in a separate bowl, adding the flaxseed mix once it has set. Slowly pour the wet mixture into the dry ingredients, whisking all the ingredients together until you have a smooth, thick batter. If needed, you can add a few extra tablespoons of milk.

Place the doughnut mix in a piping bag and pipe the batter into the doughnut rounds in the greased tin (if you don't have a piping bag, pour the batter into a freezer bag and cut the corner off). Place on the middle shelf of the oven and bake for 12 minutes.

When the doughnuts are baked, tip them gently out of the tin and place them onto a wire rack to cool.

Glaze
While the doughnuts are cooling, make the glaze by mixing together the icing sugar and maple syrup or coffee (depending on the flavour you want). If the glaze is a little too thick to dip the doughnuts in, add 1 teaspoon of water to make the glaze slightly thinner.

Once cooled, either dip the doughnuts upside down in the glaze to coat them evenly, or drizzle the glaze over the tops. Then scatter on the sprinkles or freeze-dried strawberries, if using. If you do not have any sprinkles, these doughnuts are delicious simply glazed.

JUDI DENCH

Baking, Desserts

SHORTCUT APPLE TART

Home, Surrey

Judi Dench is a national treasure, a genuine one of a kind and one of the greatest actors of her generation. She sent me an amusing message, telling me that I may well regret having asked her to participate in *Feeding Creativity*, followed by a very detailed list of her food dislikes. I wouldn't be put off that easily, but I decided to play it safe with my tried-and-trusted Shortcut Apple Tart. At the last minute I also decided to make a hearty vegetable soup, being careful to avoid anything on her list. Heading to an area of the Surrey countryside that I had never been to before, I was impressed by its beauty, so close to London. Judi told me how her beloved late husband, the actor Michael Williams, had seen the house in a magazine and taken her to see it. They instantly fell in love with the place, and it has been her home ever since. I could see from the family photos dotted around that it was a home filled with much love and happy memories.

We based ourselves in her kitchen, where Judi opened a perfectly chilled bottle of champagne. As we took our first sip, she stopped and said, *"Do you feel that fizz feeling here?"*, whilst touching both sides of her face by her jawline. She beamed and exclaimed, *"It's wonderful"*. I wished I had felt it too, as I could see it brought her such joy. She enjoyed the soup, despite the carrots, which she had forgotten to put on her "no" list. I could tell she was keen to get to the apple tart, and I was in complete bliss as she tucked in, not stopping until she had devoured it all. Then, with that cheeky glint in her eyes, she said, *"I'm going to lick the plate"*. She put it up to her face, but then stopped. I so wished she had!

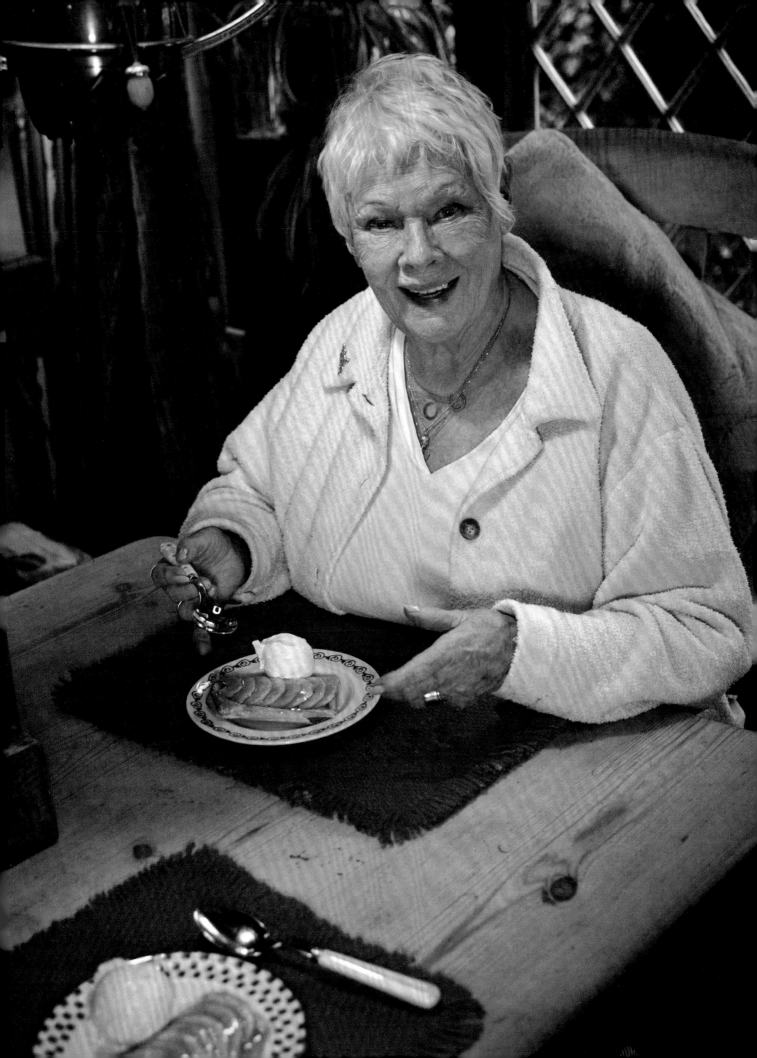

This tart looks like it came straight out of a French patisserie, but I'll let you in on my secret. It only uses 4 ingredients! Shortcrust ready roll pastry, sliced sweet apples brushed with olive oil (baked until golden), then glazed apricot jam. That's it!

SHORTCUT APPLE TART

Ingredients

1 sheet of ready-rolled shortcrust pastry
(made with vegetable shortening)
5 pink lady apples (or similar)
2–3 tablespoons olive oil
150 g (5 oz) apricot jam (preserve)

To serve (optional)
Vanilla ice cream (vegan)

Method

Preheat the oven to 190°C/ 375°F.

Roll out the shortcrust pastry onto a baking sheet to cover an area about 22 × 33 cm (9 × 13 in.), keeping the parchment paper underneath; this will make it easier to transfer to a serving platter once baked. (If you can't get a rectangular ready-rolled pastry sheet, use a circular one.)

Peel the apples and slice them down through the centre to cut them in half. Then cut each half down the centre again to quarter. Trim away the core, then cut lengthwise into thin slices about ½ cm (¼in) thick. Repeat until all the apples are prepared and sliced. Now you are ready to assemble.

Shuffle the apple slices into rows so they overlap slightly in design (as they shrink slightly when baking). You can go right up to the edge of the pastry.

Using a pastry brush, liberally brush the apples with olive oil and bake for 30–35 minutes, until the pastry is golden brown and crisp on the bottom.

Warm the apricot jam in a small pan on a low heat to loosen it to a glazing consistency. Using the pastry brush, generously brush the jam over the apples and pastry edges to glaze the whole tart.

To serve
Gently transfer the tart from the baking tray onto a serving platter, removing the parchment paper. Slice and enjoy warm, or at room temperature, with a scoop of ice cream.

ED RUSCHA

Baking, Desserts

CITRUS SYRUP POLENTA CAKE

Artist's Studio, Los Angeles

A visit to legendary American artist Ed Ruscha's studio with my sister Stella and our kids is a real treat and we were excited. He's one of our all-time favourites. His studio is a visual tsunami of inspiration: paintings, drawings, photographs and published books on every surface. Large wooden boxes of artworks sit ready to be shipped around the world, even a surfboard suspended from the ceiling personalised with his words, *"The End"*. His desk is stacked sky-high with reference books, collected magazine articles, photographs and music cassettes. There are artworks in varying degrees of completion. One I particularly connected with says, *"I HAVEN'T MADE UP MY MIND YET, BUT I'VE MADE UP MY MIND NOT TO MAKE UP MY MIND YET"*. I noticed a couple of boxes neatly marked *"Awards and Honorary Degrees"*. This was humbling stuff.

You don't want to stop looking in case you miss a gem.

Ed was generous with his time, guiding us around, his devoted dog following loyally by his side. I sensed his love of music everywhere, portable stereos connected to the mains via long extension leads, inside and outside. We ended up in the backyard, an orchard in full bloom! Packed with citrus trees: grapefruit, orange, lemon, kumquat and limes. He even showed me the pineapple he was growing. If anyone can, Ed can. I had no idea just how fitting my Citrus Syrup Polenta Cake would be. It went down well, and Ed picked me a blood orange, maybe the juiciest and certainly the freshest I've ever had. As we left, Ed offered us gifts: a plate with his artwork printed on it and art books, dedicating them personally for us. A truly memorable occasion.

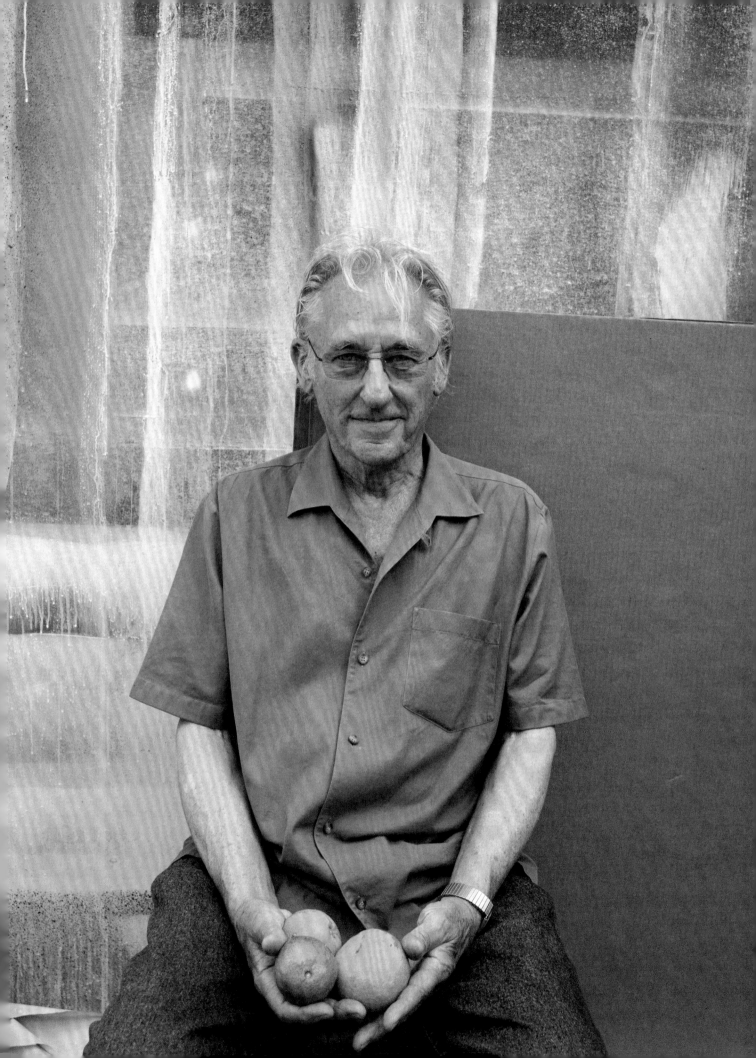

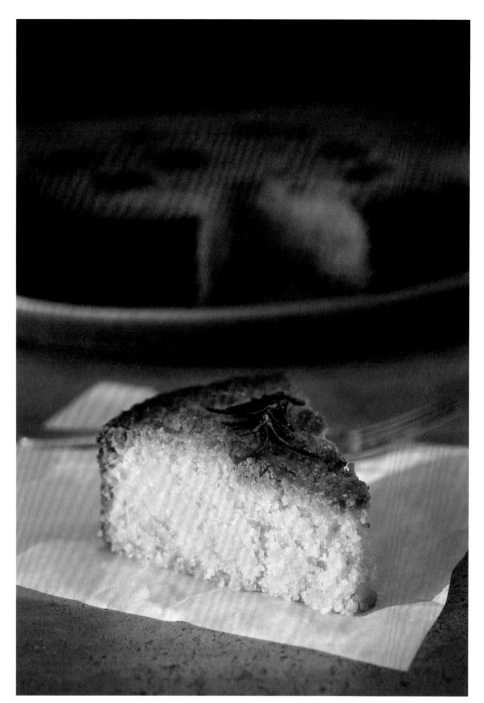

A simple, rustic, Italian inspired polenta cake. Infused with citrus flavours and sweet syrup.

CITRUS SYRUP POLENTA CAKE

Ingredients

Olive oil, for greasing
Polenta, for dusting

Batter
150 g (5 oz) polenta (not quick cook)
150 g (1½ cups) ground almonds
150 g (⅔ cup) caster sugar
3 teaspoons baking powder
80 ml (⅓ cup) extra virgin olive oil
Zest of 1 orange, 1 lemon and 1 lime
100 ml (⅓ cup plus 2 tablespoons) unsweetened
 plant-based milk

Syrup
100 g (¾ cup) confectioner's) sugar
Juice of 1 orange, 1 lemon and 1 lime

Rosemary (optional)

Method

Lightly grease the base and sides of a 20 cm (8 in.) round cake tin, and cover the base with parchment paper. Dust the sides of the tin with polenta to prevent the cake from sticking. Preheat the oven to 180°C/350°F.

Batter
Mix the polenta, ground almonds, sugar, baking powder, flour, olive oil, zest and milk together in a large mixing bowl until thoroughly combined. Spoon into the prepared cake tin and smooth evenly.

Bake for 40–42 minutes, until the cake is golden on top and is just firm to the touch.

Syrup
Meanwhile, to make the syrup, heat the sugar and citrus juices in a small saucepan over a medium heat until the sugar has dissolved completely.

While the cake is still warm in its tin, pierce it all over with a cocktail stick or skewer, so it will absorb the syrup. Pour the syrup evenly over the surface and leave the cake to soak it up. Cool slightly in the tin for 20 minutes before removing from the tin to serve.

Top with rosemary sprigs for decoration, if using.

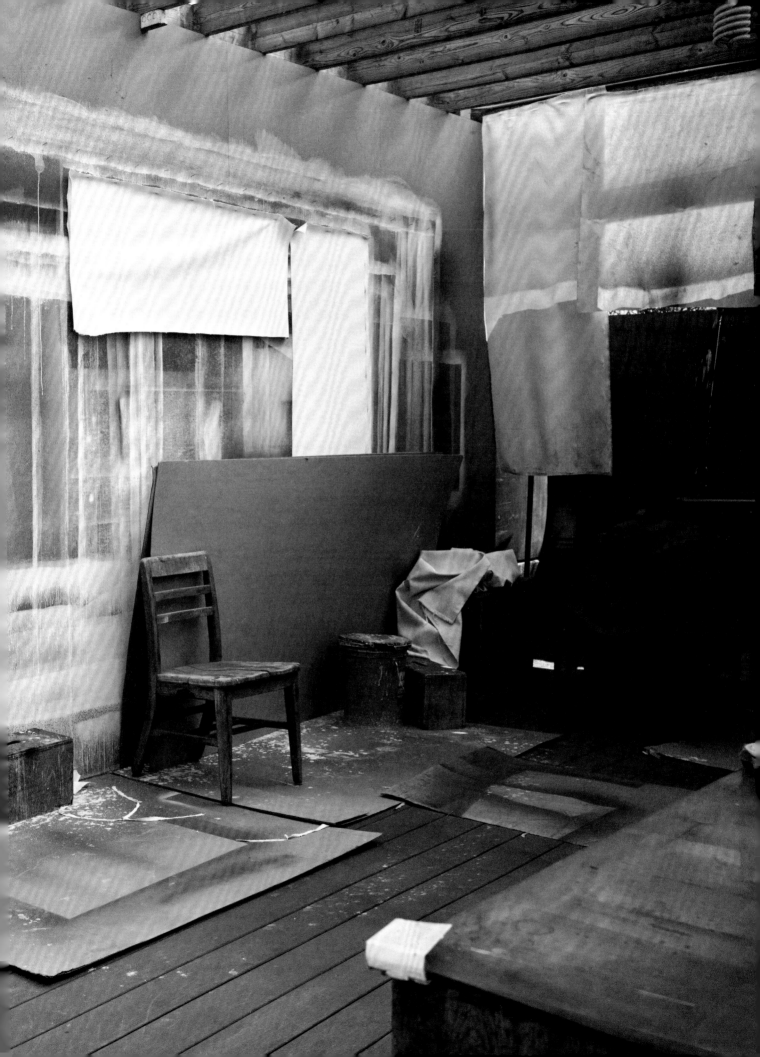

Name and Subject Index

Note: Names and page numbers in bold refer to the subjects of the photographs

Putting this book together has been a labour of love. A big thank you to the many wonderful people who have helped me along the way. X Mary

Abbey Road Studios, Alexi Alario, Alyssa Dusevic, Amanda Swart, Anika Jamieson-Cook, Annette Musker, Antonia Moussaieff, Anya Hassett, Aoife Dick, Arthur Donald, Ashley Woodfield, Athena Sammy, Ayala Daly, B, Bailey Willis, Ben Warren, Benedikt Taschen, Beth Greenwood, Bettina Korek, Billie Shephard, Bridget Harris, Charlie Lockyer, Carol Montpart, Charlotte Broomfield, Charlotte Ellis, Chris Howgate, Chrissy Blake, Claire Walden, Connie Wethington, Daniela Asmuth, Dave Grohl, David Hockney Studio, Elliot Donald, Faye Wears, Fiona Golfar, Fran Defeo, Frances Guppy, Gage Solaguren, Gina Maglangit, Glenn Wassall, Grace Dent, Grace Guppy, Hannah Warmback, Harry Weller, Heather McCartney, Hen Conrad, Honor Chapman, Isla Mathieson, Jack Hunter, James McCartney, Jamie Richardson, Jayne Hibbitt-Smith, Jordon Busson, Joshua Kirk, Julie Duffell, Julie Gorman, Kit Ning, Kit Wong, Lee Eastman, Lisa Harrison, Lottie Birmingham, Lou Kenney, Louise Goldstone, Louise Morris, Lucy Willis, Luna Esreb, Lydia Beagelman, Lydia Brand, Mallory Testa, Mandarin Oriental Hyde Park, Marcel Frederic, Maria Barreiras, Marlene Taschen, Mary Dean, Nancy McCartney, Nina Joyce, Nick Dewey, Nienke Mulder, Noah Dewey, Paul McCartney, Rachel Cooper, Rachel Purnell, Reuel Golden, Rosie Reynolds, Sam Aboud, Sarah Francus, Serena Gramaglia, Shannan Kelly, Sid Aboud, Simon Aboud, Stefan Bojilov, Stella McCartney, Sue Redmond, Sue Rutherwood, Tabitha Aboud, Tanya Khan, Team at Bayeux, Team at Hand of God, Team at Leica, Terry Hack, Tina Deane, Yasmine Hanni, Yoel Noorali, Yu Yigang

Author Mary McCartney
Editor Reuel Golden
Associate Editor Grace Guppy
Design & Art Direction Carol Montpart
Food Stylist and Recipe Reviewer Evie Harbury
Story Editor Andrew Conrad
Editorial Assistant Alexi Alario
Post Production Hand Of God

Copyrights
Photographs and Recipes unless otherwise noted © Mary McCartney
Cover photograph © Simon Aboud
Illustrations French Toast Studios

EACH AND EVERY TASCHEN BOOK PLANTS A SEED!
TASCHEN is a carbon neutral publisher. Each year, we offset our annual carbon emissions with carbon credits at the Instituto Terra, a reforestation program in Minas Gerais, Brazil, founded by Lélia and Sebastião Salgado. To find out more about this ecological partnership, please check: www.taschen.com/zerocarbon
Inspiration: unlimited. Carbon footprint: zero.

To stay informed about TASCHEN and our upcoming titles, please subscribe to our free magazine at www.taschen.com/magazine, follow us on Instagram and Facebook, or e-mail your questions to contact@taschen.com.

© 2023 TASCHEN GmbH
Hohenzollernring 53, D-50672 Köln
www.taschen.com

Printed in Italy
ISBN 978-3-8365-8942-0